Knit your own Zoo

Photographs by Holly Jolliffe

Published by
Black Dog & Leventhal Publishers, Inc.
151 West 19th Street
New York, NY 10011

Distributed by
Workman Publishing Company
225 Varick Street
New York, NY 10014

Manufactured in China

ISBN-13: 978-1-57912-960-6

h g f e d c b a

Library of Congress Cataloging-in-Publication Data available upon request.

For Georgie, Mena, Fanny, Fluffy, Ossie, and Scruffy

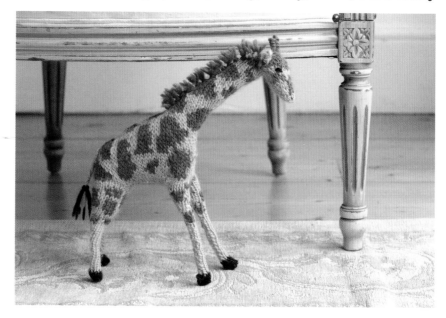

Knit your own Zoo

Easy-to-Follow Patterns for 24 Animals

Sally Muir & Joanna Osborne

BLACK DOG
& LEVENTHAL
PUBLISHERS
NEW YORK

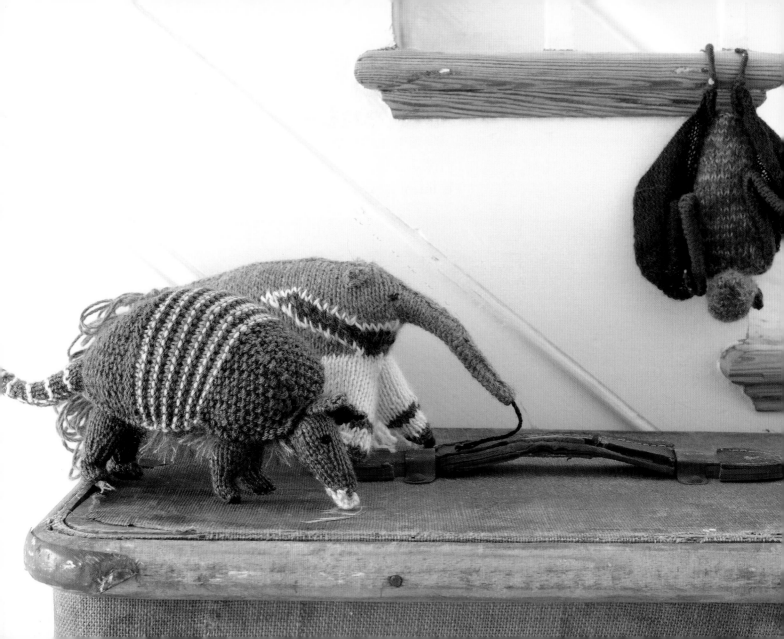

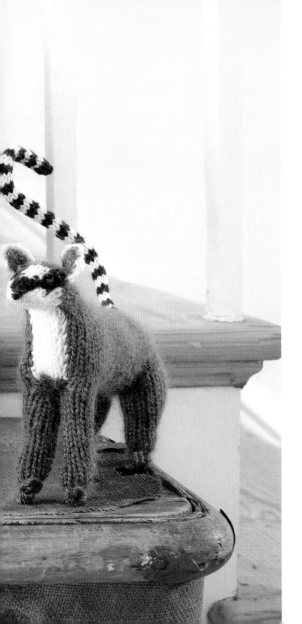

Contents

Introduction

Haven't we all wanted an exotic pet at some time? For many years we desperately wanted a lemur, but it's hardly the ideal domestic pet—now we can knit our own.

We so enjoyed writing our dog and cat books that we couldn't help ourselves and had to create a book of wild animals. If the knitted dog and cat were the perfect easy-care companions, the knitted zoo animal is even more so—you don't have to adapt your house to accommodate your giraffe, bring home freshly killed wildebeest for your lion, fly in eucalyptus leaves for your koala, or build an extension for your elephant. You get all the pleasure of the wild animal, with none of the headaches.

We couldn't include every animal, so our selection is necessarily idiosyncratic. We have included many of the obvious—the lion, tiger, elephant, giraffe—but we've also added ones we just loved and felt we had to have—the fruit bat, armadillo, and anteater—and the stranger-looking, less cuddly ones that we thought should have a place as well—the camel, crocodile, and mandrill.

You can knit your own endangered species, and for the more ambitious, with the use of some cereal boxes, straws, and sticky-backed plastic, you can make your own actual zoo. You can even knit two of each animal and create your own, rather incomplete, Noah's Ark. For the beginner, the one-color animals like the bears and seal are a good place to start, working up through the slightly more complicated meerkat and lemur to the most difficult—those with several colors, like the tiger and leopard, and those that use several techniques, like the anteater and armadillo. With simply a pair of knitting needles, some yarn, and a copy of this book, the animals of the frozen wastes of the Antarctic, the deserts of Africa, the jungles of Asia, and the outback of Australia can all be yours.

Joanna and Sally

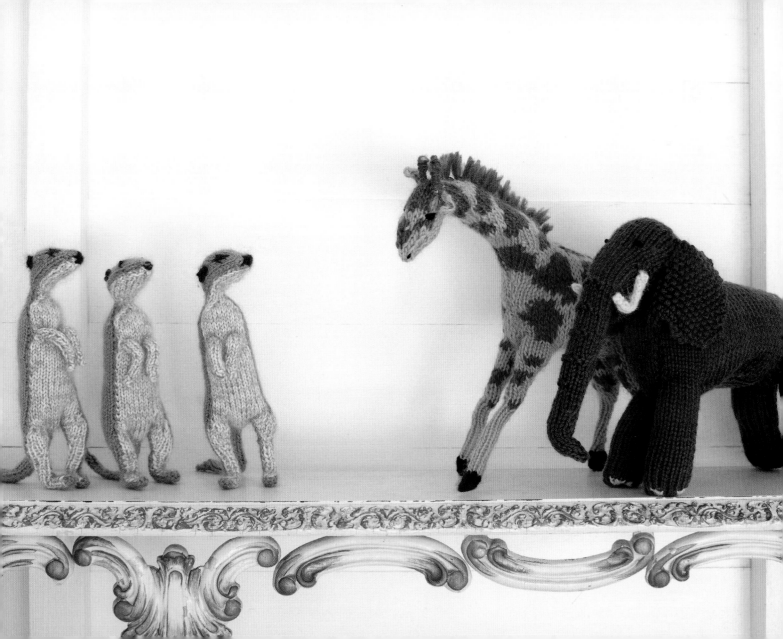

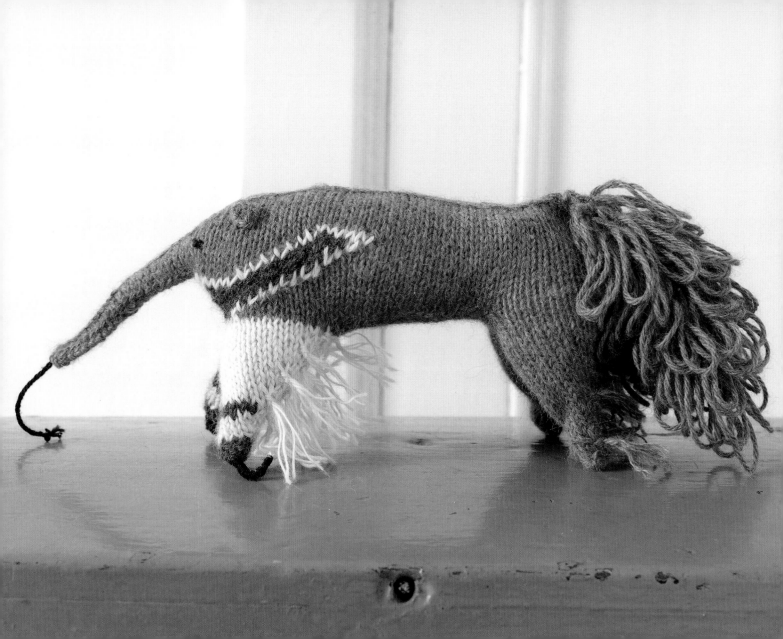

Giant Anteater

Anteaters are perfectly designed to perform the function they are named for: with long front claws for ripping apart termite mounds, tube-like snouts, and long sticky tongues, form really does follow function in this beast. Although giant anteaters—which is what ours is—have to eat an enormous number of ants just to keep alive, they are able to flick their two-foot tongue approximately 150 times a minute to pick up their tiny food. The collective noun for a group of anteaters is a parade.

Giant Anteater

The anteater is one of the more complicated animals, using several different methods.

Measurements

Length (including tail): 13in (33cm)
Height to top of head: 5in (13cm)

Materials

- Pair of US 2 (2¾mm) knitting needles
- Double-pointed US 2 (2¾mm) knitting needles (for holding stitches)
- ⅙oz (5g) of Rowan Baby Alpaca DK in Lincoln 209 (li)
- ½oz (15g) of Rowan Baby Alpaca DK in Jacob 205 (ja)
- 1½oz (35g) of Rowan Baby Alpaca DK in Cheviot 207 (ch)
- 3 pipecleaners for legs and claws
- Tiny amount of Rowan Pure Wool 4ply in Black 404 (bl) for eyes, tongue, and claws
- 2 tiny black beads for ant and sewing needle and black thread for sewing on

Abbreviations

See page 172.
See page 172 for Color Knitting.
See page 172 for Wrap and Turn Method.
See page 173 for Loopy Stitch. Work 2-finger loopy stitch throughout this pattern.

Right Back Leg

With ch, cast on 7 sts.
Beg with a k row, work 3 rows st st.
Row 4: Inc, p5, inc. (9 sts)
Row 5: Inc, loopy st 1, k5, loopy st 1, inc. (11 sts)
Row 6: Purl.
Row 7: Inc, k9, inc. (13 sts)
Row 8: Purl.
Row 9: Inc, loopy st 1, k9, loopy st 1, inc. (15 sts)
Row 10: Purl.
Row 11: Inc, k13, inc. (17 sts)
Row 12: Purl.
Row 13: Inc, loopy st 1, k13, loopy st 1, inc. (19 sts)
Row 14: Purl.
Row 15: Inc, k17, inc. (21 sts)
Row 16: Purl.
Row 17: Inc, loopy st 1, k17, loopy st 1, inc. (23 sts)
Row 18: Purl.
Row 19: Inc, k21, inc. (25 sts)
Row 20: Purl.
Row 21: Inc, loopy st 1, k21, loopy st 1, inc. (27 sts)
Row 22: Purl.
Row 23: Inc, k25, inc. (29 sts)
Row 24: Purl.*
Row 25: Bind off 14 sts, k to end (hold 15 sts on spare needle for Right Side of Body).

Left Back Leg

Work as for Right Back Leg to *.
Row 25: K15, bind off 14 sts (hold 15 sts on spare needle for Left Side of Body).

Right Front Leg

With li, cast on 7 sts.
Beg with a k row, work 2 rows st st.
Join in ja.
Row 3: Knit.
Row 4: Inc, p5, inc. (9 sts)
Row 5: Inc, k7, inc. (11 sts)

Row 6: Purl.
Join in li.
Row 7: Incja, k2ja, k5li, k2ja, incja. (13 sts)
Row 8: P2ja, p9li, p2ja.
Cont in ja.
Row 9: Inc, k11, inc. (15 sts)
Row 10: Purl.
Row 11: Inc, loopy st 1, k11, loopy st 1, inc. (17 sts)
Row 12: Purl.
Row 13: Inc, k15, inc. (19 sts)
Row 14: Purl.
Row 15: Inc, loopy st 1, k15, loopy st 1, inc. (21 sts)
Row 16: Purl.
Row 17: Inc, k19, inc. (23 sts)
Row 18: Purl.
Row 19: Inc, loopy st 1, k19, loopy st 1, inc. (25 sts)
Row 20: Purl.**
Row 21: Bind off 12 sts, k to end (hold 13 sts on spare needle for Right Side of Body).

Left Front Leg

Work as for Right Front Leg to **.
Row 21: K13, bind off 12 sts (hold 13 sts on spare needle for Left Side of Body).

Right Side of Body and Head

Row 1: With li, cast on 1 st, k3li, k1ja, k9ch from spare needle of Right Front Leg, cast on 6 sts ch. (20 sts)
Row 2: P14ch, p1ja, p5li.
Row 3: Incli, k5li, k1ja, k13ch, cast on 6 sts ch. (27 sts)
Row 4: P18ch, p1ja, p8li.
Row 5: K5ja, k4li, k1ja, k17ch, cast on 4 sts ch. (31 sts)
Row 6: P20ch, p1ja, p4li, p1ja, p5ch, cast on 24 sts ch. (55 sts)
Row 7: K30ch, k1ja, k4li, k1ja, k19ch, with RS facing k15ch from spare needle of Right Back Leg. (70 sts)

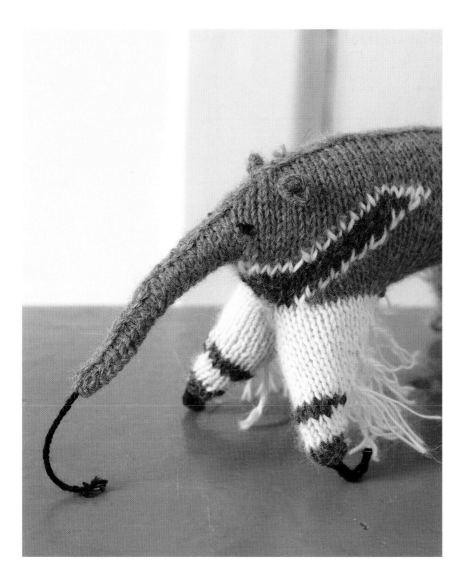

Row 8: P33ch, p1ja, p4li, p1ja, p31ch.

Shape top of nose

Row 9: Bind off 12 sts ch, k20ch ibos, k1ja, k4li, k1ja, k32ch. (58 sts)

Row 10: P2togch, p29ch, p1ja, p4li, p1ja, p21ch. (57 sts)

Row 11: Bind off 6 sts ch, k16ch ibos, k1ja, k4li, k1ja, k29ch. (51 sts)

Row 12: P2togch, p26ch, p1ja, p4li, p1ja, p15ch, p2togch. (49 sts)

Row 13: Bind off 3 sts ch, k14ch ibos, k6ja, k26ch. (46 sts)

Cont in ch.

Row 14: P2tog, p44. (45 sts)

Row 15: K2tog, k43. (44 sts)

Row 16: P2tog, p42. (43 sts)

Row 17: K2tog, k41. (42 sts)

Row 18: P2tog, p40. (41 sts)

Row 19: Bind off 4 sts, k to end. (37 sts)

Row 20: P2tog, p33, p2tog. (35 sts)

Row 21: Bind off 4 sts, k to end. (31 sts)

Row 22: P29, p2tog. (30 sts)

Bind off.

Claws

The anteater has pipecleaners poking through his front paws, wrapped in black yarn to create his characteristic claws.

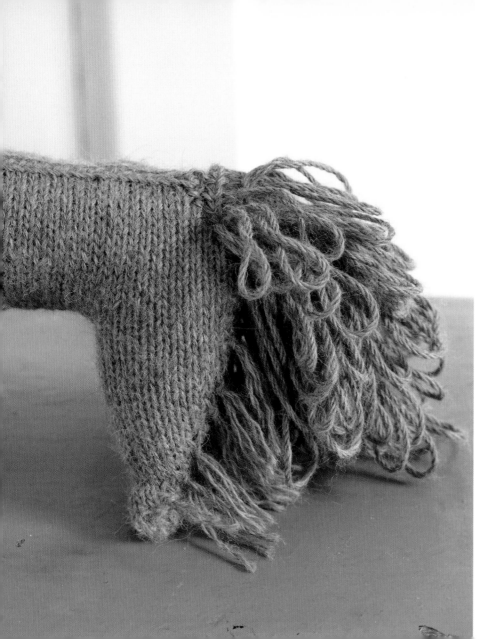

Left Side of Body and Head

Row 1: With li, cast on l st, with WS facing p3li, p1ja, p9ch from spare needle of Left Front Leg, cast on 6 sts ch. (20 sts)

Row 2: K14ch, k1ja, k5li.

Row 3: Incli, p5li, p1ja, p13ch, cast on 6 sts ch. (27 sts)

Row 4: K18ch, k1ja, k8li.

Row 5: P5ja, p4li, p1ja, p17ch, cast on 4 sts ch. (31 sts)

Row 6: K20ch, k1ja, k4li, k1ja, k5ch, cast on 24 sts ch. (55 sts)

Row 7: P30ch, p1ja, p4li, p1ja, p19ch, with WS facing p15ch from spare needle of Left Back Leg. (70 sts)

Row 8: K33ch, k1ja, k4li, k1ja, k31ch.

Shape top of nose

Row 9: Bind off 12 sts ch, p20ch ibos, p1ja, p4li, p1ja, p32ch. (58 sts)

Row 10: K2togch, k29ch, k1ja, k4li, k1ja, k21ch. (57 sts)

Row 11: Bind off 6 sts ch, p16ch ibos, p1ja, p4li, p1ja, p29ch. (51 sts)

Row 12: K2togch, k26ch, k1ja, k4li, k1ja, k15ch, k2togch. (49 sts)

Row 13: Bind off 3 sts ch, p14ch ibos, p6ja, p26ch. (46 sts)

Cont in ch.

Row 14: K2tog, k44. (45 sts)

Legs and Tail

The anteater's leg loops are cut, but the tail loops aren't.

Row 15: P2tog, p43. (44 sts)
Row 16: K2tog, k42. (43 sts)
Row 17: P2tog, p41. (42 sts)
Row 18: K2tog, k40. (41 sts)
Row 19: Bind off 4 sts, p to end. (37 sts)
Row 20: K2tog, k33, k2tog. (35 sts)
Row 21: Bind off 4 sts, p to end. (31 sts)
Row 22: K29, k2tog. (30 sts)
Bind off.

Tummy

With ch, cast on 4 sts.
Beg with a k row, work 2 rows st st.
Row 3: Inc, k2, inc. (6 sts)
Work 41 rows st st.
Join in ja.
Work 12 rows st st.
Row 57: K2tog, k2, k2tog. (4 sts)
Work 3 rows st st.
Row 61: [K2tog] twice. (2 sts)
Row 62: P2tog and fasten off.

Tail

With ch, cast on 14 sts.
Row 1: K1, loopy st 12, k1.
Row 2: Purl.
Row 3: Knit.
Row 4: Purl.
Row 5: K1, loopy st 12, k1.
Row 6: Purl.
Rep rows 3–6, 5 times more.
Bind off.

Ear

(make 2 the same)
With ch, cast on 3 sts.
Beg with a k row, work 3 rows st st.
Bind off.

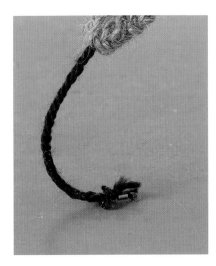

To Finish

SEWING IN ENDS Sew in ends, leaving ends from cast on rows and bound off rows for sewing up.
LEGS With WS together, fold leg in half. Starting at claw end, sew up legs on RS. Pipecleaners are used to stiffen the legs and help bend them into shape. Fold a pipecleaner into a 'U' shape and measure against front two legs. Cut to approximately fit, leaving an extra ½in (1.5cm) at both ends. These will form claws that will stick out at the end of front legs only. Roll a little stuffing around rest of pipecleaner and slip into legs. Rep with second pipecleaner and back legs, bending ¾in (2cm) of pipecleaner over at each end to stop it poking out of feet.
BODY AND HEAD With RS together, sew two sides of head and nose together with whip stitch. Sew up back and down bottom.

Tongue

The anteater's tongue is made from a length of black yarn, and his ant from two black beads.

TUMMY Attach tummy at back of back legs and sew along body to front of front legs, leaving a 1in (2.5cm) gap in side for stuffing. Cut loops on legs.
STUFFING Starting at the head, stuff firmly, then sew up the gap.
TAIL Sew cast (bound) off row of tail together and attach to end of back.
EARS Attach cast on row of ear to side of head approx 4in (10cm) from end of nose.
TONGUE Attach 1½in (4cm) of bl to end of nose for tongue. To make ant, sew 2 black beads to end of tongue.
CLAWS On front legs, wrap exposed ends of pipecleaners with bl (see page 173).
EYES With bl, sew 1-loop French knots for eyes about ¾in (2cm) in front of ears.

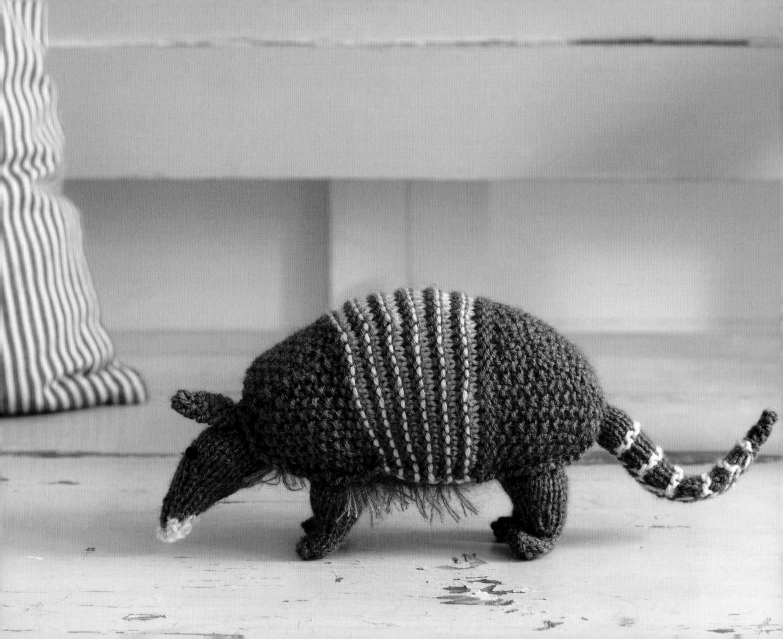

Armadillo

Absolutely extraordinary-looking—long-nosed, armor-plated, big-eared—the armadillo is one of nature's comedy animals, related to those others, the anteater and the sloth. The armadillo comes in numerous varieties from the tiny (chipmunk-sized) pink fairy, to the pig-sized giant. In Britain in 1728, King George II was presented with a pet armadillo, which he kept alive on a diet of hard-boiled eggs. Flanders and Swann, the popular 1950s comedy duo, sang a heartbreaking song called 'The Armadillo'; it tells of a misguided armadillo singing a love song to an armor-plated tank.

Armadillo

Our armadillo uses different stitch patterns on his body, legs, and tail.

Measurements
Length (including tail): 10in (25cm)
Height to top of body: 4½in (11cm)

Materials
- Pair of US 2 (2¾mm) knitting needles
- Double-pointed US 2 (2¾mm) knitting needles (for holding stitches and for tail)
- ¾oz (20g) of Rowan Pure Wool 4ply in Shale 402 (sh)
- ⅙oz (5g) of Rowan Pure Wool 4ply in Porcelaine 451 (pr)
- ¼oz (10g) of Rowan Kidsilk Haze in Smoke 605 (sm) used DOUBLE throughout
- Tiny amount of Rowan Pure Wool 4ply in Shell 468 (se) for nose
- Tiny amount of Rowan Pure Wool 4ply in Black 404 (bl) for eyes
- 3 pipecleaners for legs and tail

Abbreviations
Inc pk—purl into front, knit into back of next stitch.
Inc kp—knit into front, purl into back of next stitch.
See also page 172.
See page 172 for Wrap and Turn Method.
See page 173 for Loopy Stitch. Work 2-finger loopy stitch throughout this pattern.

Back Leg
(make 2 the same)
With sh, cast on 11 sts.
Beg with a k row, work 2 rows st st.
Row 3: K2, k2tog, k3, k2tog, k2. (9 sts)
Row 4: Purl.
Row 5: K2tog, k5, k2tog. (7 sts)
Row 6: Purl.
Row 7: K2, inc, k1, inc, k2. (9 sts)
Work 3 rows st st.
Row 11: K3, inc, k1, inc, k3. (11 sts)
Row 12: Purl.
Row 13: K4, inc, k1, inc, k4. (13 sts)
Row 14: Purl.
Row 15: K5, inc, k1, inc, k5. (15 sts)
Row 16: Purl.
Bind off.

Front Leg
(make 2 the same)
With sh, cast on 9 sts.
Beg with a k row, work 2 rows st st.
Row 3: K1, k2tog, k3, k2tog, k1. (7 sts)
Work 3 rows st st.
Row 7: K2, inc, k1, inc, k2. (9 sts)
Row 8: Purl.
Row 9: K3, inc, k1, inc, k3. (11 sts)
Row 10: Purl.
Row 11: K4, inc, k1, inc, k4. (13 sts)
Row 12: Purl.
Bind off.

Body
With sh, cast on 16 sts.
Work 2 rows seed st.
Row 3: Inc pk, seed st 14, inc pk. (18 sts)
Row 4: Seed st 5, [inc pk] twice, seed st 4, [inc pk] twice, seed st 5. (22 sts)
Work 2 rows seed st.
Row 7: Inc kp, seed st 20, inc kp. (24 sts)
Row 8: Seed st 7, [inc kp] twice, seed st 6, [inc kp] twice, seed st 7. (28 sts)
Work 2 rows seed st.
Row 11: Inc pk, seed st 26, inc pk. (30 sts)
Row 12: Seed st 9, [inc pk] twice, seed st 8, [inc pk] twice, seed st 9. (34 sts)
Work 4 rows moss (seed) st.
Row 17: Seed st 11, [inc kp] twice, seed st 8, [inc kp] twice, seed st 11. (38 sts)
Work 4 rows seed st.
Row 22: Knit.
Row 23: Purl.
Join in pr.
Row 24: Purl.
Row 25: K8, inc, k6, inc, k6, inc, k6, inc, k8. (42 sts)
Change to sh.
Row 26: Knit.

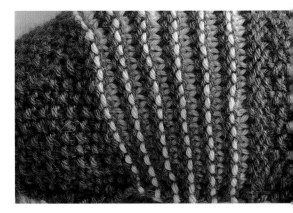

Body
The armadillo uses seed stitch to create his textured, leathery skin.

Row 27: Purl.
Change to pr.
Row 28: Purl.
Row 29: Knit.
Change to sh.
Row 30: Knit.
Row 31: Purl.
Change to pr.
Row 32: Purl.
Row 33: Knit.
Change to sh.
Row 34: Knit.
Row 35: Purl.
Change to pr.
Row 36: Purl.
Row 37: Knit.
Change to sh.
Row 38: K15, k2tog, k8, k2tog, k15. (40 sts)
Row 39: Purl.
Change to pr.
Row 40: Purl.
Row 41: Knit.
Change to sh.
Row 42: K14, k2tog, k8, k2tog, k14. (38 sts)
Row 43: Purl.
Change to pr.
Row 44: Purl.
Row 45: Knit.
Cont in sh.
Row 46: K13, k2tog, k8, k2tog, k13. (36 sts)
Row 47: Purl.
Work 2 rows seed st.
Row 50: Seed st 10, k2tog, p2tog, seed st 8, k2tog, p2tog, seed st 10. (32 sts)
Row 51: Inc kp, seed st 30, inc kp. (34 sts)
Row 52: Seed st.
Row 53: Inc pk, seed st 32, inc pk. (36 sts)
Row 54: Seed st 11, p2tog, k2tog, seed st 6, p2tog, k2tog, seed st 11. (32 sts)
Row 55: K2tog, seed st 28, p2tog. (30 sts)
Row 56: Seed st.
Row 57: Seed st 8, k2tog, p2tog, seed st 6, k2tog, p2tog, seed st 8. (26 sts)
Row 58: Seed st.

Row 59: P2tog, seed st 22, k2tog. (24 sts)
Row 60: Seed st 6, k2tog, p2tog, seed st 4, k2tog, p2tog, seed st 6. (20 sts)
Row 61: K2tog, seed st 16, p2tog. (18 sts)
Row 62: Seed st 4, p2tog, k2tog, seed st 2, p2tog, k2tog, seed st 4. (14 sts)
Row 63: P2tog, seed st 10, k2tog. (12 sts)
Bind off.

Head

With sh, cast on 18 sts.
Beg with a k row, work 2 rows st st.
Row 3: K5, inc, k6, inc, k5. (20 sts)
Row 4: Purl.
Row 5: K15, wrap and turn (leave 5 sts on left-hand needle unworked).
Row 6: Working top of head on center 10 sts only, p10, w&t.
Row 7: K10, w&t.
Row 8: P10, w&t.
Row 9: K15. (20 sts in total)
Row 10: Purl.
Row 11: K2tog, k4, k2tog, k4, k2tog, k4, k2tog. (16 sts)
Row 12: Purl.
Row 13: K4, k2tog, k4, k2tog, k4. (14 sts)
Row 14: Purl.
Row 15: K2tog, k10, k2tog. (12 sts)
Join in se.
Row 16: P1se, p10sh, p1se.
Row 17: K2se, k1sh, k2togsh, k2sh, k2togsh, k1sh, k2se. (10 sts)
Row 18: P2se, p6sh, p2se.
Row 19: K2se, k2togse, k2sh, k2togse, k2se. (8 sts)
Row 20: P3se, p2sh, p3se.
Cont in se.
Row 21: K2tog, k4, k2tog. (6 sts)
Row 22: P2tog, p2, p2tog. (4 sts)
Cast (bind) off.

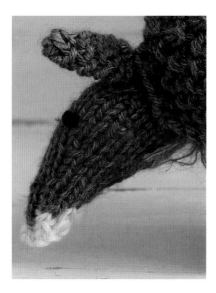

Head

The head is knitted separately and then sewn on under the front edge of the body.

Tail

Contrasting-colored reverse stockinette stitch rows accentuate the armadillo's articulated tail.

Tummy

With sm, cast on 3 sts.
Beg with a k row, work 2 rows st st.
Row 3: Inc, k1, inc. (5 sts)
Work 9 rows st st.
Row 13: Inc, k3, inc. (7 sts)
Work 9 rows st st.
Row 23: Inc, k5, inc. (9 sts)
Work 3 rows st st.
Row 27: K1, loopy st 1, k5, loopy st 1, k1.
Row 28: Purl.
Rep rows 27–28, 8 times more.
Row 45: K2tog, k5, k2tog. (7 sts)
Work 5 rows st st.
Row 51: K1, loopy st 1, k3, loopy st 1, k1.
Row 52: Purl.
Rep rows 51–52 once more.
Row 55: K2tog, k3, k2tog. (5 sts)
Work 4 rows st st.
Row 60: P2tog, p1, p2tog. (3 sts)
Bind off.

Ear

(make 2 the same)
With sh, cast on 3 sts.
Knit 2 rows.
Row 3: Inc, k1, inc. (5 sts)
Knit 6 rows.
Row 10: K2tog, k1, k2tog. (3 sts)
Knit 2 rows.
Row 13: K3tog and fasten off.

Tail

With sh, cast on 10 sts.
Beg with a k row, work 4 rows st st.
Join in pr.
Knit 2 rows.
Change to sh.
Beg with a k row, work 4 rows st st.
Change to pr.
Knit 2 rows.
Change to sh.
Beg with a k row, work 4 rows st st.
Change to pr.
Knit 2 rows.
Change to sh.
Beg with a k row, work 4 rows st st.
Change to pr.
Row 23: K2tog, k6, k2tog. (8 sts)
Row 24: Knit.
Change to sh.
Beg with a k row, work 4 rows st st.
Change to pr.
Row 29: K2tog, k4, k2tog. (6 sts)
Row 30: Knit.
Change to sh.
Beg with a k row, work 4 rows st st.
Change to pr.
Row 35: K2tog, k2, k2tog. (4 sts)
Row 36: Knit.
Cont in sh.
Beg with a k row, work 4 rows st st.
Row 41: [K2tog] twice. (2 sts)
Work 2 rows st st.
Row 44: P2tog and fasten off.

To Finish

SEWING IN ENDS Sew in ends, leaving ends from cast on rows and bound off rows for sewing up.

LEGS With WS together, fold leg in half. Starting at foot, sew up legs on RS. Leave open at top of leg.

HEAD Fold head in half and sew from nose along underside. Leave neck end open.

TUMMY Sew cast on row to armadillo's bottom and bound off row to neck end of body. Using mattress stitch, sew tummy to body, working on the inside and one stitch in from the body edge to leave a small rim and give the feel of a shell. Leave a 1in (2.5cm) gap in one side.

STUFFING Pipecleaners are used to stiffen the legs and help bend them into shape. Cut to approximately fit, leaving an extra 1in (2.5cm) at one end. Fold end over to stop the pipecleaner poking out of the paws. Roll a little stuffing around pipecleaner and slip into leg. Leave top of leg open, pipecleaner sticking out. Stuff the head, starting at the nose; leave neck end open. Stuff the body, sew up gap, and mold into shape like a giant dried bean.

ATTACHING HEAD AND LEGS Push pipecleaners of back legs into the tummy. Using whip stitch, sew the legs onto the tummy. Repeat for front legs. Sew open head end onto the body at neck, just below the front of body.

TAIL Cut a pipecleaner 1in (2.5cm) longer than tail. Roll a little stuffing around pipecleaner and slip into tail. Push protruding pipecleaner end into armadillo where back meets tummy. Sew tail to body with whip stitch.

EARS Sew cast on row of each ear to where head meets body, with one stitch between ears.

EYES With bl, sew 2 3-loop French knots for eyes, as in photograph.

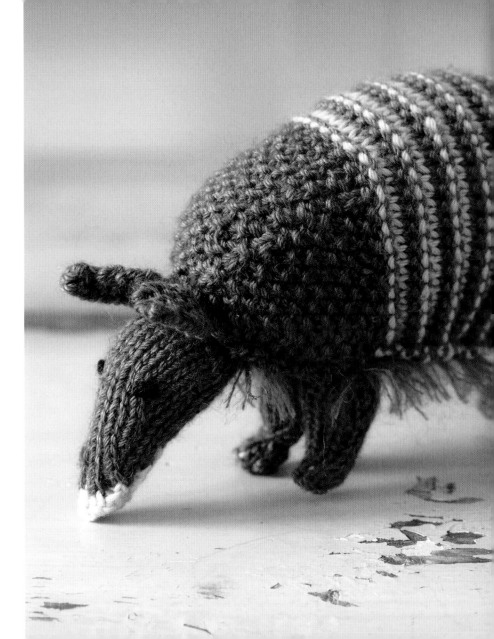

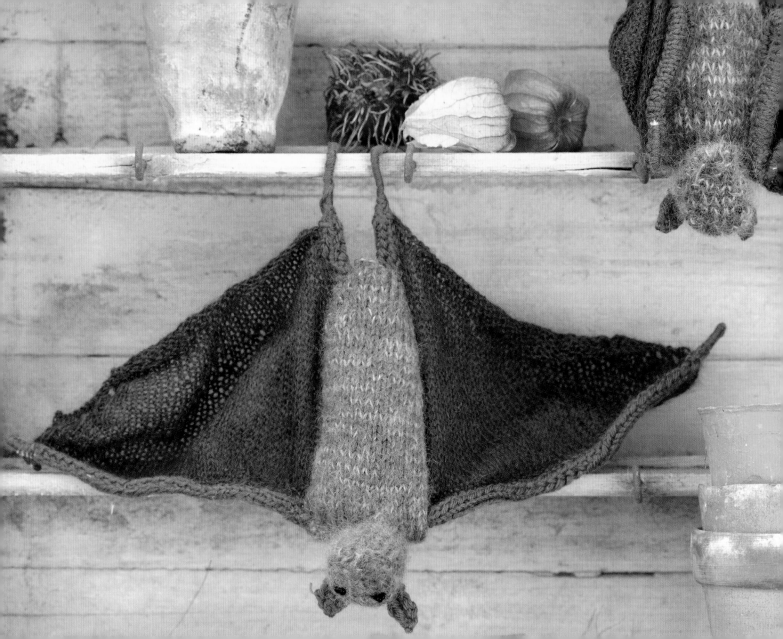

Fruit Bat

The fruit bat, or megabat, is also known as the flying fox. They are sociable animals, roosting together in the tops of trees, grooming, squabbling, and in the summer urinating and then fanning themselves with their wings to cool down. Aesop told a fable about a bat that borrowed money to start a business. The business failed and the bat had to hide during the day to avoid the people it owed money to. According to Aesop, that is why bats only come out at night.

Fruit Bat

The fruit bat is made to hang by his back legs from a shelf or something similar.

Measurements
Height: 7in (18cm)
Wingspan: 13in (33cm)

Materials
- Pair of US 2 (2¾mm) knitting needles
- ¾oz (20g) of Rowan Pure Wool 4ply in Mocha 417 (mo)
- ½oz (15g) of Rowan Kidsilk Haze in Mud 652 (mu)
NOTE: some of this animal uses 1 strand of mo and 1 strand of mu held together, and this is called momu
- ½oz (15g) of Rowan Fine Lace in Gunmetal 929 (gu)
- 3 pipecleaners for legs
- Tiny amount of Rowan Pure Wool 4ply in Black (bl) for eyes
- 2 tiny black beads for eyes and sewing needle and black thread for sewing on

Abbreviations
See page 172.
See page 172 for Wrap and Turn Method.

Back
With momu, cast on 6 sts.
Beg with a k row, work 2 rows st st.
Row 3: Inc, k4, inc. (8 sts)
Row 4: Purl.
Row 5: Inc, k6, inc. (10 sts)
Row 6: Purl.
Row 7: Inc, k8, inc. (12 sts)
Row 8: Purl.
Work 8 rows st st.
Row 17: Inc, k10, inc. (14 sts)
Row 18: Purl.
Work 8 rows st st.
Row 27: Inc, k12, inc. (16 sts)
Row 28: Purl.
Work 6 rows st st.
Row 35: Inc, k14, inc. (18 sts)
Row 36: Purl.
Work 6 rows st st.
Shape shoulders
Row 43: Bind off 7 sts, k to end. (11 sts)
Row 44: Bind off 7 sts, p to end. (4 sts)
Work 2 rows st st.
Row 47: [Inc] 4 times. (8 sts)
Row 48: Purl.
Row 49: Inc, k6, inc. (10 sts)
Row 50: Purl.
Work 6 rows st st.
Row 57: K8, wrap and turn (leave 2 sts on left-hand needle unworked).
Row 58: Working on center 6 sts only, p6, w&t.
Row 59: K6, w&t.
Row 60: P6, w&t.
Row 61: K6, w&t.
Row 62: P6, w&t.
Row 63: K8. (10 sts in total)
Row 64: Purl.
Row 65: K2tog, k6, k2tog. (8 sts)
Row 66: Purl.
Row 67: Knit.
Row 68: P2tog, p4, p2tog. (6 sts)
Row 69: Knit.
Row 70: P2tog, p2, p2tog. (4 sts)

Row 71: Knit.
Row 72: [P2tog] twice. (2 sts)
Row 73: K2tog and fasten off.

Front
With momu, cast on 6 sts.
Beg with a k row, work 2 rows st st.
Row 3: Inc, k4, inc. (8 sts)
Row 4: Purl.
Row 5: Inc, k6, inc. (10 sts)
Row 6: Purl.
Row 7: Inc, k8, inc. (12 sts)
Row 8: Purl.
Work 8 rows st st.
Row 17: Inc, k10, inc. (14 sts)
Row 18: Purl.
Work 8 rows st st.
Row 27: Inc, k12, inc. (16 sts)
Row 28: Purl.
Work 6 rows st st.
Row 35: Inc, k14, inc. (18 sts)
Row 36: Purl.
Work 6 rows st st.
Shape shoulders
Row 43: Bind off 7 sts, k to end. (11 sts)
Row 44: Bind off 7 sts, p to end. (4 sts)
Work 2 rows st st.
Row 47: [Inc] 4 times. (8 sts)
Row 48: Purl.
Row 49: Inc, k6, inc. (10 sts)
Row 50: Purl.
Work 8 rows st st.
Row 59: K2tog, k6, k2tog. (8 sts)
Row 60: Purl.
Row 61: K2tog, k4, k2tog. (6 sts)
Row 62: Purl.
Row 63: K2tog, k2, k2tog. (4 sts)
Row 64: Purl.
Row 65: [K2tog] twice. (2 sts)
Row 66: P2tog and fasten off.

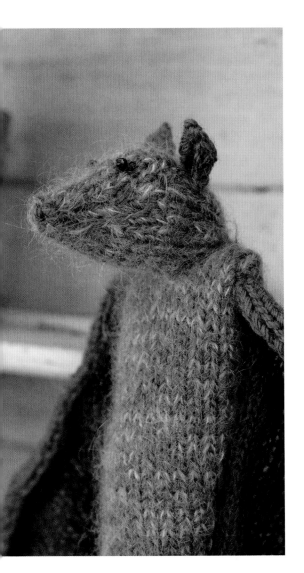

Front Legs

(make 2 the same)
With mo, cast on 5 sts.
Beg with a k row, work 48 rows st st.
Row 49: K2tog, k3. (4 sts)
Work 13 rows st st.
Bind off.

Back Legs

(make 2 the same)
With mo, cast on 5 sts.
Beg with a k row, work 10 rows st st.
Bind off.

Right Wing

With gu, cast on 40 sts.
Beg with a k row, work 3 rows st st.
Row 4: P38, wrap and turn (leave 2 sts on left-hand needle unworked).
Row 5: Knit.
Rep rows 4–5 twice more.
Row 10: P36, w&t (leave 4 sts on left-hand needle unworked).
Row 11: Knit
Rep rows 10–11 twice more.
Row 16: P34, w&t (leave 6 sts on left-hand needle unworked).
Row 17: Knit.
Rep rows 16–17 twice more.
Row 22: P32, w&t (leave 8 sts on left-hand needle unworked).
Row 23: Knit.
Rep rows 22–23 twice more.

Head

The fruit bat (shown upright here) has a fox-like face, with tiny black beads for eyes.

Wings

With the pipecleaners in the front legs, the fruit bat can be manipulated to have either folded-up or outstretched wings.

Row 28: P30, w&t (leave 10 sts on left-hand needle unworked).
Row 29: Knit.
Rep rows 28–29 twice more.
Row 34: P28, w&t (leave 12 sts on left-hand needle unworked).
Row 35: Knit.
Rep rows 34–35 twice more.
Row 40: P26, w&t (leave 14 sts on left-hand needle unworked).
Row 41: Knit.
Row 42: Purl across all sts.
Bind off.

Left Wing

With gu, cast on 40 sts.
Beg with a k row, work 2 rows st st.
Row 3: K38, wrap and turn (leave 2 sts on left-hand needle unworked).
Row 4: Purl.
Rep rows 3–4 twice more.
Row 9: K36, w&t (leave 4 sts on left-hand needle unworked).
Row 10: Purl.
Rep rows 9–10 twice more.
Row 15: K34, w&t (leave 6 sts on left-hand needle unworked).
Row 16: Purl.
Rep rows 15–16 twice more.
Row 21: K32, w&t (leave 8 sts on left-hand needle unworked).
Row 22: Purl.
Rep rows 21–22 twice more.
Row 27: K30, w&t (leave 10 sts on left-hand needle unworked).
Row 28: Purl.
Rep rows 27–28 twice more.
Row 33: K28, w&t (leave 12 sts on left-hand needle unworked).
Row 34: Purl.
Rep rows 33–34 twice more.
Row 39: K26, w&t (leave 14 sts on left-hand needle unworked).
Row 40: Purl.
Work 2 rows st st across all sts.
Bind off.

Ear

(make 2 the same)
With mo, cast on 4 sts.
Beg with a k row, work 4 rows st st.
Row 5: [K2tog] twice. (2 sts)
Row 6: P2tog and fasten off.

To Finish

SEWING IN ENDS Sew in ends, leaving ends from cast on rows and bound off rows for sewing up.

HEAD With WS together, sew top of head to bottom on RS, then stuff firmly.

BODY WS together, sew across shoulders.

LEGS Pipecleaners are used to stiffen the legs and bend them into shape. Leave 1½in (3cm) free at claw end and sew leg up around pipecleaner. For front legs, use one pipecleaner for each leg and twist other ends around each other inside body. Back legs only need one pipecleaner bent into a 'U' shape and with claw ends left free as for front legs. Sew front legs to side of body at shoulder seam, then sew down one side of body on outside, attaching back legs to bottom of side seam with ¾in (2cm) between legs. Sew along bottom of body and up second side, leaving a 1in (2.5cm) gap in side for stuffing. Wrap protruding pipecleaners (claws) in mo (see page 173).

STUFFING Stuff body firmly and sew up gap.

HEAD Sew chin approx ½in (1.5cm) from neck to chest so that head faces forward.

WINGS Press the wings with a damp cloth before sewing up as they have a tendency to curl. Sew bound off row to underside of front legs where knitting starts (leave claw free). Sew long edge of wing down side seam of body and along outside of back leg to where knitting stops and claw begins.

EARS Sew ears to top of head positioned as in photograph, with WS facing forward and 3 sts between ears.

EYES With bl, sew 2-loop French knots positioned as in photograph, with 3 sts between them. Sew a tiny black bead on top of each knot.

CLAWS Fold back claws toward back so that you can hang bat up. Fold front claws over toward front and have wings either outstretched or folded up.

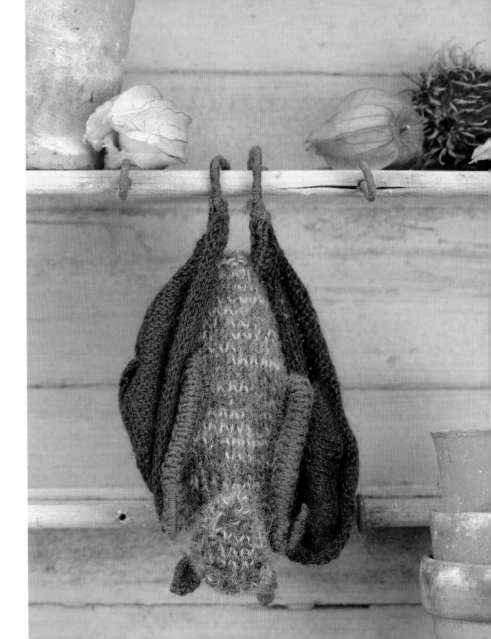

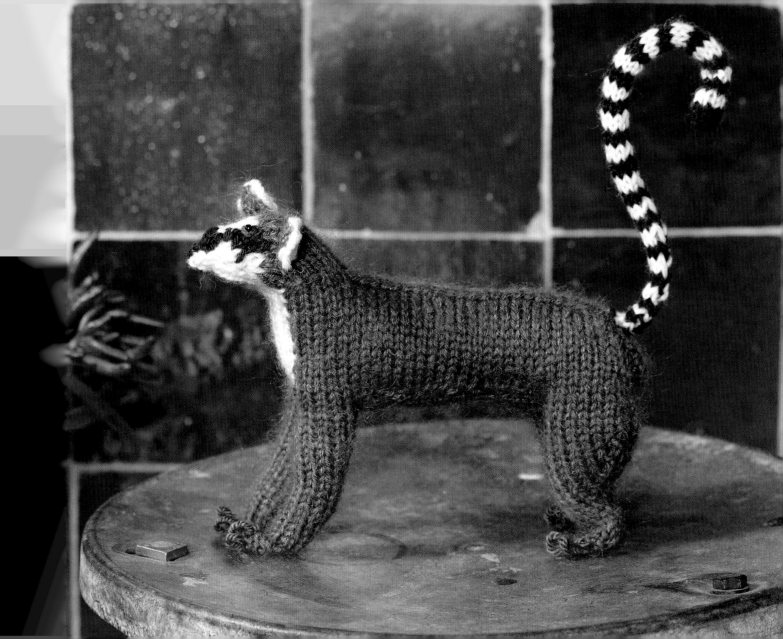

Ring-Tailed Lemur

Lemurs are found only on the island of Madagascar and the Comoros Islands. There are nearly 100 species, but ours is the ring-tailed lemur. They are highly social, living in matriarchal packs and either huddling together or sunbathing, depending on the weather. The males will indulge in 'stink fights', impregnating their tails with their scent and wafting it at opponents. Lemurs are endangered due to habitat destruction and their main predator, the cat-like fossa.

Ring-Tailed Lemur

The ring-tailed lemur can leap from tree to tree, but ours is standing.

Measurements
Length (excluding tail): 6¼in (16cm)
Height to top of head: 4¾in (12cm)

Materials
- Pair of US 2 (2¾mm) knitting needles
- Double-pointed US 2 (2¾mm) knitting needles (for holding stitches and for tail)
- 1¼oz (30g) of Rowan Wool Cotton in Misty 903 (my)
- ½oz (15g) of Rowan Kidsilk Haze in Anthracite 639 (an)

NOTE: some of this animal uses 1 strand of my and 1 strand of an held together, and this is called myan
- ⅙oz (5g) of Rowan Pure Wool 4ply in Snow 412 (sn)
- ⅙oz (5g) of Rowan Pure Wool 4ply in Black 404 (bl)
- Tiny amount of Rowan Pure Wool 4ply in Ochre 461 (oc) for eyes
- 2 pipecleaners for legs and tail
- 2 tiny black beads for eyes and sewing needle and black thread for sewing on

Abbreviations
See page 172.
See page 172 for Color Knitting.
See page 172 for I-cord Technique.
See page 172 for Wrap and Turn Method.

Right Back Leg
With my, cast on 4 sts.
Work 4 rows garter st.
Join in an (1 strand) and cont in myan.
Row 5: Inc, k2, inc. (6 sts)
Row 6: Purl.
Row 7: Inc, k4, inc. (8 sts)
Row 8: Purl.
Work 4 rows st st.
Row 13: Inc, k6, inc. (10 sts)
Row 14: Purl.
Row 15: Inc, k8, inc. (12 sts)
Row 16: Purl.
Row 17: Inc, k10, inc. (14 sts)
Row 18: Purl.
Row 19: Inc, k12, inc. (16 sts)
Row 20: Purl
Row 21: Inc, k14, inc. (18 sts)
Row 22: Purl.
Work 4 rows st st.*
Row 27: Bind off 9 sts, k to end (hold 9 sts on spare needle for Right Side of Body).

Left Back Leg
Work as for Right Back Leg to *.
Row 27: K9, bind off 9 sts (hold 9 sts on spare needle for Left Side of Body).

Paws
The lemur has embroidered loops for claws.

Right Front Leg

With my, cast on 4 sts.
Work 4 rows garter st.
Join in an (1 strand) and cont in myan.
Row 5: Inc, k2, inc. (6 sts)
Row 6: Purl.
Row 7: Inc, k4, inc. (8 sts)
Work 3 rows st st.
Row 11: Inc, k6, inc. (10 sts)
Work 13 rows st st.**
Row 25: Bind off 5 sts, k to end (hold 5 sts on spare needle for Right Side of Body).

Left Front Leg

Work as for Right Front Leg to **.
Row 25: K5, bind off 5 sts (hold 5 sts on spare needle for Left Side of Body).

Right Side of Body

With myan, cast on 1 st, with RS facing k5 from spare needle of Right Front Leg, then cast on 6 sts. (12 sts)
Row 2: Purl.
Row 3: K12, cast on 6 sts. (18 sts)
Row 4: Purl.
Row 5: K18, cast on 4 sts, then k9 from spare needle of Right Back Leg. (31 sts)
Work 6 rows st st.
Row 12: P2tog, p29. (30 sts)
Row 13: Knit.
Row 14: P2tog, p28. (29 sts)
Row 15: K27, k2tog. (28 sts)
Row 16: Bind off 21 sts, p to end (hold 7 sts on spare needle for neck).

Left Side of Body

With myan, cast on 1 st.
With WS facing, p5 from spare needle of Left Front Leg, then cast on 6 sts. (12 sts)
Row 2: Knit.

Row 3: P12, cast on 6 sts. (18 sts)
Row 4: Knit.
Row 5: P18, cast on 4 sts, then p9 from spare needle of Left Back Leg. (31 sts)
Work 6 rows st st.
Row 12: K2tog, k29. (30 sts)
Row 13: Purl.
Row 14: K2tog, k28. (29 sts)
Row 15: P27, p2tog. (28 sts)
Row 16: Bind off 21 sts, k to end (hold 7 sts on spare needle for neck).

Neck and Head

With myan and with RS facing, k7 held for neck from spare needle of Right Side of Body, then k7 held for neck from spare needle of Left Side of Body. (14 sts)
Row 2: P6, p2tog, p6. (13 sts)
Row 3: K11, wrap and turn (leave 2 sts on left-hand needle unworked).
Row 4: Working on top of head on center 9 sts only, p9, w&t.
Row 5: K9, w&t.
Row 6: P9, w&t.
Row 7: Knit across all sts. (13 sts in total)
Row 8: Purl.
Row 9: K10, wrap and turn (leave 3 sts on left-hand needle unworked).
Row 10: Working on center 7 sts only, p7, w&t.
Row 11: K7, w&t.
Row 12: P7, w&t.
Row 13: K10. (13 sts in total)
Join in bl and sn.
Row 14: P3sn, p2bl, p3sn, p2bl, p3sn.
Row 15: K2togsn, k1sn, k2bl, k3sn, k2bl, k1sn, k2togsn. (11 sts)
Row 16: P2sn, p2bl, p3sn, p2bl, p2sn.
Row 17: K2togsn, k1sn, k2bl, k1sn, k2bl, k1sn, k2togsn. (9 sts)
Row 18: P9sn.
Row 19: K1sn, k2togsn, k3bl, k2togsn, k1sn. (7 sts)

Row 20: P2sn, p3bl, p2sn.
Row 21: K2togsn, k3bl, k2togsn. (5 sts)
Row 22: P2togsn, p1bl, p2togsn. (3 sts)
Row 23: K3togsn and fasten off.

Tummy

With myan, cast on 1 st.
Row 1: Inc. (2 sts)
Row 2: Purl.
Row 3: [Inc] twice. (4 sts)
Row 4: Purl.
Row 5: Inc, k2, inc. (6 sts)
Row 6: Inc, p4, inc. (8 sts)
Row 7: Knit.
Work 55 rows st st.
Cont in sn.
Row 63: K2tog, k4, k2tog. (6 sts)

Row 64: Purl.
Work 14 rows st st.
Row 79: K2tog, k2, k2tog. (4 sts)
Row 80: Purl.
Work 9 rows st st.
Row 90: [K2tog] twice. (2 sts)
Row 91: P2tog and fasten off.

Ear Front

(make 2 the same)
With myan, cast on 4 sts.
Beg with a k row, work 3 rows st st.
Row 4: [P2tog] twice. (2 sts)
Row 5: K2tog and fasten off.

Ear Back

(make 2 the same)
With sn, cast on 5 sts.
Beg with a k row, work 4 rows st st.
Row 5: K2tog, k1, k2tog. (3 sts)
Row 6: Purl.
Row 7: K3tog and fasten off.

Tail

With two double-pointed knitting needles
and bl, cast on 6 sts.
Work in i-cord as folls:
Rows 1-2: Knit in bl.
Rows 3-4: Knit in sn.
Rep rows 1-4, 14 times more.
Row 61: K2bl, k2togbl, k2bl. (5 sts)
Row 62: Knit in bl.
Rows 63-64: Knit in sn.
Rows 65-66: Knit in bl.
Bind off in bl.

Head

Use a tiny bit of rust-colored yarn to make a French knot with a black bead on top for the characteristic eyes.

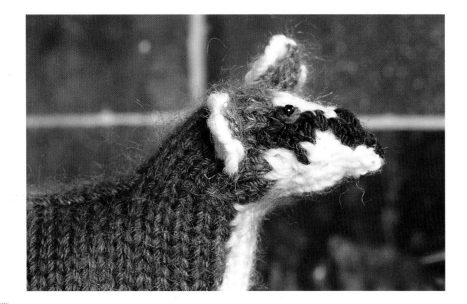

To Finish

SEWING IN ENDS Sew in ends, leaving ends from cast on rows and bound off rows for sewing up.

BODY With RS together, sew along the back using mattress or whip stitch.

TUMMY Using mattress or whip stitch, sew cast on row of tummy to base of bottom, just behind back legs, and sew bound off row to nose. Ease and sew tummy to fit body. Leave a 1in (2.5cm) gap on one side. Turn RS out.

LEGS With my, make 4 loops on end of all feet ¾in (2cm) long. Fold the leg in half; starting at the paw, sew up leg using whip or mattress stitch on outside. Cut a pipecleaner to approximately fit length of leg, leaving an extra 1in (2.5cm) at both ends. These ends are folded over to stop them poking out of the paws. Roll a little stuffing around the pipecleaner and slip into the leg. Lightly stuff the leg.

STUFFING Starting at the head, stuff the body firmly, then sew up the gap with mattress stitch. Mold into shape.

TAIL Cut pipecleaner approximately 1¼in (3cm) longer than tail, insert into tail, push other end into bottom, and sew on tail.

EARS Sew fronts of ears to back, so that the white shows behind. Attach the bound off row of ears to side of lemur head, at an angle sloping down toward back, leaving 4 sts between ears.

EYES With oc, sew 3-loop French knots, as shown in photograph. Sew a tiny black bead on top.

NOSE With bl, embroider nose using 2 satin stitches.

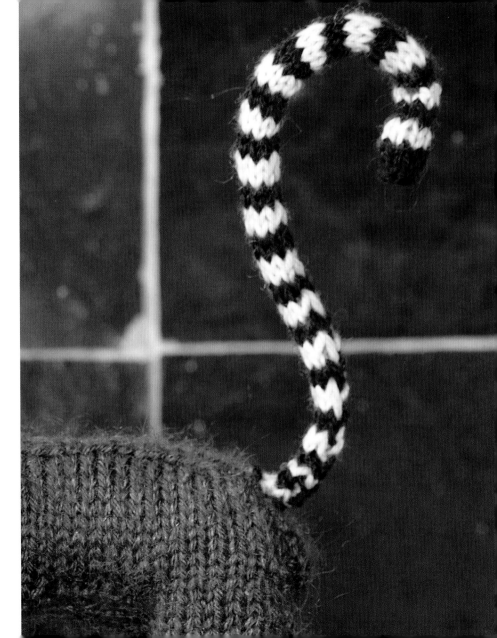

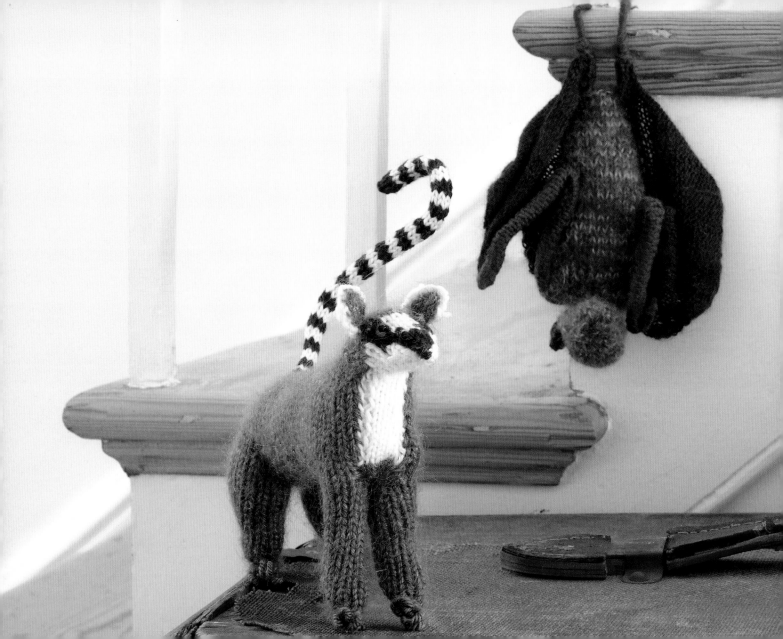

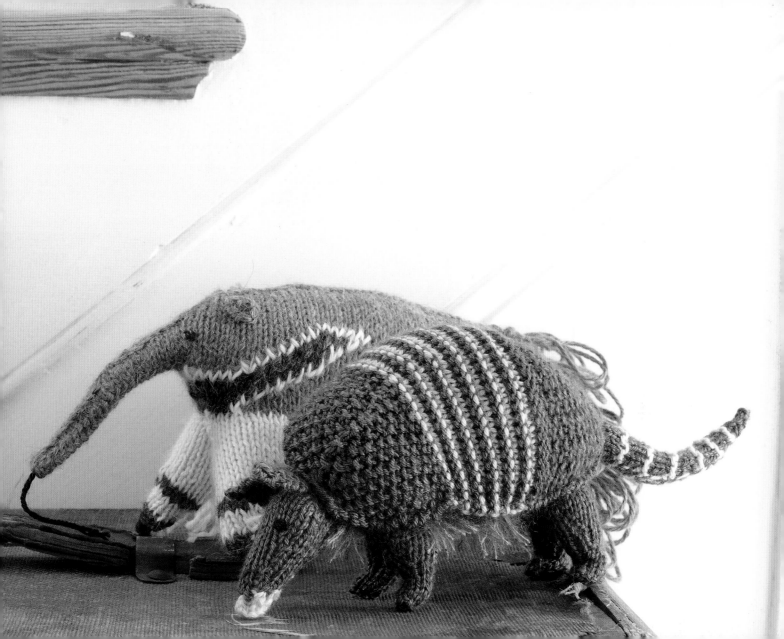

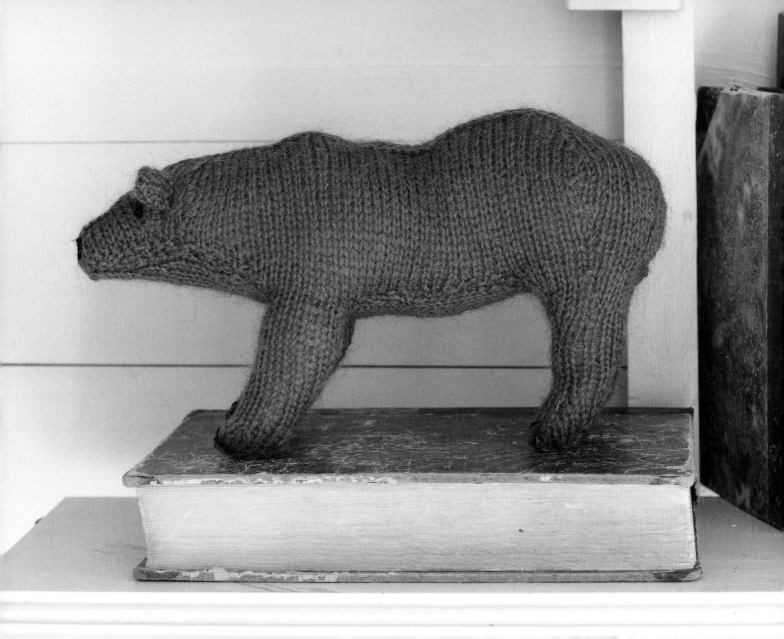

Brown Bear

The bear in the wild rules over his kingdom from his den, eating anything from berries to cattle. Bear-baiting, a brutal and voyeuristic blood sport, was finally prohibited in England in 1835, but the London Stock Exchange is still called a bear-pit. By contrast, the bear in the home is a much-loved cuddly children's toy, representing security. Many children's books are centered around bears, all of them surprisingly benevolent: Baloo in *The Jungle Book*, Rupert Bear—originally brown but changed to white to save on printing costs—Paddington Bear, and Winnie-the-Pooh.

Brown Bear

Cuddly and a little scary, this bear is one of the simpler animals to knit.

Measurements

Length: 10in (25cm)
Height to top of head: 5½in (14cm)

Materials

- Pair of US 3 (3¼mm) knitting needles
- Double-pointed US 3 (3¼mm) knitting needles (for holding stitches)
- 1¼oz (30g) of Rowan Kid Classic in Bear 817 (be)
- Tiny amount of Rowan Pure Wool 4ply in Black 404 (bl) for eyes, nose, and claws
- 2 pipecleaners for legs

Abbreviations

See page 172.
See page 172 for Short Row Patterning.
NOTE: this animal has no tail.

Right Back Leg

With be, cast on 13 sts.
Beg with a k row, work 2 rows st st.
Row 3: Inc, k3, k2tog, k1, k2tog, k3, inc. (13 sts)
Row 4: Purl.
Rep rows 3–4 twice more.
Row 9: K2tog, k9, k2tog. (11 sts)
Work 3 rows st st.
Row 13: Inc, k9, inc. (13 sts)
Work 3 rows st st.
Row 17: K5, inc, k1, inc, k5. (15 sts)
Row 18: Purl.
Row 19: K6, inc, k1, inc, k6. (17 sts)
Row 20: Purl.*
Row 21: K7, inc, k1, inc, k3, inc, k3. (20 sts)
Row 22: Purl.
Row 23: K8, inc, k1, inc, k9. (22 sts)
Row 24: Purl.
Row 25: K9, inc, k1, inc, k4, inc, k5. (25 sts)
Row 26: Purl.
Row 27: Bind off 11 sts, k to end (hold 14 sts on spare needle for Right Side of Body).

Left Back Leg

Work as for Right Back Leg to *.
Row 21: K3, inc, k3, inc, k1, inc, k7. (20 sts)
Row 22: Purl.
Row 23: K9, inc, k1, inc, k8. (22 sts)
Row 24: Purl.
Row 25: K5, inc, k4, inc, k1, inc, k9. (25 sts)
Row 26: Purl.
Row 27: K14, bind off 11 sts (hold 14 sts on spare needle for Left Side of Body).

Right Front Leg

With be, cast on 13 sts.
Beg with a k row, work 2 rows st st.
Row 3: Inc, k3, k2tog, k1, k2tog, k3, inc. (13 sts)
Row 4: Purl.
Rep rows 3–4 once more.
Row 7: K2tog, k9, k2tog. (11 sts)
Work 3 rows st st.

Row 11: Inc, k9, inc. (13 sts)
Row 12: Purl.
Row 13: Inc, k11, inc. (15 sts)
Work 5 rows st st.
Row 19: Inc, k13, inc. (17 sts)
Work 5 rows st st.**
Row 25: Bind off 8 sts, k to end (hold 9 sts on spare needle for Right Side of Body).

Left Front Leg

Work as for Right Front Leg to **.
Row 25: K9, bind off 8 sts (hold 9 sts on spare needle for Left Side of Body).

Right Side of Body and Head

Row 1: With be, cast on 1 st, with RS facing k9 from spare needle of Right Front Leg, cast on 5 sts. (15 sts)
Row 2: Purl.
Row 3: Inc, k14, cast on 5 sts. (21 sts)
Row 4: Purl.
Row 5: Inc, k20, cast on 3 sts, with RS facing k14 from spare needle of Right Back Leg, cast on 2 sts. (41 sts)
Row 6: Purl.
Row 7: Inc, k31, inc, k3, inc, k4. (44 sts)
Row 8: Purl.
Row 9: Inc, k43. (45 sts)

Shape head

Row 10: P45, cast on 12 sts. (57 sts)
Row 11: K46, inc, k5, inc, k4. (59 sts)
Row 12: P48, inc, p1, inc, p8. (61 sts)
Row 13: Knit.
Row 14: P48, inc, p1, inc, p1, inc, p8. (64 sts)
Row 15: Bind off 5 sts, k46 ibos, inc, k7, inc, k2, k2tog. (60 sts)
Row 16: P2tog, p48, inc, p2, inc, p2, inc, p1, p2tog. (61 sts)
Row 17: Bind off 2 sts, k to end. (59 sts)
Row 18: P2tog, p47, p2tog, p6, p2tog. (56 sts)
Row 19: K45, k2tog, k7, k2tog. (54 sts)
Row 20: P2tog, p43, p2tog, p5, p2tog. (51 sts)

Row 21: K5, k2tog, k35, k2tog, k5, k2tog. (48 sts)

Row 22: P2tog, p34, p2tog, p3, p2tog, p3, p2tog. (44 sts)

Row 23: Bind off 10 sts, k8 ibos (hold these 8 sts on a spare needle), bind off 7 sts, k12 ibos, k2tog, k3, k2tog. (25 sts)

Row 24: Working on 17 sts only, p2tog, p13, p2tog. (15 sts)

Row 25: K2tog, k11, k2tog. (13 sts)

Row 26: P2tog, p9, p2tog. (11 sts)

Row 27: Bind off 5 sts, k4 ibos, k2tog. (5 sts) Bind off.

Next row: Working on rem 8 sts, rejoin yarn, p2tog, p4, p2tog. (6 sts)

Next row: K2tog, k2, k2tog. (4 sts) Bind off.

Left Side of Body and Head

Row 1: With be, cast on 1 st, with WS facing p9 from spare needle of Left Front Leg, cast on 5 sts. (15 sts)

Row 2: Knit.

Row 3: Inc, p14, cast on 5 sts. (21 sts)

Row 4: Knit.

Row 5: Inc, p20, cast on 3 sts, with WS facing p14 from spare needle of Left Back Leg, cast on 2 sts. (41 sts)

Row 6: Knit.

Row 7: Inc, p31, inc, p3, inc, p4. (44 sts)

Row 8: Knit.

Row 9: Inc, p43. (45 sts)

Shape head

Row 10: K45, cast on 12 sts. (57 sts)

Row 11: P46, inc, p5, inc, p4. (59 sts)

Row 12: K48, inc, k1, inc, k8. (61 sts)

Row 13: Purl.

Row 14: K48, inc, k1, inc, k1, inc, k8. (64 sts)

Row 15: Bind off 5 sts, p46 ibos, inc, p7, inc, p2, p2tog. (60 sts)

Row 16: K2tog, k48, inc, k2, inc, k2, inc, k1, k2tog. (61 sts)

Row 17: Bind off 2 sts, p to end. (59 sts)

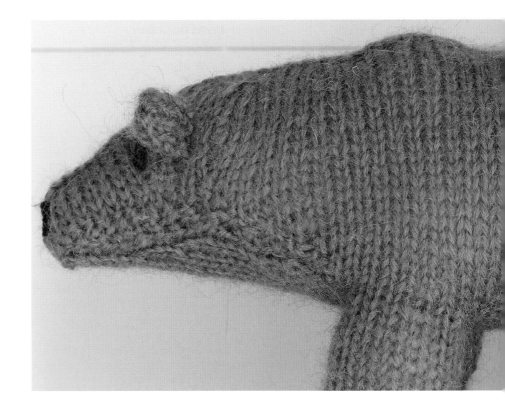

Body

Stuff the bear firmly to emphasize his large, muscular body.

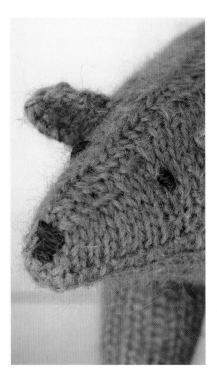

Head

Graft the head together neatly, matching stitches from left and right sides of body and head.

Row 18: K2tog, k47, k2tog, k6, k2tog. (56 sts)
Row 19: P45, p2tog, p7, p2tog. (54 sts)
Row 20: K2tog, k43, k2tog, k5, k2tog. (51 sts)
Row 21: P5, p2tog, p35, p2tog, p5, p2tog. (48 sts)
Row 22: K2tog, k34, k2tog, k3, k2tog, k3, k2tog. (44 sts)
Row 23: Bind off 10 sts, p8 ibos (hold these 8 sts on a spare needle), bind off 7 sts, p12 ibos, p2tog, p3, p2tog. (25 sts)
Row 24: Working on 17 sts only, k2tog, k13, k2tog. (15 sts)
Row 25: P2tog, p11, p2tog. (13 sts)
Row 26: K2tog, k9, k2tog. (11 sts)
Row 27: Bind off 5 sts, p4 ibos, p2tog. (5 sts) Bind off.
Next row: Working on rem 8 sts, rejoin yarn, k2tog, k4, k2tog. (6 sts)
Next row: P2tog, p2, p2tog. (4 sts) Bind off.

Tummy

With be, cast on 10 sts.
Beg with a k row, work 2 rows st st.
Row 3: K2tog, k6, k2tog. (8 sts)
Row 4: P2tog, p4, p2tog. (6 sts)
Work 12 rows st st.
Row 17: Inc, k4, inc. (8 sts)
Row 18: Inc, p6, inc. (10 sts)
Work 20 rows st st.
Row 39: K2tog, k6, k2tog. (8 sts)
Row 40: P2tog, p4, p2tog. (6 sts)
Work 5 rows st st.
Row 46: Inc, p4, inc. (8 sts)
Row 47: Inc, k6, inc. (10 sts)

Work 9 rows st st.
Row 57: K1, k2tog, k4, k2tog, k1. (8 sts)
Work 7 rows st st.
Row 65: K1, k2tog, k2, k2tog, k1. (6 sts)
Work 3 rows st st.
Row 69: K1, [k2tog] twice, k1. (4 sts)
Work 6 rows st st.
Bind off.

Ear

(make 2 the same)
With be, cast on 5 sts.
Beg with a k row, work 4 rows st st.
Row 5: K2tog, k1, k2tog. (3 sts)
Row 6: P3tog and fasten off.

To Finish

SEWING IN ENDS Sew in ends, leaving ends from cast on rows and bound off rows for sewing up.

LEGS With WS together, fold leg in half. Starting at paw, sew up legs on RS.

HEAD AND BODY With RS together, sew two sides of head and nose together with whip stitch. Sew along back of bear and around bottom.

TUMMY Sew cast on row of tummy to bottom of bear's bottom (where legs begin), and sew bound off row to chin. Ease and sew tummy to fit body, matching curves of tummy to legs. Leave a 1in (2.5cm) gap between front and back legs on one side.

STUFFING Pipecleaners are used to stiffen the legs and help bend them into shape. Fold a pipecleaner into a 'U' shape and measure against front two legs. Cut to approximately fit, leaving an extra 1in (2.5cm) at both ends. Fold these ends over to stop the pipecleaner poking out of the paws. Roll a little stuffing around pipecleaner and slip into body, one end down each front leg. Rep with second pipecleaner and back legs. Starting at the head, stuff the bear firmly, then sew up the gap. Mold body into shape.

EARS Sew cast on row of each ear to body, rev st st side facing forward, with 10 rows between ears.

EYES With bl, sew 2-loop French knots positioned as in photograph.

NOSE With bl, embroider nose in satin stitch.

PAWS With bl, make 3 satin stitches at the tip of each paw.

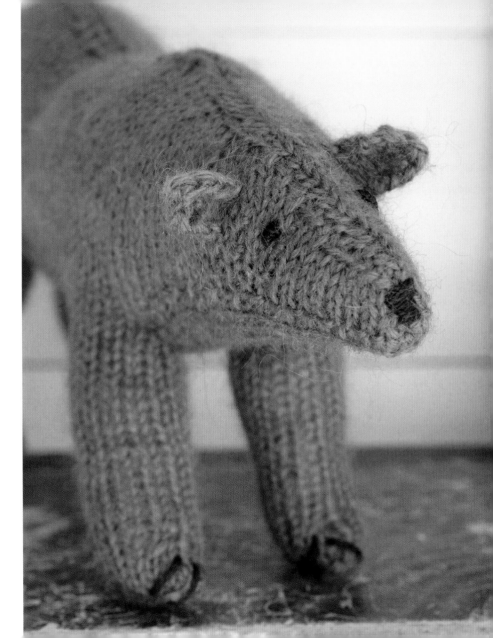

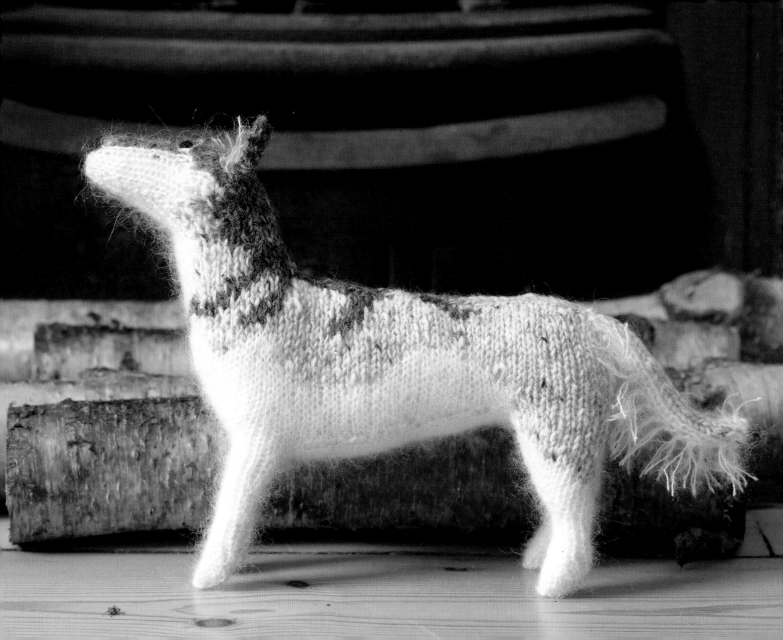

Wolf

The sole ancestor of the dog and therefore close to our hearts, the wolf is an adept hunter who is fiercely protective of his family. Famous fictional wolves include White Fang (a wolf/dog cross) from Jack London's novel, the big, bad wolf from *Little Red Riding Hood* and *Three Little Pigs*, Dracula's wolves, and our children's favorite book, *The Wolves of Willoughby Chase* by Joan Aiken, in which wolves wreak havoc in England. They are not always portrayed as fiends: in Roman mythology, Romulus and Remus, the founders of Rome, were reared by a wolf, and in Japanese mythology the wolf has an almost god-like quality.

Wolf

Similar to a dog, this wolf will be an easy knit for people who know our previous books.

Measurements
Length: 9in (23cm)
Height to top of head: 7in (18cm)

Materials
- Pair of US 2 (2¾mm) knitting needles
- Double-pointed US 2 (2¾mm) knitting needles (for holding stitches)
- ½oz (15g) of Rowan Kidsilk Haze in Cream 634 (cr) used DOUBLE throughout
- ½oz (15g) of Rowan Fine Tweed in Buckdean 364 (bu)
- ¼oz (10g) of Rowan Fine Tweed in Malham 366 (ma)
- Tiny amount of Rowan Pure Wool 4ply in Black 404 (bl) for nose
- Tiny amount of Rowan Pure Wool 4ply in Mocha 417 (mo) for eyes
- 2 pipecleaners for legs
- Crochet hook for ear tufts

Abbreviations
See page 172.
See page 172 for Color Knitting.
See page 172 for Wrap and Turn Method.
See page 173 for Loopy Stitch. Work 1-finger loopy stitch throughout this pattern.

Right Back Leg
With cr, cast on 11 sts.
Beg with a k row, work 2 rows st st.
Row 3: Inc, k2, k2tog, k1, k2tog, k2, inc. (11 sts)
Row 4: Purl.
Row 5: K3, k2tog, k1, k2tog, k3. (9 sts)
Row 6: Purl.
Row 7: K2, k2tog, k1, k2tog, k2.* (7 sts)
Work 7 rows st st.
Row 15: Inc, k1, inc, k1, inc, k1, inc. (11 sts)
Row 16: Purl.
Row 17: K2tog, k2, inc, k1, inc, k2, k2tog. (11 sts)
Row 18: Purl.
Row 19: K4, inc, k1, inc, k4. (13 sts)
Row 20: Purl.
Join in bu.**
Row 21: K5cr, inccr, k1cr, inccr, k3cr, k2bu. (15 sts)
Row 22: P3bu, p12cr.
Row 23: K6cr, inccr, k1cr, inccr, k2cr, k4bu. (17 sts)
Row 24: P6bu, p11cr.
Row 25: K7cr, inccr, k1cr, inccr, k7bu. (19 sts)
Row 26: P8bu, p11cr.
Row 27: K8cr, inccr, k1cr, inccr, k8bu. (21 sts)
Row 28: P9bu, p12cr.
Row 29: K12cr, k9bu.
Row 30: P9bu, p12cr.
Row 31: Bind off 10 sts cr, k2cr ibos, k9bu (hold 11 sts on spare needle for Right Side of Body).

Left Back Leg
Work as for Right Back Leg to **.
Row 21: K2bu, k3cr, inccr, k1cr, inccr, k5cr. (15 sts)
Row 22: P12cr, p3bu.
Row 23: K4bu, k2cr, inccr, k1cr, inccr, k6cr. (17 sts)
Row 24: P11cr, p6bu.

Legs
Stuff the legs firmly so that the wolf stands up straight.

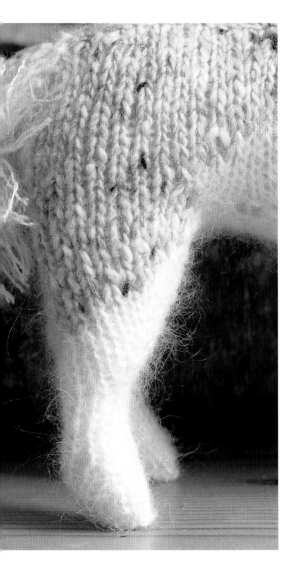

Row 25: K7bu, inccr, k1cr, inccr, k7cr. (19 sts)
Row 26: P11cr, p8bu.
Row 27: K8bu, inccr, k1cr, inccr, k8cr. (21 sts)
Row 28: P12cr, p9bu.
Row 29: K9bu, k12cr.
Row 30: P12cr, p9bu.
Row 31: K9bu, k2cr, bind off 10 sts cr (hold 11 sts on spare needle for Left Side of Body).

Right Front Leg

Work as for Right Back Leg to *.
Work 9 rows st st.
Row 17: Inc, k5, inc. (9 sts)
Work 5 rows st st.
Row 23: Inc, k7, inc. (11 sts)
Row 24: Purl.***
Row 25: Bind off 5 sts, k to end (hold 6 sts on spare needle for Right Side of Body).

Left Front Leg

Work as for Right Front Leg to ***.
Row 25: K6, bind off 5 sts (hold 6 sts on spare needle for Left Side of Body).

Right Side of Body

Row 1: With cr, cast on 1 st, with RS facing k6 from spare needle of Right Front Leg, cast on 9 sts. (16 sts)
Row 2: Purl.
Row 3: Inc, k15, cast on 5 sts. (22 sts)
Row 4: Purl.
Row 5: Inc, k21, cast on 4 sts. (27 sts)
Row 6: Purl.
Join in bu.
Row 7: Inccr, k26cr, cast on 2 sts cr, with RS facing k2cr, k9bu from spare needle of Right Back Leg, cast on 2 sts bu. (43 sts)
Row 8: P10bu, p19cr, p3bu, p11cr.
Row 9: Inccr, k9cr, k6bu, k17cr, k10bu. (44 sts)
Row 10: P11bu, p14cr, p9bu, p10cr.
Row 11: K9cr, k11bu, k12cr, k12bu.

Row 12: P13bu, p11cr, p11bu, p9cr.
Row 13: K3bu, k6cr, k12bu, k10cr, k13bu.
Row 14: P14bu, p8cr, p13bu, p5cr, p4bu.
Row 15: K5bu, k3cr, k16bu, k4cr, k16bu.
Join in ma.
Row 16: P17bu, p2cr, p9bu, p2ma, p14bu.
Row 17: K4bu, k3ma, k7bu, k3ma, k27bu.
Row 18: P26bu, p3ma, p7bu, p3ma, p3bu, p2ma.
Row 19: K3ma, k3bu, k3ma, k6bu, k3ma, k26bu.
Row 20: P25bu, p3ma, p7bu, p2ma, p3bu, p2ma, p2bu.
Row 21: K3bu, k2ma, k3bu, k1ma, k7bu, k3ma, k8bu, k2ma, k13bu, k2togbu. (43 sts)
Row 22: P2togbu, p11bu, p4ma, p6bu, p5ma, p5bu, p2ma, p2bu, p2ma, p4bu. (42 sts)
Row 23: K5bu, k16ma, k3bu, k4ma, k12bu, k2togbu. (41 sts)
Row 24: Bind off 12 sts bu, 4 sts ma, 3 sts bu, 11 sts ma, p6ma ibos, p5bu (hold 11 sts on spare needle for neck).

Left Side of Body

Row 1: With cr, cast on 1 st, with WS facing p6 from spare needle of Left Front Leg, cast on 9 sts. (16 sts)
Row 2: Knit.
Row 3: Inc, p15, cast on 5 sts. (22 sts)
Row 4: Knit.
Row 5: Inc, p21, cast on 4 sts. (27 sts)
Row 6: Knit.
Join in bu.
Row 7: Inccr, p26cr, cast on 2 sts cr, with WS facing p2cr, p9bu from spare needle of Left Back Leg, cast on 2 sts bu. (43 sts)
Row 8: K10bu, k19cr, k3bu, k11cr.
Row 9: Inccr, p9cr, p6bu, p17cr, p10bu. (44 sts)
Row 10: K11bu, k14cr, k9bu, k10cr.
Row 11: P9cr, p11bu, p12cr, p12bu.
Row 12: K13bu, k11cr, k11bu, k9cr.
Row 13: P3bu, p6cr, p12bu, p10cr, p13bu.

Row 14: K14bu, k8cr, k13bu, k5cr, k4bu.
Row 15: P5bu, p3cr, p16bu, p4cr, p16bu. Join in ma.
Row 16: K17bu, k2cr, k9bu, k2ma, k14bu.
Row 17: P4bu, p3ma, p7bu, p3ma, p27bu.
Row 18: K26bu, k3ma, k7bu, k3ma, k3bu, k2ma.
Row 19: P3ma, p3bu, p3ma, p6bu, p3ma, p26bu.
Row 20: K25bu, k3ma, k7bu, k2ma, k3bu, k2ma, k2bu.
Row 21: P3bu, p2ma, p3bu, p1ma, p7bu, p3ma, p8bu, p2ma, p13bu, p2togbu. (43 sts)
Row 22: K2togbu, k11bu, k4ma, k6bu, k5ma, k5bu, k2ma, k2bu, k2ma, k4bu. (42 sts)
Row 23: P5bu, p16ma, p3bu, p4ma, p12bu, p2togbu. (41 sts)
Row 24: Bind off 12 sts bu, 4 sts ma, 3 sts bu, 11 sts ma, k6ma ibos, k5bu (hold 11 sts on spare needle for neck).

Neck and Head

Row 1: With bu and ma and with RS facing, k5bu, k6ma from spare needle of Right Side of Body, then k6ma, k5bu from spare needle of Left Side of Body. (22 sts)
Row 2: P5bu, p12ma, p5bu.
Row 3: K3bu, k2ma, k2togma, k8ma, k2togma, k2ma, k3bu. (20 sts)
Row 4: P2bu, p16ma, p2bu.
Row 5: K2bu, k3ma, k2togma, k6ma, k2togma, k3ma, k2bu. (18 sts)
Row 6: P2bu, p14ma, p2bu.
Row 7: K2bu, k13ma, wrap and turn (leave 3 sts on left-hand needle unworked).
Row 8: Working top of head on center 12 sts only, p12ma, w&t.
Row 9: K12ma, w&t.
Row 10: P12ma, w&t.
Rep rows 9–10 once more.
Row 13: K13ma, k2bu. (18 sts in total)
Row 14: P3bu, p12ma, p3bu.
Row 15: K2cr, k2bu, k10ma, k2bu, k2cr.

Row 16: P3cr, p1bu, p10ma, p1bu, p3cr.
Row 17: K3cr, k1bu, k10ma, k1bu, w&t (leave 3 sts on left-hand needle unworked).
Row 18: Working top of head on center 12 sts only, p1cr, p10ma, p1cr, w&t.
Row 19: K1cr, k10ma, k1cr, w&t.
Rep rows 18–19 once more.
Row 22: P2cr, p8ma, p2cr, w&t.
Row 23: K2cr, k8ma, k5cr. (18 sts in total)
Row 24: P2cr, [p2togcr] twice, p6ma, [p2togcr] twice, p2cr. (14 sts)
Row 25: K3cr, k2togcr, k4ma, k2togcr, k3cr. (12 sts)
Row 26: P4cr, p4ma, p4cr.
Row 27: K4cr, k4ma, k4cr.
Row 28: P4cr, p4ma, p4cr.
Row 29: K3cr, k2togcr, k2ma, k2togcr, k3cr. (10 sts)
Row 30: P4cr, p2ma, p4cr.
Row 31: K4cr, k2ma, k4cr.
Rep rows 30–31, 3 times more.
Row 38: P4cr, p2ma, p4cr.
Bind off 4 sts cr, 2 sts ma, 4 sts cr.

Tummy

With cr, cast on 8 sts.
Beg with a k row, work 2 rows st st.
Row 3: K2tog, k4, k2tog. (6 sts)
Row 4: P2tog, p2, p2tog. (4 sts)
Work 10 rows st st.
Row 15: Inc, k2, inc. (6 sts)
Work 7 rows st st.
Row 23: Inc, k4, inc. (8 sts)
Work 25 rows st st.
Row 49: K2tog, k4, k2tog. (6 sts)
Row 50: P2tog, p2, p2tog. (4 sts)
Work 4 rows st st.
Row 55: Inc, k2, inc. (6 sts)
Work 5 rows st st.
Row 61: Inc, k4, inc. (8 sts)
Work 9 rows st st.
Join in ma.
Row 71: K3cr, k2ma, k3cr.
Row 72: P2cr, p4ma, p2cr.

Row 73: K2ma, k4cr, k2ma.
Row 74: P2ma, p4cr, p2ma.
Cont in cr.
Work 8 rows st st.
Row 83: K2tog, k4, k2tog. (6 sts)
Work 13 rows st st.
Row 97: K2tog, k2, k2tog. (4 sts)
Work 11 rows st st.
Bind off.

Tail

With cr and bu, cast on 3 sts cr, 2 sts bu, 3 sts cr. (8 sts)
Row 1: K3cr, k2bu, k3cr.
Row 2: P3cr, p2bu, p3cr.
Rep rows 1–2 twice more.
Row 7: K1cr, loopy st 1cr, k1cr, k2bu, k1cr, loopy st 1cr, k1cr.
Row 8: P3cr, p2bu, p3cr.
Rep rows 7–8, 8 times more.
Cont in cr.
Row 25: K2tog, loopy st 1, k2, loopy st 1, k2tog. (6 sts)
Row 26: Purl.
Row 27: K1, loopy st 1, k2, loopy st 1, k1.
Cont in ma.
Row 28: Purl.
Row 29: K2tog, k2, k2tog. (4 sts)
Row 30: [P2tog] twice. (2 sts)
Row 31: K2tog and fasten off.

Ear

(make 2 the same)
With ma, cast on 6 sts.
Knit 5 rows.
Row 6: K2tog, k2, k2tog. (4 sts)
Knit 2 rows.
Row 9: [K2tog] twice. (2 sts)
Row 10: K2tog and fasten off.

To Finish

SEWING IN ENDS Sew in ends, leaving ends from cast on rows and bound off rows for sewing up.

LEGS With WS together, fold leg in half. Starting at foot, sew up legs on RS.

BODY Sew along back of wolf and around bottom.

HEAD Fold bound off row of head in half and sew from nose to chin.

TUMMY Sew cast on row of tummy to bottom of wolf's bottom (where legs begin), and sew bound off row to chin. Ease and sew tummy to fit body, matching curves of tummy to legs. Leave a 1in (2.5cm) gap between front and back legs on one side.

STUFFING Pipecleaners are used to stiffen the legs and help bend them into shape. Fold a pipecleaner into a 'U' shape and measure against front two legs. Cut to approximately fit, leaving an extra 1in (2.5cm) at both ends. Fold these ends over to stop the pipecleaner poking out of the paws. Roll a little stuffing around pipecleaner and slip into body, one end down each front leg. Repeat with second pipecleaner and back legs. Starting at the head, stuff the wolf firmly, then sew up the gap. Mold body into shape.

TAIL Attach cast on row of tail to start of bottom, with loops on underside. Cut loops and trim.

EARS Sew cast on row of each ear to head, with 4 stitches between ears. Using 2 strands of cr yarn, crochet hook, and scarf fringe method (see page 173), make two tufts on the inside of each ear.

EYES With mo, sew 3-loop French knots positioned as in photograph. With cr, make a small stitch under each eye.

NOSE With bl, embroider nose in satin stitch.

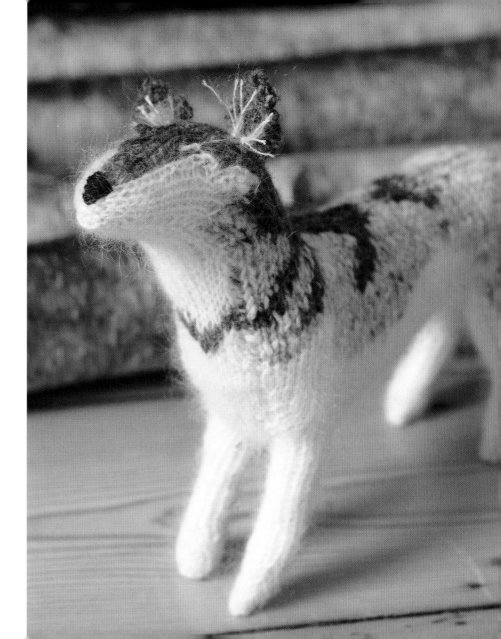

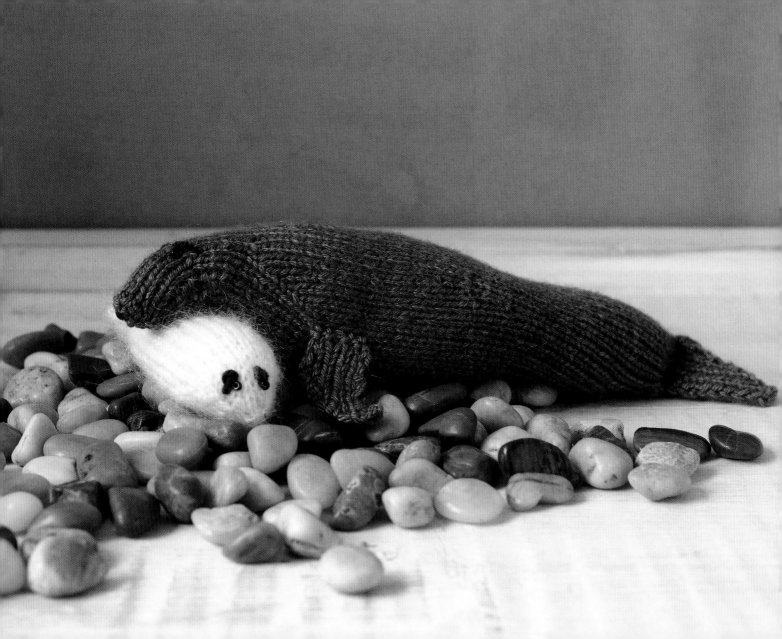

Gray Seal and Pup

The Latin name for the gray seal translates as 'hooked-nosed sea pig', which is a rather rude description of this slightly comic and endearingly ungainly mammal. Gray seals have a strong bond with their pups; the mother is so devoted to feeding that she can lose up to 140 pounds while suckling her young. One of the numerous collective nouns for seals is a plump.

Gray Seal and Pup

Seals are one of the simplest patterns to knit: one color and no complicated stitches.

Measurements

Adult
Length: 9in (23cm)
Height to top of head: 3in (7cm)

Pup
Length: 3½in (9cm)
Height to top of head: 1¼in (3cm)

Materials

- Pair of US 2 (2¾mm) knitting needles
- Double-pointed US 2 (2¾mm) knitting needles (for holding stitches)
- ½oz (15g) of Rowan Wool Cotton in Misty 903 (my)
- ⅙oz (5g) of Rowan Kidsilk Haze in Cream 634 (cr) used DOUBLE throughout
- 1 pipecleaner to help shape body
- Tiny amount of Rowan Pure Wool 4ply in Black 404 (bl) for eyes and nose
- Nylon thread or fishing line for whiskers
- Dried lentils for stuffing
- 2 tiny black beads for each seal's eyes and sewing needle and black thread for sewing on

Abbreviations

See page 172.
See page 172 for Wrap and Turn Method.

Adult Seal

Body and Head
First tail flipper
With my, cast on 2 sts.
Row 1: [Inc] twice. (4 sts)
Row 2: K1, p1, k1, p1.
Row 3: Inc, p1, k1, p1. (5 sts)
Row 4: K1, p1, k1, p1, k1.
Row 5: Inc, k1, p1, k1, p1. (6 sts)
Row 6: K1, p1, k1, p1, k1, p1.
Row 7: Inc, p1, k1, p1, k1, p1. (7 sts)
Row 8: [K1, p1] to last st, k1.
Row 9: Inc, [k1, p1] to end. (8 sts)
Row 10: [K1, p1] to end.
Row 11: Inc, [p1, k1] to last st, p1. (9 sts)
Hold these 9 sts on spare needle.

Second tail flipper
Rep rows 1–11 for second flipper.
Row 12 [K1, p1] across second flipper to last st, k1, then turning sts around to begin with inc edge on inside, [p1, k1] across sts held for first flipper to last st, p1. (18 sts)

Body and head
Row 13: [K1, p1] to end.
Rep row 13, 3 times more.
Row 17: Inc, k16, inc. (20 sts)
Work 3 rows st st.
Row 21: Inc, k18, inc. (22 sts)
Work 3 rows st st.
Row 25: Inc, k20, inc. (24 sts)
Work 3 rows st st.
Row 29: Inc, k22, inc. (26 sts)
Work 3 rows st st.
Row 33: Inc, k24, inc. (28 sts)
Work 3 rows st st.
Row 37: Inc, k26, inc. (30 sts)
Work 3 rows st st.
Row 41: Inc, k28, inc. (32 sts)
Work 3 rows st st.

Body

As well as stuffing, the gray seal has lentils in her body to give her characteristic weight.

Row 45: Inc, k30, inc. (34 sts)
Row 46: Purl.
Row 47: K9, inc, k14, inc, k9. (36 sts)
Work 3 rows st st.
Row 51: Inc, k34, inc. (38 sts)
Row 52: Purl.
Row 53: K11, inc, k14, inc, k11. (40 sts)
Row 54: Purl.
Row 55: Inc, k38, inc. (42 sts)
Row 56: Purl.
Row 57: K13, inc, k14, inc, k13. (44 sts)
Row 58: Purl.
Row 59: Inc, k42, inc. (46 sts)
Work 11 rows st st.
Row 71: K2tog, k7, k2tog, k7, k2tog, k6,
k2tog, k7, k2tog, k7, k2tog. (40 sts)
Row 72: Purl.
Row 73: K2tog, k6, k2tog, k6, k2tog, k4,
k2tog, k6, k2tog, k6, k2tog. (34 sts)
Row 74: Purl.
Row 75: K2tog, k5, k2tog, k5, k2tog, k2,
k2tog, k5, k2tog, k5, k2tog. (28 sts)
Row 76: Purl.
Row 77: K2tog, k4, k2tog, k4, k2tog, k2tog,
k4, k2tog, k4, k2tog. (22 sts)
Row 78: Purl.
Row 79: K2tog, k3, k2tog, k2, k2tog, k2tog,
k2, k2tog, k3, k2tog. (16 sts)
Row 80: Purl.
Row 81: K13, wrap and turn (leave 3 sts on
left-hand needle unworked).
Row 82: Working top of head on center
10 sts only, p10, w&t.
Row 83: K10, w&t.
Row 84: P10, w&t.
Row 85: K10, w&t.
Row 86: P10, w&t.
Row 87: K13. (16 sts in total)
Row 88: P2tog, p2, p2tog, p4, p2tog, p2,
p2tog. (12 sts)
Row 89: K10, wrap and turn (leave 2 sts on
left-hand needle unworked).
Row 90: Working on center 8 sts only, p8, w&t.
Row 91: K8, w&t.

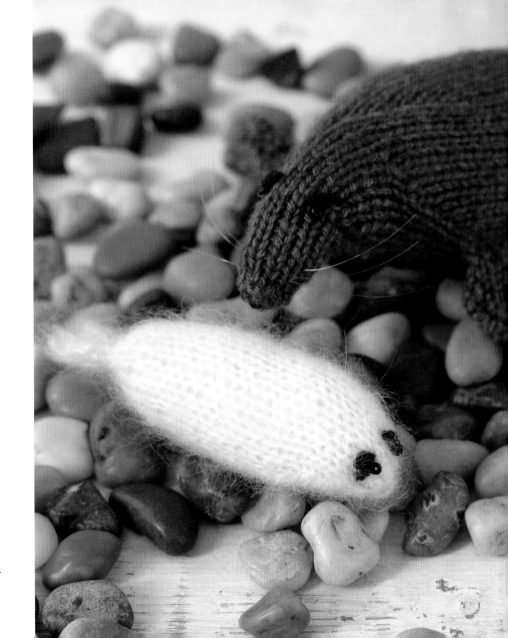

Flippers

You can play around with the flipper placement, but bear in mind that seals drag themselves around with their flippers, so don't put them too high up.

Row 92: P8, w&t.
Row 93: K10. (12 sts in total)
Row 94: Purl.
Row 95: K2tog, k8, k2tog. (10 sts)
Work 3 rows st st.
Row 99: K3, work into back, front, and back again of next st, k2, work into back, front, and back again of next st, k3. (14 sts)
Bind off.

Flippers

(make 2 the same)
With my, cast on 9 sts.
Row 1: [K1, p1] to last st, k1.
Row 2: [P1, k1] to last st, p1.
Rep rows 1–2 twice more.
Row 7: K2tog, [k1, p1] to to last st, k1. (8 sts)
Row 8: [P1, k1] 3 times, p2tog. (7 sts)
Row 9: K2tog, [k1, p1] twice, k1. (6 sts)
Row 10: [P1, k1] twice, p2tog. (5 sts)
Row 11: K2tog, k1, p1, k1. (4 sts)
Row 12: P1, k1, p2tog. (3 sts)
Row 13: K2tog, k1. (2 sts)
Row 14: K2tog and fasten off.

Seal Pup

Body and Head
First tail flipper
With cr, cast on 2 sts.
Row 1: [Inc] twice. (4 sts)
Row 2: K1, p1, k1, p1.
Row 3: Inc, p1, k1, p1. (5 sts)
Row 4: Inc, p1, k1, p1, k1. (6 sts)
Row 5: P1, k1, p1, k1, p1, k1.
Row 6: P1, k1, p1, k1, p1, k1.
Hold these 6 sts on spare needle.
Second tail flipper
Rep rows 1–6 for second flipper.
Row 7: K6 across second flipper, then k6 across sts held for first flipper. (12 sts)
Body and head
Row 8: Inc, p10, inc. (14 sts)

Row 9: K3, inc, k6, inc, k3. (16 sts)
Row 10: Purl.
Row 11: K3, inc, k8, inc, k3. (18 sts)
Row 12: Purl.
Row 13: K3, inc, k10, inc, k3. (20 sts)
Row 14: Purl.
Work 2 rows st st.
Row 17: K3, inc, k12, inc, k3. (22 sts)
Row 18: Purl.
Work 4 rows st st.
Row 23: K3, inc, k14, inc, k3. (24 sts)
Row 24: Purl
Row 25: K2tog, k3, k2tog, k10, k2tog, k3, k2tog. (20 sts)
Row 26: Purl.
Row 27: K15, wrap and turn (leave 5 sts on left-hand needle unworked)
Row 28: Working top of head on center 10 sts only, p10, w&t.
Row 29: K10, w&t.
Row 30: P10, w&t.
Row 31: K10, w&t.
Row 32: P10, w&t.
Row 33: K15. (20 sts in total)
Row 34: P2tog, p3, p2tog, p6, p2tog, p3, p2tog. (16 sts)
Row 35: K2tog, k3, k2tog, k2, k2tog, k3, k2tog. (12 sts)
Row 36: Purl.
Row 37: K2tog, k2, k2tog, k2tog, k2, k2tog. (8 sts)
Bind off.

To Finish

Adult Seal

SEWING IN ENDS Sew in ends, leaving ends from cast on rows and bound off rows for sewing up.

HEAD Fold nose in half and sew together.

BODY Sew across tail, just above tail fins, to prevent lentils leaking out. Sew up seam with mattress st, leaving a 1in (2.5cm) hole in side; stuff firmly with a mixture of stuffing and lentils, to add weight. Insert a pipecleaner along back to help shape the seal.

FLIPPERS Sew flippers onto sides of body, 11 sts from center seam and about 3in (7.5cm) from nose.

EYES With bl, sew 3-loop French knots for eyes approx 10 rows up from end of nose, with 2.5 sts between them. Sew a black bead onto bottom of each knot.

NOSE Work 2 ⅛in (2mm) vertical sts for the nostrils.

WHISKERS Thread 3 3in (8cm) lengths of nylon cord through nose to make whiskers.

Seal Pup

SEWING IN ENDS Sew in ends, leaving ends from cast on row and bound off row for sewing up.

BODY Sew across tail just above tail flippers. Sew up seam with mattress st, leaving a 1in (2.5cm) gap in side, then stuff firmly and sew up gap.

EYES With bl, make 2 3-loop French knots for eyes approx 4 rows up from end of nose, with 1.5 sts between them. Sew a black bead onto bottom of each knot.

NOSE Work 2 ⅛in (2mm) vertical sts for nostrils.

WHISKERS Thread 3 2in (5cm) lengths of nylon cord through nose to make whiskers.

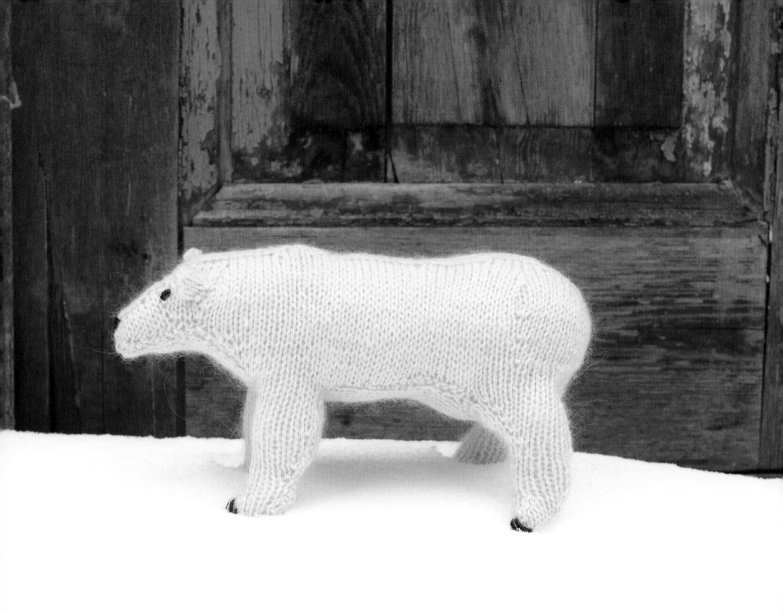

Polar Bear

The largest bear and largest land carnivore in the world, the not-so-cuddly polar bear reigns over the Arctic Circle. Due to his enthusiasm for seals, the polar bear is as happy in water as on land and is often called a marine mammal. In Britain in the 1920s, a polar bear called Peppy became the logo for a brand of candies called Fox's Glacier Mints. A taxidermist was asked to shoot and stuff a real polar bear that then toured the country visiting soccer matches to promote the mints. Now an endangered species, polar bears are highly regarded by the Inuit population.

Polar Bear

Similar to the brown bear, the polar bear is knitted in a soft mohair mix.

Measurements
Length: 10in (25cm)
Height to top of head: 5½in (14cm)

Materials
- Pair of US 3 (3¼mm) knitting needles
- Double-pointed US 3 (3¼mm) knitting needles (for holding stitches)
- 1¼oz (30g) of Rowan Kid Classic in Feather 828 (fr)
- Tiny amount of Rowan Pure Wool 4ply in Black 404 (bl) for eyes, nose, and claws
- 2 pipecleaners for legs

Abbreviations
See page 172.
See page 172 for Short Row Patterning.
NOTE: this animal has no tail.

Right Back Leg
With fr, cast on 13 sts.
Beg with a k row, work 2 rows st st.
Row 3: Inc, k3, k2tog, k1, k2tog, k3, inc. (13 sts)
Row 4: Purl.
Rep rows 3–4 twice more.
Row 9: K2tog, k9, k2tog. (11 sts)
Work 3 rows st st.
Row 13: Inc, k9, inc. (13 sts)
Work 3 rows st st.
Row 17: K5, inc, k1, inc, k5. (15 sts)
Row 18: Purl.
Row 19: K6, inc, k1, inc, k6. (17 sts)
Row 20: Purl.
Row 21: K7, inc, k1, inc, k7. (19 sts)
Row 22: Purl.
Row 23: K8, inc, k1, inc, k8. (21 sts)
Row 24: Purl.
Row 25: K9, inc, k1, inc, k9. (23 sts)
Row 26: Purl.*
Row 27: Bind off 11 sts, k to end
(hold 12 sts on spare needle for Right Side of Body).

Left Back Leg
Work as for Right Back Leg to *.
Row 27: K12, bind off 11 sts (hold 12 sts on spare needle for Left Side of Body).

Right Front Leg
With fr, cast on 13 sts.
Beg with a k row, work 2 rows st st.
Row 3: Inc, k3, k2tog, k1, k2tog, k3, inc. (13 sts)
Row 4: Purl.
Rep rows 3–4 once more.
Row 7: K2tog, k9, k2tog. (11 sts)
Work 3 rows st st.
Row 11: Inc, k9, inc. (13 sts)
Row 12: Purl.
Row 13: Inc, k11, inc. (15 sts)
Work 5 rows st st.
Row 19: Inc, k13, inc. (17 sts)
Work 5 rows st st.**

Row 25: Bind off 8 sts, k to end (hold 9 sts on spare needle for Right Side of Body).

Left Front Leg
Work as for Right Front Leg to **.
Row 25: K9, bind off 8 sts (hold 9 sts on spare needle for Left Side of Body).

Right Side of Body and Head
Row 1: With fr, cast on 1 st, with RS facing k9 from spare needle of Right Front Leg, cast on 5 sts. (15 sts)
Row 2: Purl.
Row 3: Inc, k14, cast on 6 sts. (22 sts)
Row 4: Purl.
Row 5: Inc, k21, cast on 6 sts, with RS facing k12 from spare needle of Right Back Leg, cast on 2 sts. (43 sts)
Row 6: Purl.
Row 7: Inc, k42. (44 sts)
Row 8: P4, inc, p3, inc, p35. (46 sts)
Row 9: Inc, k45. (47 sts)
Row 10: P47, cast on 12 sts. (59 sts)
Row 11: Knit.
Row 12: P4, inc, p5, inc, p37, inc, p1, inc, p8. (63 sts)
Row 13: Knit.
Row 14: P50, inc, p3, inc, p8. (65 sts)
Row 15: Bind off 5 sts, kto end. (60 sts)
Row 16: P4, inc, p7, inc, p37, inc, p5, inc, p1, p2tog. (63 sts)
Row 17: Bind off 2 sts, k to end. (61 sts).
Row 18: P52, p2tog, p5, p2tog. (59 sts)
Row 19: K57, k2tog. (58 sts)
Row 20: P2tog, p2, p2tog, p7, p2tog, p35,

Body
The polar bear has a wide chest and sturdy legs with embroidered claws.

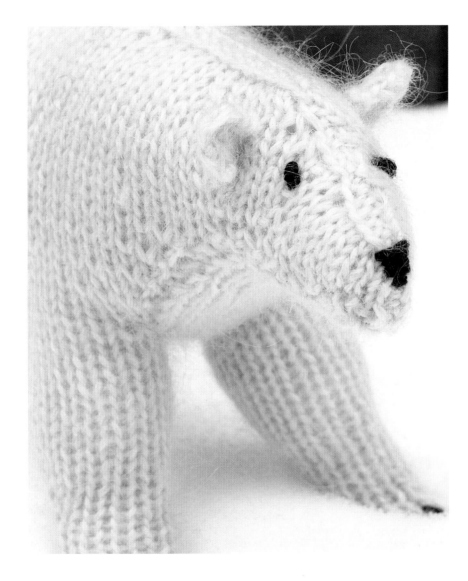

p2tog, p4, p2tog. (53 sts)

Row 21: K5, k2tog, k44, k2tog. (51 sts)

Row 22: P2tog, p1, p2tog, p5, p2tog, p39. (48 sts)

Row 23: Bind off 10 sts, k8 ibos (hold these 8 sts on spare needle), bind off 9 sts, k19 ibos, k2tog. (28 sts)

Row 24: Working on 20 sts only, p2tog, p4, p2tog, p10, p2tog. (17 sts)

Row 25: Bind off 6 sts, k9 ibos, k2tog. (10 sts)

Row 26: P2tog, p6, p2tog. (8 sts)
Bind off.

Next row: Rejoin yarn to rem 8 sts, p2tog, p4, p2tog. (6 sts)

Next row: K2tog, k2, k2tog. (4 sts)
Bind off.

Left Side of Body and Head

Row 1: With fr, cast on 1 st, with WS facing p9 from spare needle of Left Front Leg, cast on 5 sts. (15 sts)

Row 2: Knit.

Row 3: Inc, p14, cast on 6 sts. (22 sts)

Row 4: Knit.

Row 5: Inc, p21, cast on 6 sts, with WS facing p12 from spare needle of Left Back Leg, cast on 2 sts. (43 sts)

Row 6: Knit.

Row 7: Inc, p42. (44 sts)

Row 8: K4, inc, k3, inc, k35. (46 sts)

Row 9: Inc, p45. (47 sts)

Row 10: K47, cast on 12 sts. (59 sts)

Row 11: Purl.

Row 12: K4, inc, k5, inc, k37, inc, k1, inc, k8. (63 sts)

Row 13: Purl.

Row 14: K50, inc, k3, inc, k8. (65 sts)

Row 15: Bind off 5 sts, p to end. (60 sts)

Row 16: K4, inc, k7, inc, k37, inc, k5, inc, k1, k2tog. (63 sts)

Row 17: Bind off 2 sts, p to end. (61 sts)

Row 18: K52, k2tog, k5, k2tog. (59 sts)

Row 19: P57, p2tog. (58 sts)

Row 20: K2tog, k2, k2tog, k7, k2tog, k35, k2tog, k4, k2tog. (53 sts)
Row 21: P5, p2tog, p44, p2tog. (51 sts)
Row 22: K2tog, k1, k2tog, k5, k2tog, k39. (48 sts)
Row 23: Bind off 10 sts, p8 ibos (hold these 8 sts on spare needle), bind off 9 sts, p19 ibos, p2tog. (28 sts)
Row 24: Working on 20 sts only, k2tog, k4, k2tog, k10, k2tog. (17 sts)
Row 25: Bind off 6 sts, p9 ibos, p2tog. (10 sts)
Row 26: K2tog, k6, k2tog. (8 sts)
Bind off.
Next row: Rejoin yarn to rem 8 sts, k2tog, k4, k2tog. (6 sts)
Next row: P2tog, p2, p2tog. (4 sts)
Bind off.

Tummy

With fr, cast on 10 sts.
Beg with a k row, work 2 rows st st.
Row 3: K2tog, k6, k2tog. (8 sts)
Row 4: P2tog, p4, p2tog. (6 sts)
Work 10 rows st st.
Row 15: Inc, k4, inc. (8 sts)
Row 16: Inc, p6, inc. (10 sts)
Work 22 rows st st.
Row 39: K2tog, k6, k2tog. (8 sts)
Row 40: P2tog, p4, p2tog. (6 sts)
Work 5 rows st st.
Row 46: Inc, p4, inc. (8 sts)
Row 47: Inc, k6, inc. (10 sts)
Work 9 rows st st.
Row 57: K1, k2tog, k4, k2tog, k1. (8 sts)
Work 7 rows st st.
Row 65: K1, k2tog, k2, k2tog, k1. (6 sts)
Work 3 rows st st.
Row 69: K1, [k2tog] twice, k1. (4 sts)
Work 6 rows st st.
Bind off.

Ears

With fr, cast on 5 sts.
Beg with a k row, work 4 rows st st.
Row 5: K2tog, k1, k2tog. (3 sts)
Row 6: P3tog and fasten off.

Head

Manipulate the stuffing so that the bear's head has a downward slant.

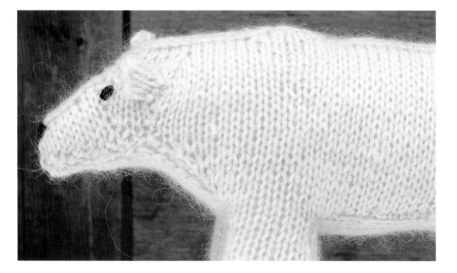

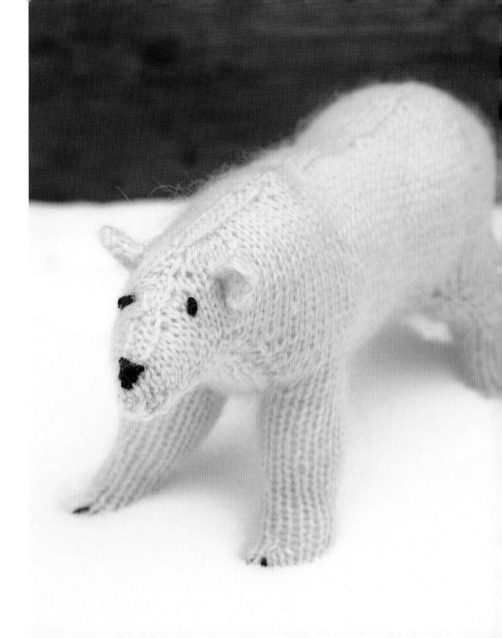

To Finish

SEWING IN ENDS Sew in ends, leaving ends from cast on rows and bound off rows for sewing up.

LEGS With WS together, fold leg in half. Starting at paw, sew up legs on RS.

HEAD AND BODY With RS together, sew two sides of head and nose together with whip stitch. Sew along back of polar bear and around bottom.

TUMMY Sew cast on row of tummy to bottom of polar bear's bottom (where legs begin), and sew bound off row to chin. Ease and sew tummy to fit body, matching curves of tummy to legs. Leave a 1in (2.5cm) gap between front and back legs on one side.

STUFFING Pipecleaners are used to stiffen the legs and help bend them into shape. Fold a pipecleaner into a 'U' shape and measure against front two legs. Cut to approximately fit, leaving an extra 1in (2.5cm) at both ends. Fold these ends over to stop the pipecleaner poking out of the paws. Roll a little stuffing around pipecleaner and slip into body, one end down each front leg. Rep with second pipecleaner and back legs. Starting at the head, stuff the polar bear firmly, then sew up the gap. Mold body into shape.

EARS Sew cast on row of each ear to body, rev st st side facing forward, with 10 rows between ears.

EYES With bl, sew 2-loop French knots positioned as in photograph.

NOSE With bl, embroider nose in satin stitch.

CLAWS With bl, make 4 satin stitches at the tip of each paw.

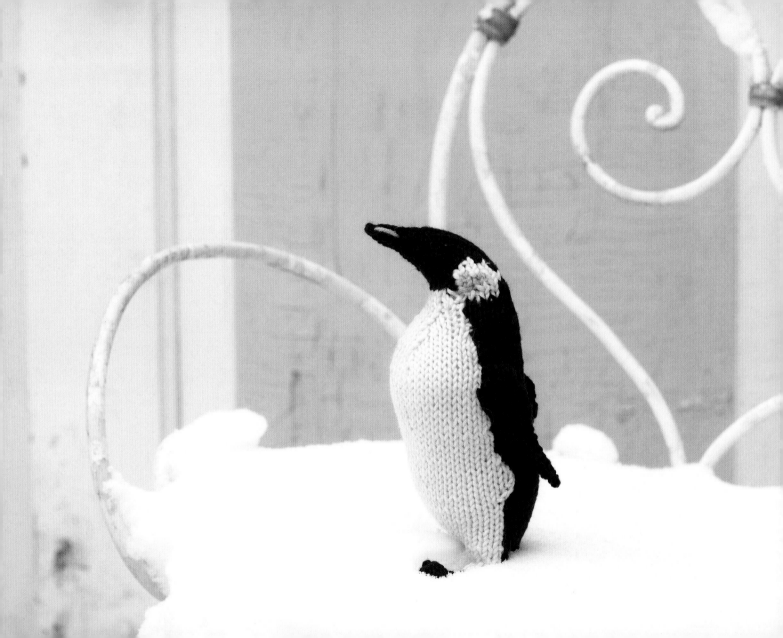

Penguin

There is 'something' about penguins. The much-loved icon for products ranging from clothes to books has also found fame on film in *Happy Feet* and *Pingu*. These flightless birds live mainly in the Antarctic, where they have adapted to life in the water, their wings evolving into flippers. With their particularly wobbly gait, their tuxedo-like coloring, and friendly nature, penguins are very appealing. Sociable, they like to gather in vast groups, and are known to form long-term homosexual partnerships.

Penguin

The penguin's large feet and all-important tail help him stand upright.

Measurements

Width: 3¼in (8cm)
Height to top of head: 7½in (19cm)

Materials

- Pair of US 2 (2¾mm) knitting needles
- Double-pointed US 2 (2¾mm) knitting needles (for holding stitches)
- ½oz (15g) of Rowan Wool Cotton in Inky 908 (ik)
- ¾oz (20g) of Rowan Wool Cotton in Antique 900 (an)
- Tiny amount of Rowan Wool Cotton in Brolly 980 (by)
- 2 pipecleaners for legs and tail
- 4 safety pins for holding stitches on legs
- 2 tiny black beads for eyes and sewing needle and black thread for sewing on

Abbreviations

See page 172.
See page 172 for Color Knitting.
See page 172 for Wrap and Turn Method.

Back Leg

(make 2 the same)
With ik, cast on 10 sts.
Beg with a k row, work 2 rows st st.
Row 3: K2, k2tog, k2, k2tog, k2. (8 sts)
Row 4: Purl.
Row 5: K1, k2tog, k2, k2tog, k1. (6 sts)
Row 6: Purl.
Cont in an, but do not break off ik.
Row 7: Inc, k4, inc. (8 sts)
Row 8: Purl.
Pick up ik.
Row 9: K2ik, k4an, k2ik.
Row 10: P2ik, p4an, p2ik.
Row 11: K2ik, incan, k2an, incan, k2ik. (10 sts)
Row 12: P2ik, p6an, p2ik.
Row 13: K2ik, k1an, incan, k2an, incan, k1an, k2ik. (12 sts)
Row 14: P2ik, p8an, p2ik (hold center 8an sts on a safety pin, hold 4ik sts on safety pin for Back of Body).

Tail

With ik, cast on 6 sts.
Beg with a k row, work 2 rows st st.
Row 3: K1, inc, k2, inc, k1. (8 sts)
Row 4: Purl.
Row 5: K2, inc, k2, inc, k2. (10 sts)
Row 6: Purl.
Row 7: K2, inc, k4, inc, k2. (12 sts)
Row 8: Purl.
Row 9: Bind off 2 sts, k to end. (10 sts)
Row 10: Bind off 2 sts, p to end (hold 8 sts on spare needle for Back of Body).
Fold the tail in half and with RS facing sew seam.

Back of Body

Row 1: With ik and with RS facing, k4 from safety pin of first Back Leg, with RS facing k8 from Tail, with RS facing k4 from safety pin of second Back Leg. (16 sts)
Work 5 rows st st.

Row 7: K5, inc, k4, inc, k5. (18 sts)
Work 3 rows st st.
Row 11: K2tog, k14, k2tog. (16 sts)
Row 12: Purl.
Row 13: K2tog, k12, k2tog. (14 sts)
Work 2 rows st st.
Row 16: Inc, p12, inc. (16 sts)
Row 17: Knit.
Row 18: Inc, p14, inc. (18 sts)
Work 2 rows st st.
Row 21: K6, inc, k4, inc, k6. (20 sts)
Work 11 rows st st.
Row 33: K6, k2tog, k4, k2tog, k6. (18 sts)
Row 34: Purl.
Row 35: K2tog, k14, k2tog. (16 sts)
Row 36: Purl.
Row 37: K4, k2tog, k4, k2tog, k4. (14 sts)
Work 3 rows st st.
Row 41: K3, k2tog, k4, k2tog, k3. (12 sts)
Row 42: Purl.
Join in an.
Row 43: K4an, k4ik, k4an.
Row 44: P1ik, p3an, p4ik, p3an, p1ik.
Join in by.
Row 45: K1ik, k1by, k3an, k2ik, k3an, k1by, wrap and turn (leave 1 st on left-hand needle unworked).
Row 46: Working on top of head on center 10 sts only, p2by, p2an, p2ik, p2an, p2by, w&t.
Row 47: K2by, k1an, k4ik, k1an, k2by, w&t.
Row 48: P1by, p2an, p4ik, p2an, p1by, w&t.
Row 49: K3an, k4ik, k3an, w&t.
Row 50: P2an, p6ik, p2an, w&t.
Row 51: K2an, k6ik, p2an, k1ik. (12 sts in total)
Cont in ik.
Row 52: P2, p2tog, p4, p2tog, p2. (10 sts)
Row 53: K9, wrap and turn (leave 1 st on left-hand needle unworked).
Row 54: Working on center 8 sts only, p8, w&t.
Row 55: K8, w&t.
Rep rows 54–55 once more.

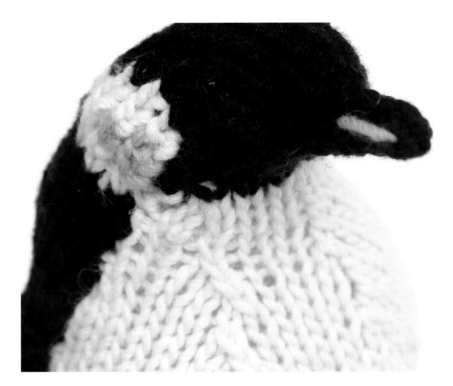

Body

The penguin has a very pronounced, well-stuffed chest.

Row 58: P8, w&t.
Row 59: K9. (10 sts in total)
Row 60: P2tog, p6, p2tog. (8 sts)
Row 61: Knit.
Row 62: P2tog, p4, p2tog. (6 sts)
Row 63: K2tog, k2, k2tog. (4 sts)
Row 64: [P2tog] twice. (2 sts)
Work 3 rows st st.
Row 68: P2tog and fasten off.

Body and Chin

Row 1: With an and with RS facing, k8 from safety pin of front of first Back Leg, cast on 4 sts, k8 from safety pin of front of second Back Leg. (20 sts)
Work 3 rows st st.
Row 5: K6, inc, k6, inc, k6. (22 sts)
Row 6: Purl.
Row 7: K7, inc, k6, inc, k7. (24 sts)
Work 3 rows st st.
Row 11: Inc, k22, inc. (26 sts)

Row 12: Purl.
Row 13: Inc, k24, inc. (28 sts)
Row 14: Purl.
Row 15: K10, inc, k6, inc, k10. (30 sts)
Row 16: P2tog, p26, p2tog. (28 sts)
Row 17: Knit.
Row 18: P2tog, p24, p2tog. (26 sts)
Work 4 rows st st.
Row 23: K9, inc, k6, inc, k9. (28 sts)
Work 9 rows st st.
Row 33: K9, k2tog, k6, k2tog, k9. (26 sts)

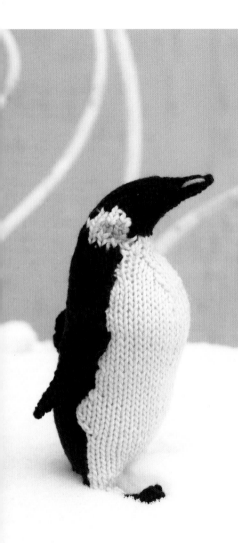

Wings

The penguin's wings may need a small stitch in the middle of each one to hold them down against his body.

Row 34: Purl.
Row 35: K2tog, k7, k2tog, k4, k2tog, k7, k2tog. (22 sts)
Row 36: P7, p2tog, p4, p2tog, p7. (20 sts)
Row 37: K2tog, k4, k2tog, k4, k2tog, k4, k2tog. (16 sts)
Row 38: P2tog, p12, p2tog. (14 sts)
Row 39: K4, k2tog, k2, k2tog, k4. (12 sts)
Row 40: P3, p2tog, p2, p2tog, p3. (10 sts)
Row 41: K2, k2tog, k2, k2tog, k2. (8 sts)
Work 3 rows st st.
Cont in ik.
Row 45: K1, k2tog, k2, k2tog, k1. (6 sts)
Work 5 rows st st.
Row 51: K1, [k2tog] twice, k1. (4 sts)
Work 7 rows st st.
Row 59: [K2tog] twice. (2 sts)
Work 3 rows st st.
Row 63: K2tog and fasten off.

Right Wing

With ik, cast on 2 sts.
Row 1: Knit.
Row 2: Inc, k1. (3 sts)
Row 3: Knit.
Row 4: Inc, k2. (4 sts)
Row 5: Knit.
Row 6: Inc, k3. (5 sts)
Work 7 knit rows.
Row 14: Inc, k2, k2tog. (5 sts)
Work 4 knit rows.
Row 19: Inc, k4. (6 sts)
Work 3 knit rows.

Row 23: K2tog, k3, inc. (6 sts)
Work 5 knit rows.
Row 29: K2tog, k4. (5 sts)
Row 30: Knit.
Row 31: K2tog, k1, k2tog. (3 sts)
Row 32: Knit.
Row 33: K2tog, k1. (2 sts)
Row 34: K2tog and fasten off.

Left Wing

With ik, cast on 2 sts.
Row 1: Knit.
Row 2: K1, inc. (3 sts)
Row 3: Knit.
Row 4: K2, inc. (4 sts)
Row 5: Knit.
Row 6: K3, inc. (5 sts)
Work 7 knit rows.
Row 14: K2tog, k2, inc. (5 sts)
Work 4 knit rows.
Row 19: K4, inc. (6 sts)
Work 3 knit rows.
Row 23: Inc, k3, k2tog. (6 sts)
Work 5 knit rows.
Row 29: K4, k2tog. (5 sts)
Row 30: Knit.
Row 31: K2tog, k1, k2tog. (3 sts)
Row 32: Knit.
Row 33: K1, k2tog. (2 sts)
Row 34: K2tog and fasten off.

To Finish

SEWING IN ENDS Sew in ends, leaving ends from cast on rows and bound off rows for sewing up.

BACK AND LEGS With WS together, fold leg in half. Starting at foot, sew up legs on RS.

FRONT OF BODY Sew cast on row of tummy to tail, between the back legs and sew bound off row to tip of the beak. Ease and sew front to fit body, matching curves of tummy to curves of back. Leave a 1in (2.5cm) gap on one side.

STUFFING Pipecleaners are used to stiffen the legs and help bend them into shape. Fold a pipecleaner into a wide 'U' shape and measure against two legs. Cut to approximately fit, leaving an extra 1in (2.5cm) at both ends. For stability, use a pipecleaner in the tail, make a small 1in (2.5cm) circle and slip into tail. Fold the ends over to stop the pipecleaner poking out. Roll a little stuffing around pipecleaner and slip into body, one end down each front leg. Without stuffing the beak or feet, starting at the head, stuff the penguin firmly, then sew up the gap. Mold body into shape.

EYES Sew on two black beads, placing them as in photograph.

BEAK With by, make two long satin stitches on both sides of the beak.

WINGS Attach the angled edge at top of wings to side of the penguin, sloping toward the back of the penguin.

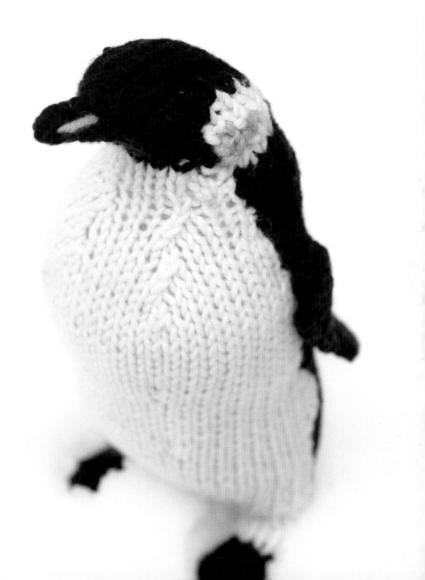

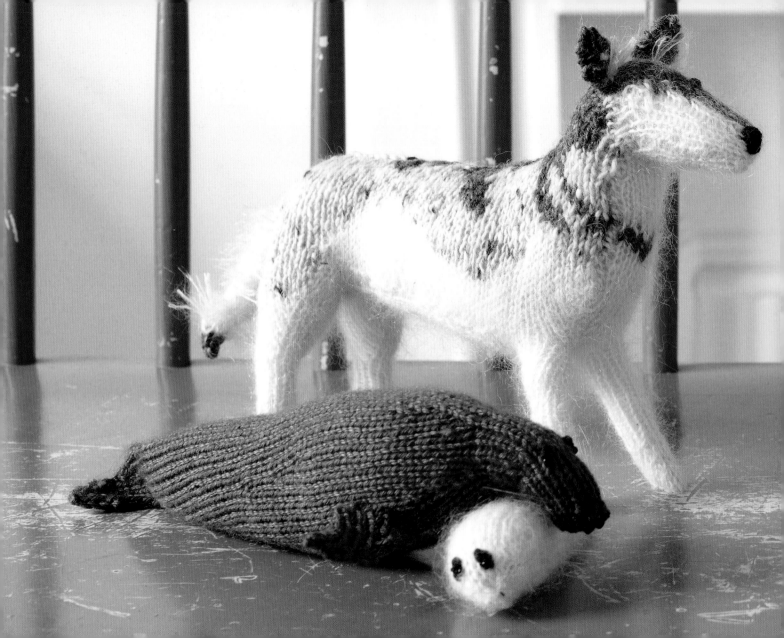

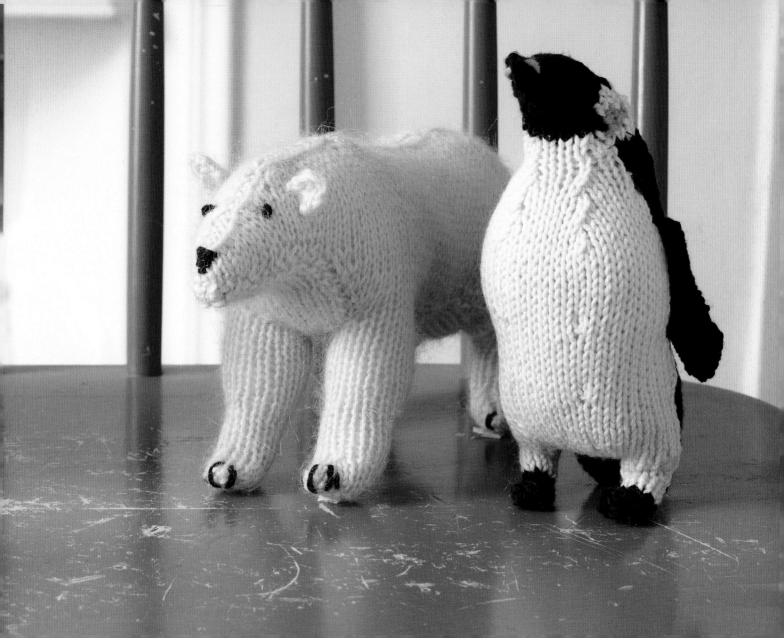

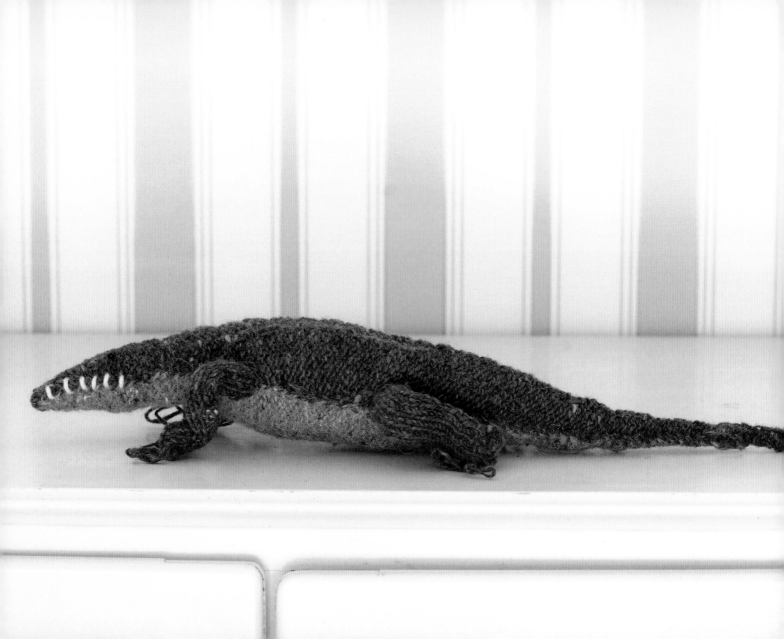

Crocodile

Crocodiles are the stuff of nightmares. They can swim up to 25mph just with their tails, they can leap out of the water, they can run, and their eyes bubble and froth when they eat—hence the term 'crocodile tears', which has nothing to do with remorse. For those of us who read or saw *Peter Pan*, the crocodile invaded our dreams from an early age, relentlessly stalking Captain Hook: our knitted version is comparatively cuddly.

Crocodile

Our knitted crocodile is a lot less scary than the real thing.

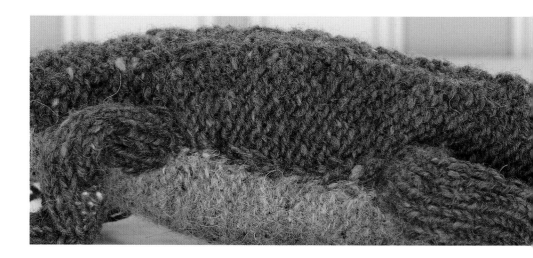

Measurements

Length: 12¾in (32cm)

Materials

- Pair of US 2 (2¾mm) knitting needles
- ¾oz (20g) of Rowan Fine Tweed in Hubberholme 370 (hu)
- ½oz (15g) of Rowan Felted Tweed in Celadon 184 (ce)
- Tiny amount of Rowan Pure Wool 4ply in Porcelaine 451 (pr) for teeth
- 2 pipecleaners for legs
- 2 tiny black beads for eyes and sewing needle and black thread for sewing on

Abbreviations

See page 172.
See page 173 for Loopy Stitch. Work 1-finger loopy stitch throughout this pattern.

NOTE: on twisted rib rows, sts are made and lost. The stitch count does not include the increase worked to make the twisted rib.

Right Back Leg

With hu, cast on 11 sts.
Beg with a k row, work 10 rows st st.
Row 11: K2tog, k7, k2tog. (9 sts)
Work 11 rows st st.
Row 23: K1, inc, k5, inc, k1. (11 sts)
Work 3 rows st st.*
Row 27: K1, loopy st 5, k5.
Bind off.

Left Back Leg

Work as for Right Back Leg to *.
Row 27: K5, loopy st 5, k1.
Bind off.

Front Leg

(make 2 the same)
With hu, cast on 9 sts.
Beg with a k row, work 10 rows st st.
Row 11: K2tog, k5, k2tog. (7 sts)
Work 11 rows st st.

Body

The crocodile has twisted rib on his back to give his skin a ridged look.

Row 23: K1, inc, k3, inc, k1. (9 sts)
Work 3 rows st st.
Row 27: K2, loopy st 5, k2.
Bind off.

Top of Body

With hu, cast on 3 sts.
Beg with a k row, work 8 rows st st.
Row 9: Inc, k1, inc. (5 sts)
Work 8 rows st st.
***Row 18 (RS):** P2, k into front and back of next st (this forms first row of twisted rib, from now on referred to as TR), p2.
Row 19: K2, p2tog (this forms second row of Twisted Rib, from now on referred to as TRp2tog), k2.

Row 20: Purl.
Row 21: Knit.*
Rep from * to * twice more.
Row 30: Inc, p1, TR, p1, inc. (7 sts)
Row 31: K3, TRp2tog, k3.
Work 2 rows st st.
Row 34: P3, TR, p3.
Row 35: K3, TRp2tog, k3.
Work 2 rows st st.
Row 38: Inc, p2, TR, p2, inc. (9 sts)
Row 39: K4, TRp2tog, k4.
Work 2 rows st st.
Row 42: P4, TR, p4.
Row 43: K4, TRp2tog, k4.
Work 2 rows st st.
Row 46: Inc, p3, TR, p3, inc. (11 sts)
Row 47: K5, TRp2tog, k5.
Work 2 rows st st.
Row 50: Inc, p4, TR, p4, inc. (13 sts)
Row 51: K6, TRp2tog, k6.
Work 2 rows st st.
Row 54: P2, TR, p3, TR, p3, TR, p2.
Row 55: K2, TRp2tog, k3, TRp2tog, k3, TRp2tog, k2.
Work 2 rows st st.
Row 58: Inc, p1, TR, p3, TR, p3, TR, p1, inc. (15 sts)
Row 59: K3, TRp2tog, k3, TRp2tog, k3, TRp2tog, k3.
Work 2 rows st st.
Row 62: P3, TR, p3, TR, p3, TR, p3.
Row 63: K3, TRp2tog, k3, TRp2tog, k3, TRp2tog, k3.
Work 2 rows st st.
Row 66: Inc, p2, TR, p3, TR, p3, TR, p2, inc. (17 sts)
Row 67: K4, TRp2tog, k3, TRp2tog, k3, TRp2tog, k4.
Work 2 rows st st.
Row 70: Inc, p3, TR, p3, TR, p3, TR, p3, inc. (19 sts)
Row 71: K5, TRp2tog, k3, TRp2tog, k3, TRp2tog, k5.
Work 2 rows st st.

Row 74: Inc, p4, TR, p3, TR, p3, TR, p4, inc. (21 sts)
Row 75: K6, TRp2tog, k3, TRp2tog, k3, TRp2tog, k6.
Work 2 rows st st.
Row 78: Inc, p5, TR, p3, TR, p3, TR, p5, inc. (23 sts)
Row 79: K7, TRp2tog, k3, TRp2tog, k3, TRp2tog, k7.
Work 2 rows st st.
**** Row 82:** P7, TR, p3, TR, p3, TR, p7.
Row 83: K7, TRp2tog, k3, TRp2tog, k3, TRp2tog, k7.
Work 2 rows st st.**
Rep from ** to ** twice more.
Row 94: P2tog, p5, TR, p3, TR, p3, TR, p5, p2tog. (21 sts)
Row 95: K6, TRp2tog, k3, TRp2tog, k3, TRp2tog, k6.
Work 2 rows st st.
Row 98: P2tog, p4, TR, p3, TR, p3, TR, p4, p2tog. (19 sts)
Row 99: K5, TRp2tog, k3, TRp2tog, k3, TRp2tog, k5.
Work 2 rows st st.
Row 102: P2tog, p3, TR, p3, TR, p3, TR, p3, p2tog. (17 sts)
Row 103: K4, TRp2tog, k3, TRp2tog, k3, TRp2tog, k4.
Work 2 rows st st.
Row 106: P2tog, p2, TR, p3, TR, p3, TR, p2, p2tog. (15 sts)
Row 107: K3, TRp2tog, k3, TRp2tog, k3, TRp2tog, k3.
Work 2 rows st st.
Row 110: P2tog, p1,TR, p3, TR, p3, TR, p1, p2tog. (13 sts)
Row 111: K2, TRp2tog, k3, TRp2tog, k3, TRp2tog, k2.
Row 112: P2tog, p9, p2tog. (11 sts)
Row 113: Knit.
Row 114: P5, TR, p5.
Row 115: K2tog, k3, TRp2tog, k3, k2tog. (9 sts)

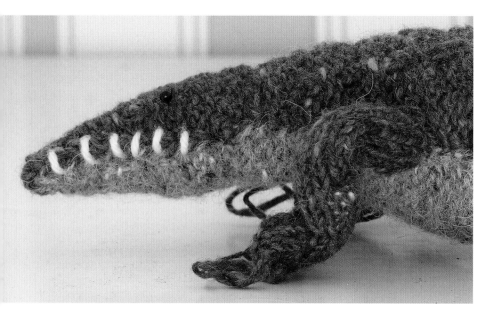

Row 134: P2tog, p3, TR, p3, p2tog. (9 sts)
Row 135: K4, TRp2tog, k4.
Work 2 rows st st.
Row 138: P2tog, p2, TR, p2, p2tog. (7 sts)
Row 139: K3, TRp2tog, k3.
Row 140: Purl.
Row 141: Knit.
Row 142: Purl.
Row 143: K2tog, k3, k2tog. (5 sts)
Row 144: Purl.
Bind off.

Underbelly

With ce, cast on 2 sts.
Beg with a k row, work 8 rows st st.
Row 9: [Inc] twice. (4 sts)
Work 20 rows st st.
Row 30: Inc, p2, inc. (6 sts)
Work 8 rows st st.
Row 39: Inc, k4, inc. (8 sts)
Work 7 rows st st.
Row 47: Inc, k6, inc. (10 sts)
Work 3 rows st st.
Row 51: Inc, k8, inc. (12 sts)
Work 7 rows st st.
Row 59: Inc, k10, inc. (14 sts)
Work 7 rows st st.
Row 67: Inc, k12, inc. (16 sts)
Work 3 rows st st.
Row 71: Inc, k14, inc. (18 sts)
Work 19 rows st st.
Row 91: K2tog, k14, k2tog. (16 sts)
Row 92: Purl.
Row 93: K2tog, k12, k2tog. (14 sts)
Row 94: Purl.
Row 95: K2tog, k10, k2tog. (12 sts)
Row 96: Purl.
Row 97: K2tog, k8, k2tog. (10 sts)
Row 98: Purl.
Row 99: K2tog, k6, k2tog. (8 sts)
Work 5 rows st st.
Row 105: Inc, k6, inc. (10 sts)
Work 7 rows st st.

Teeth

The crocodile's teeth are vertical
cream stitches; you can make them
as big or as small as you like.

Row 116: Purl.
Row 117: Knit.
Row 118: P4, TR, p4.
Row 119: Inc, k3, TRp2tog, k3, inc. (11 sts)
Row 120: Inc, p9, inc. (13 sts)
Row 121: Knit.
Row 122: P2, TR, p3, TR, p3, TR, p2.
Row 123: K2, TRp2tog, k3, TRp2tog, k3,
TRp2tog, k2.
Work 2 rows st st.
Row 126: P6, TR, p6.
Row 127: K6, TRp2tog, k6.
Row 128: Purl.
Row 129: K2tog, k9, k2tog. (11 sts)
Row 130: P2, TR, p2, TR, p2, TR, p2.
Row 131: K2, TRp2tog, k2, TRp2tog, k2,
TRp2tog, k2.
Work 2 rows st st.

Row 113: K2tog, k6, k2tog. (8 sts)
Work 3 rows st st.
Row 117: K2tog, k4, k2tog. (6 sts)
Row 118: Purl.
Row 119: K2tog, k2, k2tog. (4 sts)
Work 5 rows st st.
Bind off.

To Finish

SEWING IN ENDS Sew in ends, leaving ends
from cast on rows and bound off rows for
sewing up.
LEGS With WS together, fold leg in half.
Starting at claw end, sew up legs on RS.
Pipecleaners are used to stiffen the legs and
help bend them into shape. Cut one
pipecleaner to approximately fit front legs,
leaving an extra 1in (2.5cm) at both ends.
Fold these ends over to stop the pipecleaner
poking out of the leg. Roll a little stuffing
around each pipecleaner and slip into legs.
Repeat with second pipecleaner and back
legs. Attach front legs about 3½in (9cm)
from nose and back legs 6¼in (16cm) from
end of tail.
BODY Rev st st side is RS of top of body and
of underbelly. With WS (knit sides) together,
sew top of body and underbelly together
along sides of crocodile, attaching legs as
you go along and leaving a 1in (2.5cm) gap
in side.
STUFFING Stuff firmly, then sew up gap.
TEETH With pr, work 6 vertical sts on either
side of head starting at ¼in (5mm) long and
decreasing toward end of nose to ⅛in (3mm)
long, all spaced ¼in (5mm) apart.
EYES Sew on beads for eyes 1½in (4cm)
from end of nose.

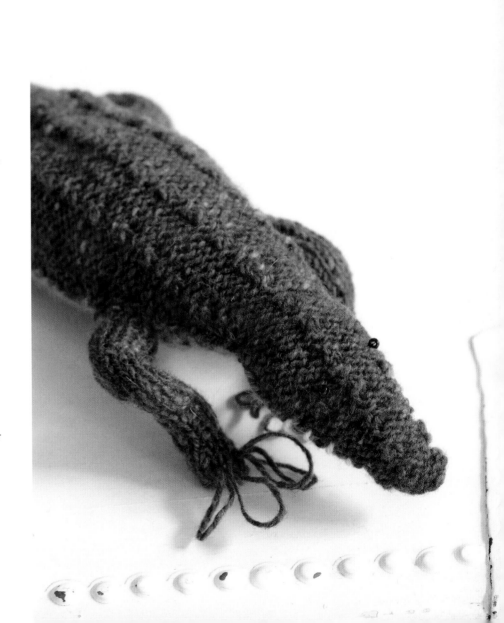

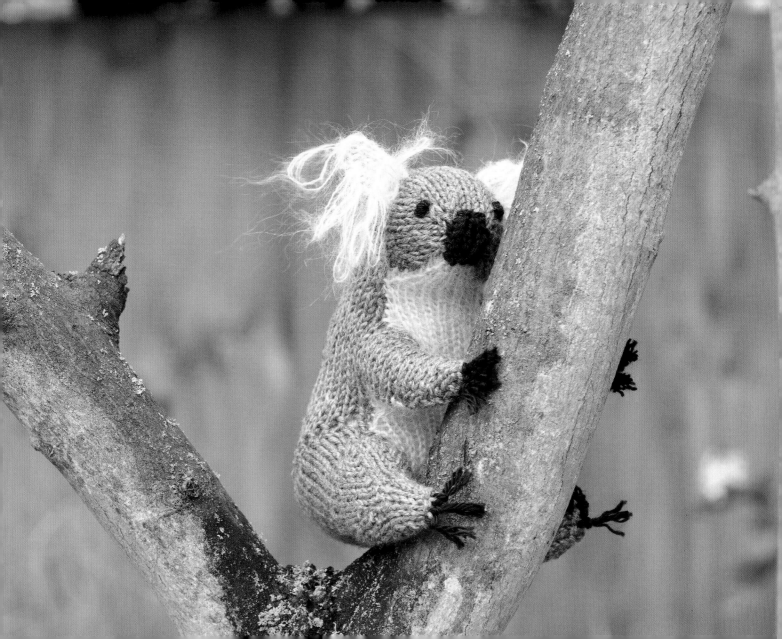

Koala

A marsupial, the koala carries its young either in a pouch or on its back. Because of their exclusive diet of eucalyptus, the koala can only live in southern and eastern Australia. They have sophisticated feet for gripping onto trees and are generally nocturnal creatures. Contrary to popular opinion, koalas are not bears, but are thought to have been called bears because of their bear-like heads. From our childhood, we have a much-loved toy koala bear called Ossie, named after his country of origin.

Koala

The cute koala is easy to knit, although it has two sections of wrap and turn method.

Measurements
Width (including legs): 4½in (11cm)
Height to top of head (seated): 5½in (14cm)

Materials
- Pair of US 2 (2¾mm) knitting needles
- Double-pointed US 2 (2¾mm) knitting needles (for holding stitches)
- 1¼oz (30g) of Rowan Wool Cotton in Misty 903 (my)
- ¼oz (10g) of Rowan Kidsilk Haze in Pearl 590 (pe) used DOUBLE throughout
- Tiny amount of Rowan Pure Wool 4ply in Black 404 (bl) for nose, eyes, and claws
- 2 pipecleaners for legs
- Crochet hook for tufts

Abbreviations
See page 172.
See page 172 for Wrap and Turn Method.
See page 172 for Color Knitting.
See page 172 for Short Row Patterning.
See page 173 for Loopy Stitch. Work 2-finger loopy stitch throughout this pattern.
NOTE: this animal has no tail.

Right Back Leg
With my, cast on 9 sts.
Beg with a k row, work 6 rows st st.
Row 7: K2, [inc] twice, k1, [inc] twice, k2. (13 sts)
Row 8: Purl.
Row 9: K3, inc, k1, inc, k1, inc, k1, inc, k3. (17 sts)
Row 10: Purl.
Row 11: K7, inc, k1, inc, k7. (19 sts)
Row 12: Purl.
Row 13: K8, inc, k1, inc, k8. (21 sts)
Row 14: Purl.
Row 15: K9, inc, k1, inc, k9. (23 sts)
Row 16: Purl.
Row 17: K9, k2tog, k1, k2tog, k9. (21 sts)
Row 18: P8, p2tog, p1, p2tog, p8.* (19 sts)
Row 19: Bind off 8 sts, k to end (hold 11 sts on spare needle for Back).

Left Back Leg
Work as for Right Back Leg to *.
Row 19: K11, bind off 8 sts (hold 11 sts on spare needle for Back).

Back and Head
Row 1: With my and with RS facing, starting at center of Right Back Leg k11 from spare needle of Right Back Leg, cast on 8 sts, then with RS facing, starting at outside edge of Left Back Leg k11 from spare needle of Left Back Leg. (30 sts)
Row 2: Purl.
Row 3: K28, wrap and turn (leave 2 sts on left-hand needle unworked).
Row 4: P26, w&t.
Row 5: K25, w&t.
Row 6: P24, w&t.
Row 7: K23, w&t.
Row 8: P22, w&t.
Row 9: K21, w&t.
Row 10: P20, w&t.
Row 11: K19, w&t.
Row 12: P18, w&t.
Row 13: K17, w&t.
Row 14: P16, w&t.
Row 15: K15, w&t.
Row 16: P14, w&t.
Row 17: K15, w&t.
Row 18: P16, w&t.
Row 19: K17, w&t.
Row 20: P18, w&t.
Row 21: K19, w&t.
Row 22: P20, w&t.
Row 23: K21, w&t.
Row 24: P22, w&t.
Row 25: K6, k2tog, k6, k2tog, k7, w&t. (21 sts)
Row 26: P22, w&t.
Row 27: K23, w&t.
Row 28: P24, w&t.
Row 29: K26. (28 sts in total)
Row 30: Purl.
Row 31: K8, k2tog, k8, k2tog, k8. (26 sts)
Work 2 rows st st.

Shape front legs
Row 34: P7, p2tog, p8, p2tog, p7, cast on 6 sts. (30 sts)
Row 35: K30, cast on 6 sts. (36 sts)
Row 36: P36, cast on 5 sts. (41 sts)
Row 37: K41, cast on 5 sts. (46 sts)
Row 38: Purl.
Row 39: Inc, k44, inc. (48 sts)
Row 40: Purl.
Row 41: Inc, k46, inc. (50 sts)
Row 42: Purl.
Row 43: Working on 13 sts for Right Front Leg, k13 (hold rem 37 sts on spare needle).
Row 44: Purl.
Join in pe.
Row 45: K2togmy, k7my, k4pe. (12 sts)
Row 46: P5pe, p7my.
Row 47: K2togmy, k4my, k6pe. (11 sts)
Row 48: P8pe, p3my.
Row 49: Bind off 2 sts my, k1my icos, k8pe. (9 sts)
Cont in pe.
Row 50: P7, p2tog. (8 sts)
Row 51: Bind off 2 sts, k to end. (6 sts)

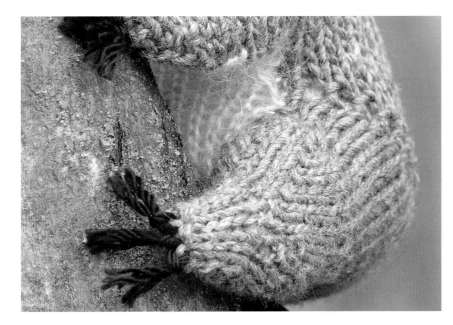

Claws

The claws are attached after finishing using the scarf fringe method, and then trimmed.

Row 52: P4, p2tog. (5 sts)
Row 53: Bind off.
Next row: Rejoin my, k7, k2tog, k6, k2tog, k7, working on 13 sts for Left Front Leg, k13 (hold rem 22 sts on spare needle).
Next row: Purl.
Rejoin pe.
Next row: K4pe, k7my, k2togmy. (12 sts)
Next row: P7my, p5pe.
Next row: K6pe, k4my, k2togmy. (11 sts)
Next row: P3my, p8pe.
Next row: K9pe, k2my.
Next row: Bind off 2 sts my, p1my ibos, p8pe. (9 sts)
Cont in pe.
Next row: K7, k2tog. (8 sts)
Next row: Bind off 2 sts, p to end. (6 sts)
Next row: K4, k2tog. (5 sts)

Next row: Bind off.

Shape neck and head

Rejoin my.
Next row: Working on center 22 sts, purl.
Next row: K2tog, k18, k2tog. (20 sts)
Next row: Purl.
Next row: K19, wrap and turn (leave 1 st on left-hand needle unworked).
Next row: P18, w&t.
Next row: K17, w&t.
Next row: P16, w&t.
Next row: K15, w&t.
Next row: P14, w&t.
Next row: K13, w&t.
Next row: P12, w&t.
Next row: K11, w&t.
Next row: P10, w&t.
Next row: K11, w&t.
Next row: P12, w&t.
Next row: K13, w&t.
Next row: P14, w&t.
Next row: K15, w&t.
Next row: P16, w&t.
Next row: K17, w&t.
Next row: P18, w&t.
Next row: K19. (20 sts in total)
Next row: Inc, p18, inc. (22 sts)
Next row: Inc, k5, k2tog, k6, k2tog, k5, inc.
Next row: Purl.
Next row: K2tog, k4, k2tog, k6, k2tog, k4, k2tog. (18 sts)
Next row: P4, p2tog, p6, p2tog, p4. (16 sts)
Next row: K1, k2tog, k2, k2tog, k2, k2tog, k2, k2tog, k1. (12 sts)
Next row: P2, p2tog, p4, p2tog, p2. (10 sts)
Bind off.

Tummy

With pe, cast on 10 sts.
Beg with a k row, work 18 rows st st.
Row 19: K2tog, k6, k2tog. (8 sts)
Work 19 rows st st.
Row 39: K2tog, k4, k2tog. (6 sts)
Work 5 rows st st.

Head
The black nose is knitted separately and then sewn on.

Row 45: K2tog, k2, k2tog. (4 sts)
Row 46: Purl.
Bind off.

Nose
With bl, cast on 5 sts.
Beg with a k row, work 4 rows st st.
Row 5: K2tog, k1, k2tog. (3 sts)
Row 6: Purl.
Bind off.

Left Ear
With my, cast on 6 sts.
Beg with a k row, work 5 rows st st.
Row 6: P2tog, p4. (5 sts)

Row 7: K3, k2tog. (4 sts)
Row 8: P2tog, p2. (3 sts)
Row 9: K1, k2tog. (2 sts)
Row 10: P2tog and fasten off.

Inner Left Ear
With pe, cast on 7 sts.
Row 1: K1, loopy st 3, k3.
Row 2: Purl.
Row 3: K1, loopy st 1, k5.
Row 4: Purl.
Row 5: K1, loopy st 1, k5.
Row 6: P5, p2tog. (6 sts)
Row 7: K2tog, loopy st 1, k3. (5 sts)
Row 8: P3, p2tog. (4 sts)
Row 9: K2tog, loopy st 1, k1. (3 sts)
Row 10: P1, p2tog. (2 sts)
Row 11: K2tog and fasten off.

Right Ear
With my, cast on 6 sts.
Beg with a k row, work 5 rows st st.
Row 6: P4, p2tog. (5 sts)
Row 7: K2tog, k3. (4 sts)
Row 8: P2, p2tog. (3 sts)
Row 9: K2tog, k1. (2 sts)
Row 10: P2tog and fasten off.

Inner Right Ear
With pe, cast on 7 sts.
Row 1: K3, loopy st 3, k1.
Row 2: Purl.
Row 3: K5, loopy st 1, k1.
Row 4: Purl.
Row 5: K5, loopy st 1, k1.
Row 6: P2tog, p5. (6 sts)
Row 7: K3, loopy st 1, k2tog. (5 sts)
Row 8: P2tog, p3. (4 sts)
Row 9: K1, loopy st 1, k2tog. (3 sts)
Row 10: P2tog, p1. (2 sts)
Row 11: K2tog and fasten off.

To Finish

SEWING IN ENDS Sew in ends, leaving ends from cast on rows and bound off rows for sewing up.

LEGS With WS together, fold legs in half. Starting at paw, sew up legs on RS.

HEAD Fold bound off row of head in half and sew from nose to chin.

TUMMY Sew cast on row of tummy to koala's bottom, between back legs, and sew bound off row to chin. Ease and sew tummy to fit body, matching curves to legs. Leave a 1in (2.5cm) gap between front and back legs on one side.

STUFFING Pipecleaners are used to stiffen the legs and help bend them into shape. Fold a pipecleaner into a 'U' shape and measure against front two legs. Cut to approximately fit, leaving an extra 1in (2.5cm) at both ends. Fold these ends over to stop the pipecleaner poking out of the paws. Roll a little stuffing around pipecleaner and slip into body, one end down each front leg. Repeat with second pipecleaner and back legs. Starting at the head, stuff the koala firmly, then sew up the gap. Mold body into shape.

EARS Sew inner ear to back of ear. Sew cast on row of each ear to head, leaving 6 sts between ears. The loops are on the outer edge of both ears.

EYES With bl, sew 3-loop French knots positioned as in photograph.

NOSE With bl, sew on nose positioned as in photograph, with bound off row at the bottom.

CLAWS Using crochet hook and scarf fringe method (see page 173) and 4 strands of bl for each paw, at the tip of each paw make four tufts and trim.

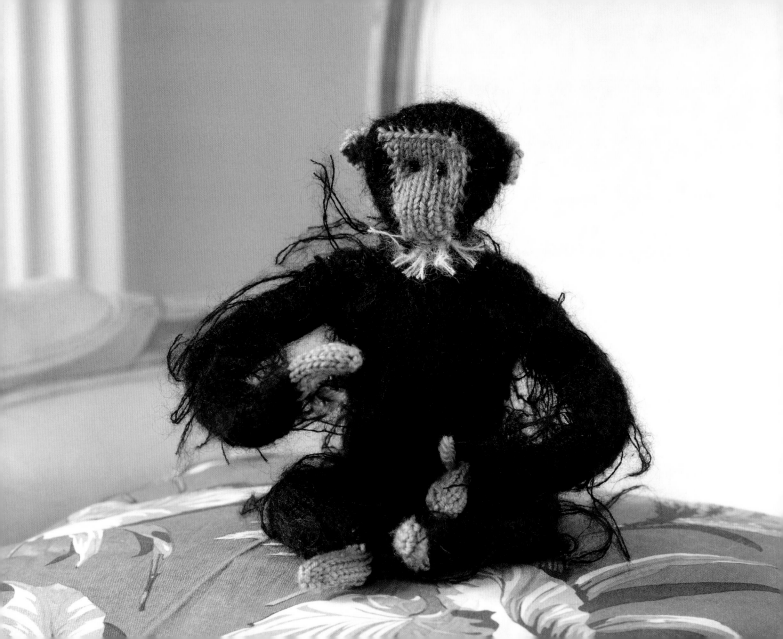

Chimpanzee

Our closest relatives—we all love a chimp. Dressed-up chimpanzees impressively acting out tea-drinking scenarios were used to advertise PG Tips tea in Britain for over 40 years. Jilloch, one of the stars of the PG Tips ads, died at the relatively young age of 34; she was described by a curator at Twycross Zoo where she lived as 'shy but friendly, she's never let fame go to her head'. The tea-drinking chimpanzees have now been replaced by a knitted monkey.

Chimpanzee

As in real life, our chimpanzee can perform all kinds of tricks.

Measurements
Height to top of head: 10in (25cm)
Height (sitting): 6in (15cm)

Materials
- Pair of US 2 (2¾mm) knitting needles
- ¼oz (10g) of Rowan Pure Wool 4ply in Toffee 453 (tf)
- ¾oz (20g) of Rowan Pure Wool 4ply in Black 404 (bl)
- ¾oz (20g) of Rowan Kidskilk Haze in Wicked 599 (wk)

NOTE: some of this animal uses 1 strand of wk and 1 strand of bl held together, and this is called wkbl

- Tiny amount of Rowan Kidsilk Haze in Cream 634 (cr) for beard, used DOUBLE throughout
- 2 tiny black beads for eyes and sewing needle and black thread for sewing on
- 4 pipecleaners for arms and legs

Abbreviations
See page 172.
See page 172 for Wrap and Turn Method.
See page 173 for Loopy Stitch. Work 3-finger loopy stitch throughout this pattern unless otherwise stated. When working with wkbl, loops are made with wk only.

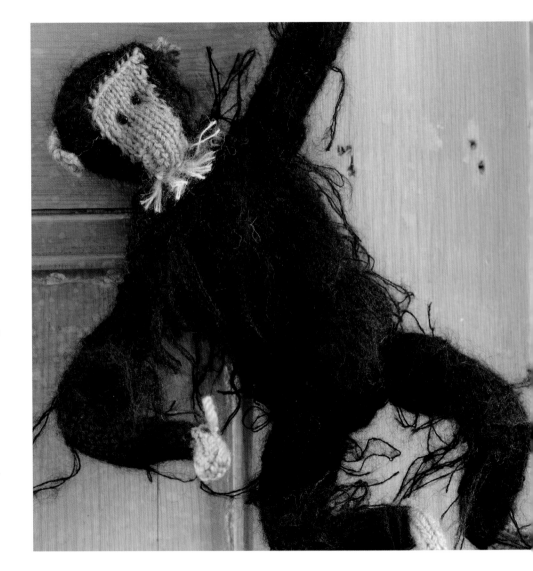

Arms and Legs

The chimpanzee can either sit or hang off things, thanks to the pipecleaners in his arms and legs.

Back Legs

(make 2 the same)
With tf, cast on 8 sts.
Beg with a k row, work 10 rows st st.
Cont in wkbl.
Row 11: Inc, k6, inc. (10 sts)
Work 5 rows st st.
Row 17: Inc, k8, inc. (12 sts)
Work 3 rows st st.
Row 21: K2, [loopy stitch 1, k1] to end.
Row 22: Purl.
Row 23: Inc, k10, inc. (14 sts)
Work 5 rows st st.
Row 29: As row 21.
Work 5 rows st st.
Row 35: As row 21.
Row 36: Purl.
Row 37: Inc, k12, inc. (16 sts)
Work 7 rows st st.
Row 45: As row 21.
Work 3 rows st st.
Cast (bind) off.

Arms

(make 2 the same except for row 7)
With tf, cast on 8 sts.
Beg with a k row, work 6 rows st st.
Row 7 right arm: K7, loopy st 1 (making 1-finger loopy stitch).
Row 7 left arm: Loopy st 1, k7 (making 1-finger loopy stitch).
Join in wkbl.
Work 7 rows st st.
Row 15: Inc, k6, inc. (10 sts)
Work 3 rows st st.
Row 19: K2, [loopy stitch 1, k1] to end.
Row 20: Purl.
Row 21: Inc, k8, inc. (12 sts)
Work 5 rows st st.
Row 27: As row 19.
Work 5 rows st st.
Row 33: As row 19.
Work 9 rows st st.

Row 43: As row 19.
Work 7 rows st st.
Row 51: As row 19.
Row 52: Purl.
Bind off.

Back of Body and Head

With wkbl, cast on 14 sts.
Beg with a k row, work 8 rows st st.
Row 9: Inc, k12, inc. (16 sts)
Row 10: Purl.
Row 11: K2, [loopy stitch 1, k1] to end.
Work 7 rows st st.
Row 19: As row 11.
Row 20: Purl.
Row 21: Inc, k14, inc. (18 sts)
Work 5 rows st st.
Row 27: As row 11.
Work 5 rows st st.
Row 33: Inc, k16, inc. (20 sts)
Row 34: Purl.
Row 35: As row 11.
Work 7 rows st st.
Row 43: As row 11.

Shape shoulders

Row 44: Bind off 8 sts, p to end. (12 sts)
Row 45: Bind off 8 sts, k to end. (4 sts)*
Row 46: Purl.
Row 47: Inc, k2, inc. (6 sts)
Row 48: Inc, p4, inc. (8 sts)
Row 49: Inc, k6, inc. (10 sts)
Row 50: Inc, p8, inc. (12 sts)
Row 51: Inc, k10, inc. (14 sts)
Row 52: Purl.
Row 53: Inc, k12, inc. (16 sts)
Row 54: Purl.
Row 55: Inc, k14, inc. (18 sts)
Work 7 rows st st.
Row 63: K2tog, k10, wrap and turn (leave 6 sts on left-hand needle unworked).
Row 64: Working on 6 sts for top of head only, p6, w&t.
Row 65: K6, w&t.

Head

The chimpanzee has deep-set eyes: you can create this effect by sewing the French knot eyes through to the back of the head and manipulating the stuffing to make brows.

Row 66: P6, w&t.
Row 67: K6, w&t.
Row 68: P6, w&t.
Row 69: K to last 2 sts, k2tog. (16 sts in total)
Row 70: P2tog, p12, p2tog. (14 sts)
Row 71: Bind off 4 sts, k6 ibos, bind off 4 sts.
Row 72: Rejoin yarn, bind off 6 sts.

Front of Body and Face

Work as for Back of Body and Head to *.
Join in 2 ends of cr.
Row 46: P4.
Row 47: Loopy stitch 4.
Cont in tf.
Row 48: [Inc] 4 times. (8 sts)
Row 49: K6, wrap and turn (leave 2 sts on left-hand needle unworked).
Row 50: Working muzzle on center 4 sts only, p4, w&t.
Row 51: K4, w&t.
Row 52: P4, w&t.
Row 53: K6. (8 sts in total)
Row 54: P6, w&t (leave 2 sts on left-hand needle unworked).
Row 55: Working muzzle on center 4 sts only, k4, w&t.
Row 56: P4, w&t.
Row 57: K4, w&t.
Row 58: P4, w&t.
Row 59: K6. (8 sts in total)
Row 60: Purl.
Work 4 rows st st.
Row 65: Inc, k6, inc. (10 sts)
Work 3 rows st st.
Bind off.

Ear

(make 2 the same)
With tf, cast on 7 sts.
Knit 2 rows.
Row 3: K2tog, k3, k2tog. (5 sts)
Row 4: Knit.
Row 5: K2tog, k1, k2tog. (3 sts)
Bind off.

To Finish

SEWING IN ENDS Sew in ends, leaving ends from cast on rows and bound off rows for sewing up.

HEAD With WS together, sew two sides of head together, sewing bound off row of face to bound off row of back of head and sewing down sides of face; you will need to ease the back of the head into the face as there are more rows on the back. Leave 1in (2.5cm) gap in side for stuffing, then stuff head firmly, making sure you stuff the muzzle well to achieve the rounded shape. Sew up head and sides of neck.

BODY With WS together, sew across shoulders.

ARMS, LEGS, AND BODY Pipecleaners are used to stiffen the arms and legs and help bend them into shape. Measure pipecleaners to fit arms and legs, leaving an extra 1in (2.5cm) at paw ends. Fold these ends over to stop the pipecleaner poking out of the paws. Roll a little stuffing around pipecleaner and wrap knitted piece around it, then sew up on outside. Twist other end of the pipecleaners around each other inside body. Sew arms to side of the body below shoulder seam, sew down one side of body on outside, attaching legs to bottom of side seam with inside ends of pipecleaner attached to each other, as before. Sew along bottom of body and up second side, leaving a 1in (2.5cm) gap in side for stuffing.

STUFFING Stuff body firmly, then sew up gap.

EYES Using bl, sew 2-loop French knots for eyes, 5 rows down from hairline with 2 sts between eyes. To give the eyes their characteristic deep-set look, sew the bl yarn tightly to back of head, pull brows down over the eyes, then sew tiny black beads on top.

EARS Sew ears to side of head approx 4 rows back from where face and head meet, and approx ¼in (5mm) down from the top of head.

LOOPS Cut loops on body, and trim beard.

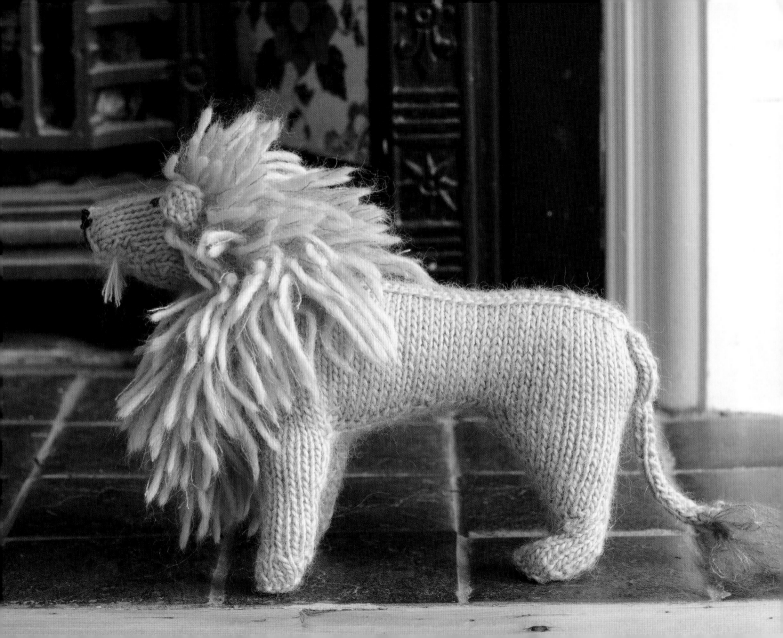

Lion

Aslan, Simba, the Cowardly Lion, Elsa—the lion holds a special place in our imagination. King of the Beasts, we see lions as a symbol of bravery: majestic, powerful, ferocious, but noble. In fact, lions are the most lethargic of all wild cats, spending up to 20 hours a day lounging around doing nothing. The lion is the only truly social cat, although males do indulge in the rather anti-social practice of infanticide to ensure their dominance of the pride. The African lion population has been reduced by half since the 1950s.

Lion

Magnificent and not too difficult to make once you have got the hang of loopy stitch.

Measurements

Length (excluding tail): 10in (25cm)
Height to top of head: 7in (18cm)

Materials

- Pair of 3¼mm (US 3) knitting needles
- Double-pointed 3¼mm (US 3) knitting needles (for holding stitches)
- 45g (1¾oz) of Rowan Pure Wool DK in Tan 054 (ta) used DOUBLE throughout
- 10g (¼oz) of Rowan Kidsilk Haze in Fudge 658 (fu)
NOTE: some of this animal uses 2 strands of ta and 1 strand of fu held together, and this is called tafu
- Small amount of Rowan Kidsilk Haze in Cream 634 (cr) for beard
- Tiny amount of Rowan Pure Wool 4ply 404 in Black (bl) for eyes and nose
- 2 pipecleaners for legs

Abbreviations

See page 172.
See page 172 for Wrap and Turn Method.
See page 173 for Loopy Stitch. Work 2-finger loopy stitch throughout this pattern.

Right Back Leg

With ca, cast on 11 sts.
Beg with a k row, work 2 rows st st.
Row 3: Inc, k2, k2tog, k1, k2tog, k2, inc. (11 sts)
Row 4: Purl.
Row 5: Inc, k2, k2tog, k1, k2tog, k2, inc. (11 sts)*
Work 3 rows st st.
Row 9: K4, inc, k1, inc, k4. (13 sts)
Row 10: Purl.
Row 11: K2tog, k3, inc, k1, inc, k3, k2tog. (13 sts)
Row 12: P2tog, p3, inc, p1, inc, p3, p2tog. (13 sts)
Row 13: K2tog, k1, inc, k1, inc, k1, inc, k1, inc, k1, k2tog. (15 sts)
Row 14: Purl.
Row 15: K6, inc, k1, inc, k6. (17 sts)
Row 16: Purl.
Row 17: K7, inc, k1, inc, k7. (19 sts)
Row 18: Purl.
Row 19: K8, inc, k1, inc, k8. (21 sts)
Row 20: Purl.
Row 21: K9, inc, k1, inc, k9. (23 sts)
Row 22: Purl.
Row 23: K10, inc, k1, inc, k10. (25 sts)
Row 24: Purl.**
Row 25: Bind off 12 sts, k to end (hold 13 sts on spare needle for Right Side of Body).

Left Back Leg

Work as for Right Back Leg to **.
Row 25: K12, bind off 13 sts (hold 13 sts on spare needle for Left Side of Body).

Right Front Leg

Work as for Right Back Leg to *.
Work 9 rows st st.
Row 15: Inc, k9, inc. (13 sts)
Work 5 rows st st.***
Row 21: Bind off 6 sts, k to end (hold 7 sts on spare needle for Right Side of Body).

Tail
The lion has a loopy-stitch tuft at the end of his tail.

Left Front Leg

Work as for Right Front leg to ***.

Row 21: K7, bind off 6 sts (hold 7 sts on spare needle for Left Side of Body).

Right Side of Body

Row 1: With ca, cast on 1 st, k7 from spare needle of Right Front Leg, cast on 6 sts. (14 sts)

Row 2: P13, inc. (15 sts)

Row 3: K15, cast on 4 sts. (19 sts)

Row 4: P18, inc. (20 sts)

Row 5: K20, cast on 6 sts, k13 from spare needle of Right Back Leg, cast on 2 sts. (41 sts)

Row 6: P41.

Join in fu (1 strand).

Row 7: Loopy st 3tafu, k38ca.

Row 8: Purl in ca.

Row 9: Incca, k40ca. (42 sts)

Row 10: Purl in ca.

Row 11: Loopy st 4tafu, k38ca.

Work 3 rows st st in ca.

Row 15: Loopy st 5tafu, k37ca.

Row 16: P2togca, p40ca. (41 sts)

Row 17: Knit in ca.

Row 18: P2togca, p39ca. (40 sts)

Row 19: Loopy st 6tafu, k34ca.

Row 20: With ca, bind off 29 sts, p to end (hold 11 sts on spare needle for neck).

Left Side of Body

Row 1: With ca, cast on 1 st, p7 from spare needle of Left Front Leg, cast on 6 sts. (14 sts)

Row 2: K13, inc. (15 sts)

Row 3: P15, cast on 4 sts. (19 sts)

Row 4: K18, inc. (20 sts)

Row 5: P20, cast on 6 sts, p13 from spare needle of Left Back Leg, cast on 2 sts. (41 sts)

Join in fu (1 strand).

Row 6: K38ca, loopy st 3tafu.

Row 7: Purl in ca.

Row 8: K40ca, incca. (42 sts)

Row 9: Purl in ca.

Row 10: K38ca, loopy st 4tafu.

Work 3 rows st st in ca.

Row 14: K37ca, loopy st 5tafu.

Row 15: P40ca, p2togca. (41 sts)

Row 16: Knit in ca.

Row 17: P39ca, p2togca. (40 sts)

Row 18: K34ca, loopy st 6tafu.

Row 19: Purl in ca.

Row 20: With ca, bind off 29 sts, k to end (hold 11 sts on spare needle for neck).

Neck and Head

Row 1: With ca and with RS facing, k11 from spare needle of Right Side of Body, then k11 from spare needle of Left Side of Body. (22 sts)

Row 2: Purl.

Join in fu (1 strand).

Row 3: Loopy st 22tafu.

Cont in tafu.

Row 4: Purl.

Row 5: Loopy st 22.

Row 6: Purl.

Row 7: K18, wrap and turn (leave 4 sts on left-hand needle unworked).

Row 8: Working on center 14 sts only, p14, w&t.

Row 9: Loopy st 14, w&t.

Row 10: P14, w&t.

Row 11: K14, w&t.

Row 12: P14, w&t.

Row 13: Loopy st 14, k4. (22 sts in total)

Row 14: P22.

Row 15: Knit.

Row 16: Purl.

Row 17: K6, loopy st 10, w&t (leave 6 sts on left-hand needle unworked).

Row 18: Working on center 10 sts only, p10, w&t.

Row 19: K10, w&t.

Row 20: P10, w&t.

Row 21: Loopy st 10, k6. (22 sts in total)

Cont in ca only.

Head

The lion's mane is cut loopy stitch, which you can trim into shape. The same applies to his little beard.

Row 22: Purl.
Row 23: K2tog, k4, k2tog, k6, k2tog, k4, k2tog. (18 sts)
Row 24: K2tog, k5, p1, k2, p1, k5, k2tog. (16 sts)

Row 25: P6, k1, p2, k1, p6.
Row 26: K2tog, k4, p1, k2, p1, k4, k2tog. (14 sts)
Row 27: P5, k1, p2, k1, p5.
Row 28: K5, p1, k2, p1, k5.
Row 29: P5, k1, p2, k1, p5.
Row 30: K5, p1, k2, p1, k5.
Row 31: P5, k1, p2, k1, p5.
Row 32: K5, p1, k2, p1, k5.
Bind off.

Tail

With ca, cast on 5 sts.
Beg with a k row, work 34 rows st st.
Join in fu (2 strands).
Row 35: Loopy st 5.
Row 36: Purl.
Row 37: Loopy st 5.
Bind off.

Tummy

With ca, cast on 6 sts.
Beg with a k row, work 48 rows st st.
Row 49: K1, loopy st 4, k1.
Work 3 rows st st.
Rep rows 49–52, 3 times more.
Work 22 rows st st.
Row 87: K2tog, k2, k2tog. (4 sts)
Row 88: Purl.
Join in cr (2 strands).
Work 2 rows st st.
Row 91: Loopy st 4.
Row 92: Purl.
Bind off.

Ear

(make 2 the same)
With ca, cast on 5 sts.
Work 6 rows garter st.
Row 7: K2tog, k1, k2tog. (3 sts)
Row 8: K3tog and fasten off.

To Finish

SEWING IN ENDS Sew in ends, leaving ends from cast on rows and bound off rows for sewing up.

LEGS With WS together, fold the leg in half. Starting at the paw, sew up leg on RS.

HEAD Fold bound off row of head in half and sew from nose to chin.

BODY Sew along the back of lion and around bottom.

TUMMY Sew cast on row of tummy to base of bottom (to where back legs begin), and sew bound off row to nose. Ease and sew tummy to fit body. Leave a 1in (2.5cm) gap between front and back legs on one side.

STUFFING Pipecleaners are used to stiffen the legs and help bend them into shape. Fold a pipecleaner into a 'U' shape and measure against the front two legs. Cut to approximately fit, leaving an extra 1in (2.5cm) at both ends. Fold these ends over to stop pipecleaner poking out of paws. Roll a little stuffing around pipecleaner and slip into the body, one end down each front leg. Rep with second pipecleaner and back legs. Starting at the head, stuff the lion firmly, but don't overstuff center of body; pinch to get slouch in center of body. Sew up the gap. Mold body into shape.

TAIL. Sew up tail. Attach to top of bottom, sewing down ¾in (2cm) of length.

EARS Attach the cast on row of ears to side of lion's head behind last row of loops, leaving 8 sts between ears.

EYES With bl, sew triangular eyes with 3 satin sts, approx ⅛in (3mm) at inside edge and getting smaller toward outside, with 2 center sts between eyes.

NOSE With bl, embroider nose with 4 rows of satin st, beg with ¼in (5mm) at top of nose increasing to ½in (1cm) at bottom, with one ½in (1cm)-long vertical row of bl down center of nose.

MANE Cut loops of mane and beard and trim.

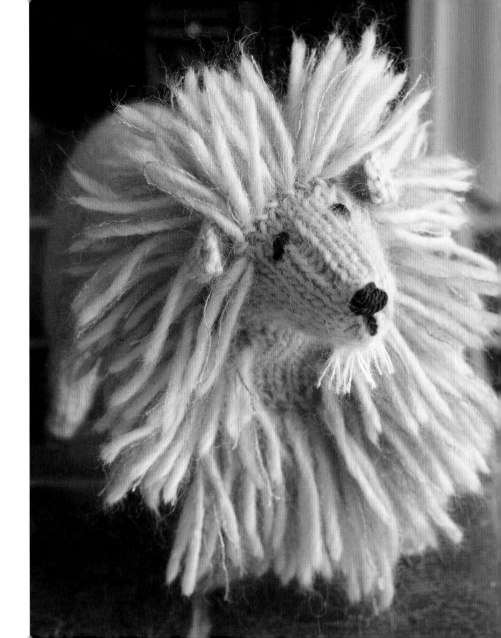

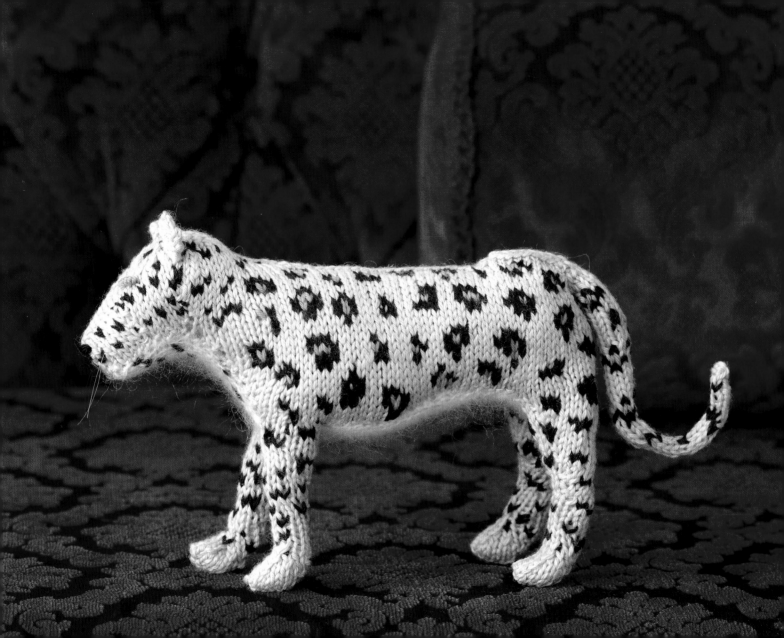

Leopard

Sleek, agile, and beautiful, the leopard is a superb hunter due to its speed and ability to climb trees, even with a heavy carcass. Injured leopards are known to attack humans; 'Panar Leopard' in India killed up to 400 humans, after being attacked by a poacher. He was finally killed by Jim Corbett, founder of the wonderful Corbett Tiger Reserve in Uttarakhand. Leopards are often used in coats of arms because they symbolize power, strength, and mystery. The leopard is an adaptable animal—the panther is a leopard that lost its spots, and the snow leopard, a close relative, is off-white with spots, to blend with its snowy habitat.

Leopard

Complex and rewarding, the leopard is one of the more difficult animals to knit.

Measurements

Length: 7¾in (20cm)
Height to top of head: 5½in (14cm)

Materials

- Pair of US 2 (2¾mm) knitting needles
- Double-pointed US 2 (2¾mm) knitting needles (for holding stitches)
- 1oz (25g) of Rowan Pure Wool 4ply in Toffee 351 (tf)
- ¼oz (10g) of Rowan Pure Wool 4ply in Black 404 (bl)
- ⅛oz (5g) of Rowan Pure Wool 4ply in Ochre 461 (oc)
- ¼oz (10g) of Rowan Kidsilk Haze in Cream 634 (cr) used DOUBLE throughout
- 3 pipecleaners for legs and tail
- Transparent nylon thread for whiskers

Abbreviations

See page 172.
See page 172 for Color Knitting.
See page 172 for Short Row Patterning.

Right Back Leg

With tf, cast on 13 sts.
Beg with a k row, work 2 rows st st.
Row 3: Inc, k3, k2tog, k1, k2tog, k3, inc. (13 sts)
Row 4: Purl.

Row 5: Inc, k1, [k2tog] twice, k1, [k2tog] twice, k1, inc. (11 sts)
Join in bl.*
Row 6: P3tf, p1bl, p3tf, p1bl, p1tf, p1bl, p1tf.
Row 7: K3tf, k2togtf, k1bl, k2togtf, k1tf, k1bl, k1tf. (9 sts)
Row 8: Purl in tf.
Row 9: K3tf, k1bl, k2tf, k1bl, k2tf.
Row 10: Purl in tf.
Row 11: K1tf, k1bl, k2tf, k1bl, k4tf.
Row 12: Purl in tf.
Row 13: K6tf, k2bl, k1tf.
Row 14: P5tf, p2bl, p2tf.
Row 15: K2togtf, k1tf, inctf, k1tf, inctf, k1tf, k2togtf. (9 sts)
Row 16: Purl in tf.
Row 17: K2togtf, k1tf, inctf, k1tf, inctf, k1bl, k2togbl. (9 sts)
Row 18: P3tf, inctf, p1tf, inctf, p2bl, p1tf. (11 sts)
Row 19: K4tf, inctf, k1bl, inctf, k4tf. (13 sts)
Row 20: P2tf, p2bl, p4tf, p2bl, p3tf.
Row 21: K4tf, k1bl, inctf, k1tf, inctf, k5tf. (15 sts)
Row 22: P6tf, p1bl, p6tf, p2bl.
Row 23: K2bl, k4tf, inctf, k1tf, incbl, k6tf. (17 sts)
Row 24: P2tf, p2bl, p5tf, p2bl, p6tf.
Row 25: K7tf, incbl, k1tf, inctf, k2tf, k3bl, k2tf. (19 sts)
Row 26: Purl in tf.
Row 27: K8tf, inctf, k1tf, inctf, k2bl, k6tf. (21 sts)
Row 28: P1tf, p2bl, p3tf, p2bl, p8tf, p2bl, p3tf.
Row 29: Bind off 10 sts tf, k7tf ibos, k3bl, k1tf (hold 11 sts on spare needle for Right Side of Body).

Left Back Leg

Work as for Right Back Leg to *.
Row 6: P1tf, p1bl, p1tf, p1bl, p3tf, p1bl, p3tf.
Row 7: K1tf, k1bl, k1tf, k2togtf, k1bl, k2togtf, k3tf. (9 sts)

Row 8: Purl in tf.
Row 9: K2tf, k1bl, k2tf, k1bl, k3tf.
Row 10: Purl in tf.
Row 11: K4tf, k1bl, k2tf, k1bl, k1tf.
Row 12: Purl in tf.
Row 13: K1tf, k2bl, k6tf.
Row 14: P2tf, p2bl, p5tf.
Row 15: K2togtf, k1tf, inctf, k1tf, inctf, k1tf, k2togtf. (9 sts)
Row 16: Purl in tf.
Row 17: K2togbl, k1bl, inctf, k1tf, inctf, k1tf, k2togtf. (9 sts)
Row 18: P1tf, p2bl, inctf, p1tf, inctf, p3tf. (11 sts)
Row 19: K4tf, inctf, k1bl, inctf, k4tf. (13 sts)
Row 20: P3tf, p2bl, p4tf, p2bl, p2tf.
Row 21: K5tf, inctf, k1tf, inctf, k1bl, k4tf. (15 sts)
Row 22: P2bl, p6tf, p1bl, p6tf.
Row 23: K6tf, inctf, k1tf, incbl, k4tf, k2bl. (17 sts)
Row 24: P6tf, p2bl, p5tf, p2bl, p2tf.
Row 25: K2tf, k3bl, k2tf, incbl, k1tf, inctf, k7tf. (19 sts)
Row 26: Purl in tf.
Row 27: K6tf, k2bl, inctf, k1tf, inctf, k8tf. (21 sts)
Row 28: P3tf, p2bl, p8tf, p2bl, p3tf, p2bl, p1tf.
Row 29: K1tf, k3bl, k7tf, bind off 10 sts tf (hold 11 sts on spare needle for Left Side of Body).

Right Front Leg

Work as for Right Back Leg to *.
Row 6: P3tf, p1bl, p3tf, p1bl, p2tf, p1bl.
Row 7: K3tf, k2togtf, k1tf, k2togtf, k3tf. (9 sts)
Row 8: P4tf, p1bl, p4tf.
Row 9: K2tf, k1bl, k2tf, k1bl, k2tf, k1bl.
Row 10: Purl in tf.
Row 11: K2tf, k1bl, k2tf, k1bl, k3tf.
Row 12: Purl in tf.
Row 13: Inctf, k2tf, k2bl, k2tf, k1bl, inctf. (11 sts)

Legs

The legs are quite thin, so it's easiest to wrap a little stuffing around the pipecleaner, wrap the knitted leg around the pipecleaner, and then sew up on the right side.

Row 14: Purl in tf.
Row 15: K2tf, k2bl, k2tf, k2bl, k3tf.
Row 16: P1tf, p1bl, p8tf, p1bl.
Row 17: Inctf, k3tf, k2bl, k4tf, inctf. (13 sts)
Row 18: P4tf, p1bl, p4tf, p1bl, p3tf.
Row 19: K4tf, k2bl, k4tf, k1bl, k2tf.
Row 20: P1tf, p2bl, p7tf, p2bl, p1tf.
Row 21: Inctf, k11tf, inctf. (15 sts)
Row 22: P5tf, p2bl, p2tf, p1bl, p5tf.
Row 23: K4tf, k1bl, k3tf, k1bl, k6tf.
Row 24: P2tf, p2bl, p8tf, p1bl, p2tf.
Row 25: Bind off 7 sts tf, k8tf ibos (hold 8 sts on spare needle for Right Side of Body).

Left Front Leg

Work as for Right Back Leg to *.
Row 6: P1bl, p2tf, p1bl, p3tf, p1bl, p3tf.
Row 7: K3tf, k2togtf, k1tf, k2togtf, k3tf. (9 sts)
Row 8: P4tf, p1bl, p4tf.
Row 9: K1bl, k2tf, k1bl, k2tf, k1bl, k2tf.
Row 10: Purl in tf.
Row 11: K3tf, k1bl, k2tf, k1bl, k2tf.
Row 12: Purl in tf.
Row 13: Inctf, k1bl, k2tf, k2bl, k2tf, inctf. (11 sts)
Row 14: Purl in tf.
Row 15: K3tf, k2bl, k2tf, k2bl, k2tf.
Row 16: P1bl, p8tf, p1bl, p1tf.
Row 17: Inctf, k4tf, k2bl, k3tf, inctf. (13 sts)
Row 18: P3tf, p1bl, p4tf, p1bl, p4tf.
Row 19: K2tf, k1bl, k4tf, k2bl, k4tf.
Row 20: P1tf, p2bl, p7tf, p2bl, p1tf.
Row 21: Inctf, k11tf, inctf. (15 sts)
Row 22: P5tf, p1bl, p2tf, p2bl, p5tf.
Row 23: K6tf, k1bl, k3tf, k1bl, k4tf.
Row 24: P2tf, p1bl, p8tf, p2bl, p2tf.
Row 25: K8tf, bind off 7 sts tf (hold 8 sts on spare needle for Left Side of Body).

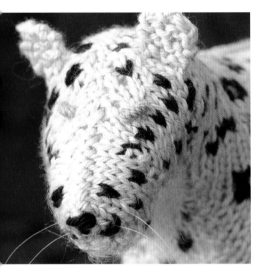

Right Side of Body and Head

Row 1: With tf and bl, cast on 1 st tf, with RS facing k3tf, k1bl, k4tf from spare needle of Right Front Leg, cast on 10 sts tf. (19 sts) Join in oc.

Row 2: P2tf, p1bl, p11tf, p1bl, p1oc, p3tf.

Row 3: Inctf, k2tf, k1bl, k4tf, k1bl, k7tf, k2bl, k1tf, cast on 8 sts tf. (28 sts)

Row 4: P3tf, p1bl, p5tf, p1bl, p1oc, p1bl, p3tf, p2bl, p2tf, p1bl, p8tf.

Row 5: Inctf, k10tf, k3bl, k2tf, k2bl, k4tf, k1bl, k2oc, k1bl, k2tf, cast on 5 sts tf, with RS facing k8tf, k2bl, k1tf from spare needle of Right Back Leg, cast on 2 sts tf. (47 sts)

Row 6: P15tf, p1bl, p5tf, p1bl, p1oc, p1bl, p8tf, p1bl, p1oc, p1bl, p5tf, p2bl, p5tf.

Row 7: Inctf, k3tf, k1bl, k1oc, k1bl, k6tf, k1bl, k10tf, k4tf, k1bl, k1oc, k1bl, k5tf, k3bl, k7tf. (48 sts)

Row 8: P7tf, p1bl, p1oc, p7tf, p2bl, p18tf, p2bl, p3tf, p1bl, p6tf.

Row 9: Inctf, k1tf, k3bl, k5tf, k3bl, k4tf, k2bl, k3tf, k1bl, k4tf, k1bl, k6tf, k1bl, k9tf, k2bl, k2tf. (49 sts)

Row 10: P2tf, p1bl, p1oc, p1bl, p7tf, p1bl, p1oc, p1bl, p5tf, p2bl, p2tf, p1bl, p1oc, p3tf, p1bl, p1oc, p4tf, p1bl, p2oc, p1bl, p4tf, p1bl, p1oc, p1bl, p3tf.

Row 11: K3tf, k2bl, k5tf, k3bl, k5tf, k1bl, k4tf, k1bl, k3tf, k1bl, k1oc, k1bl, k3tf, k2bl, k1oc, k1bl, k8tf, k1bl, k3tf.

Row 12: P6tf, p1bl, p6tf, p2bl, p4tf, p2bl, p28tf.

Row 13: Inctf, k5tf, k1bl, k8tf, k1bl, k25tf, k3bl, k5tf. (50 sts)

Ro w 14: P5tf, p1bl, p1oc, p1bl, p3tf, p1bl, p15tf, p2bl, p3tf, p1bl, p1oc, p1bl, p2tf, p2bl, p3tf, p1bl, p7tf.

Row 15: K6tf, k1oc, k1bl, k2tf, k1bl, k1oc, k2bl, k1tf, k1bl, k1oc, k1bl, k3tf, k1oc, k1bl, k2tf, k3bl, k3tf, k2bl, k4tf, k3bl, k3tf, k2bl, k2tf, k1bl, k1oc, k1tf.

Row 16: P1tf, p1bl, p1oc, p7tf, p1bl, p1oc, p2bl, p2tf, p1bl, p2oc, p1bl, p2tf, p1bl, p1oc, p4tf, p1bl, p4tf, p1bl, p2tf, p1bl, p2oc, p1bl, p7tf, p1bl, p2tf, cast on 10 sts tf. (60 sts)

Row 17: K5tf, inctf, k3tf, inctf, k3tf, k2bl, k6tf, k2bl, k13tf, k2bl, k2tf, k3bl, k4tf, k2bl, k7tf, k2bl, k2tf. (62 sts)

Row 18: P6tf, p2bl, p25tf, p1bl, p7tf, p2bl, p5tf, p1bl, inctf, p1bl, p3tf, p1bl, inctf, p2tf, p1bl, p3tf. (64 sts)

Row 19: K1tf, k1bl, k3tf, k1bl, inctf, k3tf, k1bl, k1tf, inctf, k7tf, k1bl, k1oc, k1bl, k6tf, k1bl, k1oc, k2tf, k3bl, k7tf, k1bl, k12tf, k1bl, k1oc, k1bl, k3tf, k2togtf. (65 sts)

Row 20: P2togtf, p3tf, p2bl, p2tf, p2bl, p3tf, p1bl, p3tf, p1bl, p1oc, p1bl, p2tf, p2bl, p3tf, p1oc, p1bl, p6tf, p2bl, p3tf, p2bl, p2tf, p1bl, p4tf, inctf, p1bl, p5tf, incbl, p7tf. (66 sts)

Row 21: K3tf, k1bl, k4tf, inctf, k1bl, k5tf, inctf, k1tf, k2bl, k3tf, k1bl, k6tf, k1bl, k1oc, k1bl, k9tf, k1bl, k1oc, k1bl, k3tf, k2bl, k2tf, k1bl, k3tf, k1bl, k2oc, k1bl, k5tf, k2togtf. (67 sts)

Row 22: P2togtf, p5tf, p2bl, p4tf (hold 12 sts on spare needle for rump), bind off 17 sts tf, p4tf ibos, p1bl, p10tf, p1bl, p4tf, p1bl, p3tf, p1bl, p12tf. (37 sts)

Row 23: Bind off 8 sts tf, k7tf ibos, k1bl, k2tf, k1bl, k8tf, k1bl, k7tf, k2togtf. (28 sts)

Row 24: P2togtf, p5tf, p1bl, p6tf, p2togtf, p7tf, p2togtf, p3tf. (25 sts)

Row 25: K2togtf, k5tf, k1bl, k5tf, k1bl, k6tf, k1bl, k2tf, k2togtf. (23 sts)

Row 26: Bind off 5 sts tf, p3tf ibos, p1bl, p2tf, p2togtf, p1bl, p4tf, p2togtf, p1tf, p2togtf. (15 sts)

Row 27: K3tf, k2togtf, k3tf, k1bl, k1tf, k2togtf, k3tf. (13 sts)

Row 28: P2togtf, p8tf, p1bl, p2tf. (12 sts)

Row 29: K2togtf, k2tf, k2togtf, k2tf, k2togtf, k2tf. (9 sts)

Row 30: P2tf, p2togtf, p1tf, p1bl, p2togtf, p1tf. (7 sts)

Row 31: Bind off.
Rejoin tf to rem 12 sts.

Head

Sew up the center seam of the head as neatly as possible using whip stitch.

Next row: K2tog, k8, k2tog. (10 sts)
Cast (bind) off.

Left Side of Body and Head

Row 1: With tf and bl, cast on 1 st tf, with WS facing p3tf, p1bl, p4tf from spare needle of Left Front Leg, cast on 10 sts tf. (19 sts) Join in oc.

Row 2: K2tf, k1bl, k11tf, k1bl, k1oc, k3tf.

Row 3: Inctf, p2tf, p1bl, p4tf, p1bl, p7tf, p2bl, p1tf, cast on 8 sts tf. (28 sts)

Row 4: K3tf, k1bl, k5tf, k1bl, k1oc, k1bl, k3tf, k2bl, k2tf, k1bl, k8tf.

Row 5: Inctf, p10tf, p3bl, p2tf, p2bl, p4tf, p1bl, p2oc, p1bl, p2tf, cast on 5 sts tf, with WS facing p8tf, p2bl, p1tf from spare needle of Left Back Leg, cast on 2 sts tf. (47 sts)

Row 6: K15tf, k1bl, k5tf, k1bl, k1oc, k1bl, k8tf, k1bl, k1oc, k1bl, k5tf, k2bl, k5tf.

Row 7: Inctf, p3tf, p1bl, p1oc, p1bl, p6tf, p1bl, p10tf, p1bl, p4tf, p1bl, p1oc, p1bl, p5tf, p3bl, p7tf. (48 sts)

Row 8: K7tf, k1bl, k1oc, k7tf, k2bl, k18tf, k2bl, k3tf, k1bl, k6tf.

Row 9: Inctf, p1tf, p3bl, p5tf, p3bl, p4tf, p2bl, p3tf, p1bl, p4tf, p1bl, p6tf, p1bl, p9tf, p2bl, p2tf. (49 sts)

Row 10: K2tf, k1bl, k1oc, k1bl, k7tf, k1bl, k1oc, k1bl, k5tf, k2bl, k2tf, k1bl, k1oc, k3tf, k1bl, k1oc, k4tf, k1bl, k2oc, k1bl, k4tf, k1bl, k1oc, k1bl, k3tf.

Row 11: P3tf, p2bl, p5tf, p3bl, p5tf, p1bl, p4tf, p1bl, p3tf, p1bl, p1oc, p1bl, p3tf, p2bl, p1oc, p1bl, p8tf, p1bl, p3tf.

Row 12: K6tf, k1bl, k6tf, k2bl, k4tf, k2bl, k28tf.

Row 13: Inctf, p5tf, p1bl, p8tf, p1bl, p25tf, p3bl, p5tf. (50 sts)

Row 14: K5tf, k1bl, k1oc, k1bl, k3tf, k1bl, k15tf, k2bl, k3tf, k1bl, k1oc, k1bl, k2tf, k2bl, k3tf, k1bl, k7tf.

Row 15: P6tf, p1oc, p1bl, p2tf, p1bl, p1oc, p2bl, p1tf, p1bl, p1oc, p1bl, p3tf, p1oc, p1bl, p2tf, p3bl, p3tf, p2bl, p4tf, p3bl, p3tf, p2bl, p2tf, p1bl, p1oc, p1tf.

Row 16: K1tf, k1bl, k1oc, k7tf, k1bl, k1oc, k2bl, k2tf, k1bl, k2oc, k1bl, k2tf, k1bl, k1oc, k4tf, k1bl, k4tf, k1bl, k2tf, k1bl, k2oc, k1bl, k7tf, k1bl, k2tf, cast on 10 sts tf. (60 sts)

Row 17: P5tf, inctf, p3tf, inctf, p3tf, p2bl, p6tf, p2bl, p13tf, p2bl, p2tf, p3bl, p4tf, p2bl, p7tf, p2bl, p2tf. (62 sts)

Row 18: K6tf, k2bl, k25tf, k1bl, k7tf, k2bl, k5tf, k1bl, inctf, k1bl, k3tf, k1bl, inctf, k2tf, k1bl, k3tf. (64 sts)

Row 19: P1tf, p1bl, p3tf, p1bl, inctf, p3tf, p1bl, p1tf, inctf, p7tf, p1bl, p1oc, p1bl, p6tf, p1bl, p1oc, p2tf, p3bl, p7tf, p1bl, p12tf, p1bl, p1oc, p1bl, p3tf, p2togtf. (65 sts)

Row 20: K2togtf, k3tf, k2bl, k2tf, k2bl, k3tf, k1bl, k3tf, k1bl, k1oc, k1bl, k2tf, k2bl, k3tf, k1oc, k1bl, k6tf, k2bl, k3tf, k2bl, k2tf, k1bl, k4tf, inctf, k1bl, k5tf, incbl, k7tf. (66 sts)

Row 21: P3tf, p1bl, p4tf, inctf, p1bl, p5tf, inctf, p1tf, p2bl, p3tf, p1bl, p6tf, p1bl, p1oc, p1bl, p9tf, p1bl, p1oc, p1bl, p3tf, p2bl, p2tf, p1bl, p3tf, p1bl, p2oc, p1bl, p5tf, p2togtf. (67 sts)

Row 22: K2togtf, k5tf, k2bl, k4tf (hold 12 sts on spare needle for rump), bind off 17 sts tf, k4tf ibos, k1bl, k10tf, k1bl, k4tf, k1bl, k3tf, k1bl, k12tf. (37 sts)

Row 23: Bind off 8 sts tf, p7tf ibos, p1bl, p2tf, p1bl, p8tf, p1bl, p7tf, p2togtf. (28 sts)

Row 24: K2togtf, k5tf, k1bl, k6tf, k2togtf, k7tf, k2togtf, k3tf. (25 sts)

Row 25: P2togtf, p5tf, p1bl, p5tf, p1bl, p6tf, p1bl, p2tf, p2togtf. (23 sts)

Row 26: Bind off 5 sts tf, k3tf ibos, k1bl, k2tf, k2togtf, k1bl, k4tf, k2togtf, k1tf, k2togtf. (15 sts)

Row 27: P3tf, p2togtf, p3tf, p1bl, p1tf, p2togtf, p3tf. (13 sts)

Row 28: K2togtf, k8tf, k1bl, k2tf. (12 sts)

Row 29: P2togtf, p2tf, p2togtf, p2tf, p2togtf, p2tf. (9 sts)

Row 30: K2tf, k2togtf, k1tf, k1bl, k2togtf, k1tf. (7 sts)

Row 31: Bind off.

Working on rem 12 sts, rejoin tf.
Next row: P2tog, p8, p2tog. (10 sts)
Bind off.

Tummy

With cr, cast on 8 sts.
Beg with a k row, work 2 rows st st.
Row 3: K2tog, k4, k2tog. (6 sts)
Row 4: P2tog, p2, p2tog. (4 sts)
Work 10 rows st st.
Row 15: Inc, k2, inc. (6 sts)
Work 9 rows st st.
Row 25: Inc, k4, inc. (8 sts)
Work 21 rows st st.
Row 47: K2tog, k4, k2tog. (6 sts)
Row 48: P2tog, p2, p2tog. (4 sts)
Work 5 rows st st.
Row 54: Inc, p2, inc. (6 sts)
Join in bl.
Row 55: K3cr, k2bl, k1cr.
Work 2 rows st st in cr.
Row 58: P4cr, p1bl, p1cr.
Row 59: K4cr, k1bl, k1cr.
Row 60: Purl in cr.
Row 61: K1bl, k4cr, k1bl.
Work 2 rows st st in cr.
Row 64: P2cr, p1bl, p3cr.
Work 2 rows st st in cr.
Row 67: K2cr, k1bl, k1cr, k1bl, k1cr.
Row 68: P1cr, p1bl, p3cr, p1bl.
Work 2 rows st st in cr.
Row 71: K2cr, k1bl, k3cr.
Row 72: Purl in cr.
Row 73: K1cr, k1bl, k1cr, k2bl, k1cr.
Row 74: Purl in cr.
Row 75: K1bl, k4cr, k1bl.
Row 76: Purl in cr.
Bind off.

Body
Mold the stuffing to give the leopard a waist.

Ear
(make 2 the same)
With tf, cast on 5 sts.
Knit 4 rows.
Row 5: K2tog, k1, k2tog. (3 sts)
Bind off.

Tail
With tf, cast on 10 sts.
Beg with a k row, work 2 rows st st.
Join in bl.
Row 3: K3tf, k1bl, k6tf.
Join in oc.
Row 4: P5tf, p1bl, p1oc, p1bl, p2tf.
Row 5: K3tf, k1bl, k3tf, k1bl, k2tf.
Row 6: P1tf, p1bl, p1oc, p1bl, p6tf.
Row 7: K7tf, k1bl, k2tf.
Row 8: P5tf, p1bl, p4tf.
Row 9: K2togtf, k2tf, k1bl, k1oc, k2tf, k2togtf. (8 sts)
Row 10: Purl in tf.

Row 11: K5tf, k1bl, k2tf.
Row 12: P4tf, p1bl, p1oc, p1bl, p1tf.
Row 13: K2tf, k1bl, k2tf, k1bl, k2tf.
Row 14: P4tf, p1bl, p1oc, p1bl, p1tf.
Row 15: K2tf, k1bl, k5tf.
Row 16: Purl in tf.
Row 17: K5tf, k1bl, k2tf.
Row 18: P2tf, p1bl, p1oc, p4tf.
Row 19: K4tf, k2bl, k2tf.
Row 20: P5tf, p1bl, p2tf.
Row 21: K1tf, k1bl, k1oc, k1bl, k4tf.
Row 22: P5tf, p1bl, p2tf.
Row 23: K5tf, k1bl, k2tf.
Row 24: P1tf, p1bl, p1oc, p1bl, p4tf.
Row 25: K5tf, k1bl, k2tf.
Row 26: P5tf, p1bl, p2tf.
Row 27: K2togtf, k1tf, k1bl, k2tf, k2togtf. (6 sts)
Row 28: Purl in tf.
Row 29: Knit in tf.
Row 30: P3tf, p1bl, p2tf.

Row 31: K2tf, k1bl, k1oc, k1bl, k1tf.
Row 32: P2tf, p1bl, p3tf.
Row 33: Knit in tf.
Row 34: Purl in tf.
Row 35: K1tf, k1bl, k4tf.
Row 36: P2tf, p1bl, p3tf.
Row 37: K2togtf, k2tf, k2togtf. (4 sts)
Row 38: Purl in tf.
Row 39: Knit in tf.
Row 40: P1tf, p1bl, p2tf.
Row 41: K1tf, k1bl, k2tf.
Cont in tf.
Row 42: Purl.
Row 43: Knit.
Row 44: [P2tog] twice. (2 sts)
Row 45: K2tog and fasten off.

To Finish

SEWING IN ENDS Sew in ends, leaving ends from cast on rows and bound off rows for sewing up.

LEGS With WS together, fold leg in half. Starting at foot, sew up legs on RS.

HEAD AND BODY Fold bound off row of head in half and sew from nose to chin. Sew up center of head and along back of leopard and around bottom.

TUMMY Sew cast on row of tummy to bottom of leopard's bottom (where legs begin), and sew bound off row to chin. Ease and sew tummy to fit body, matching curves of tummy to legs. Leave a 1in (2.5cm) gap between front and back legs on one side.

STUFFING Pipecleaners are used to stiffen the legs and help bend them into shape. Fold a pipecleaner into a 'U' shape and measure against front two legs. Cut to approximately fit, leaving an extra 1in (2.5cm) at both ends. Fold these ends over to stop the pipecleaner poking out of the paws. Roll a little stuffing around pipecleaner and slip into body, one end down each front leg. Repeat with second pipecleaner and back legs. Starting at the head, stuff the leopard firmly, then sew up the gap. Mold body into shape.

TAIL Cut a pipecleaner 1in (2.5cm) longer than tail. Roll a little stuffing around pipecleaner, wrap tail around pipecleaner, and sew up. Push protruding pipecleaner end into leopard where back meets bottom and sew on tail.

EARS Sew cast on row of each ear to head, with ¾in (2cm) between ears.

EYES With oc, sew, at a slant, 3-loop elongated French knots positioned as in photograph.

NOSE With bl, embroider nose in satin stitch.

WHISKERS Cut 6 4in (10cm) strands of transparent nylon and thread through cheeks, then trim.

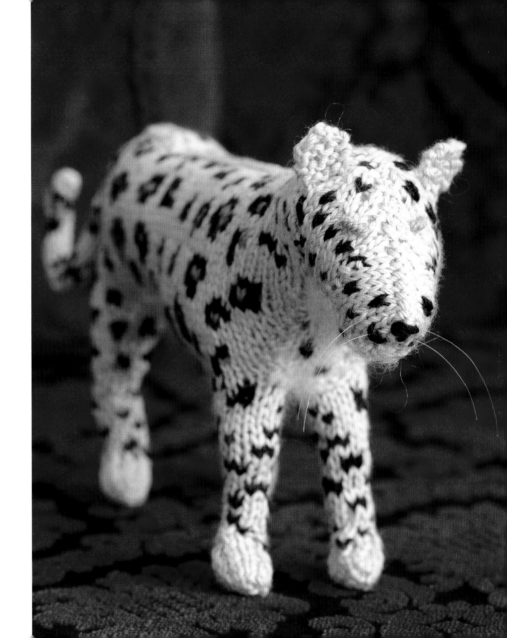

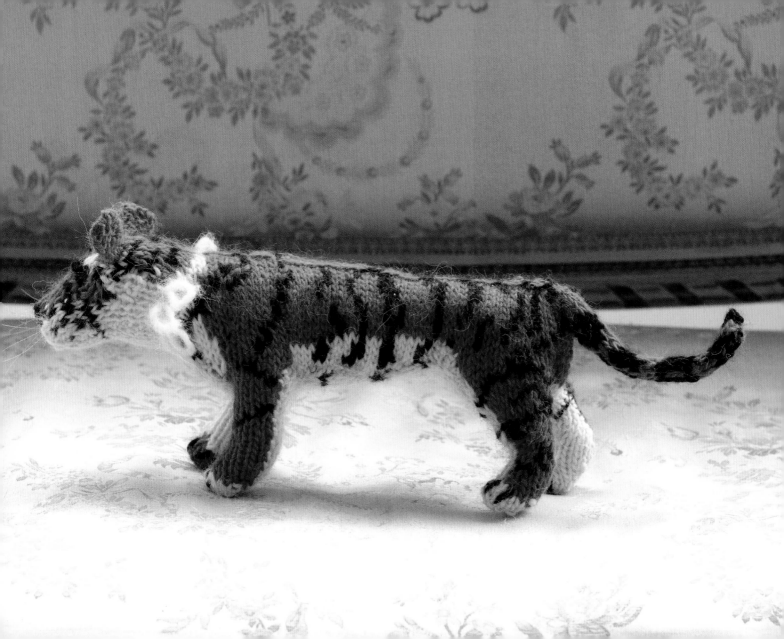

Tiger

Considered to be one of the most popular animals in the world, the endangered tiger is the largest 'cat' and one of the fastest. Because of their speed, tenacity, and distinctive markings, the tiger is a popular character in books: Shere Khan in *The Jungle Book*, bouncy Tigger in *Winnie-the-Pooh*, and *The Tiger Who Came To Tea* by Judith Kerr. My cousin, in Italy, cared for Wotan, a tiger cub, until he became too big. She felt that Pi in *Life of Pi* shouldn't have been so scared of Richard Parker, the tiger.

Tiger

Pipecleaners are essential to make the tiger prowl.

Measurements

Length (excluding tail): 10¼in (26cm)
Height to top of head: 5in (13cm)

Materials

- Pair of US 3 (3¼mm) knitting needles
- Double-pointed US 3 (3¼mm) knitting needles (for holding stitches and for tail)
- ¼oz (10g) of Rowan Kid Classic in Feather 828 (fr)
- ¾oz (20g) of Rowan Kid Classic in Rosewood 870 (rd)
- ¼oz (10g) of Rowan Kid Classic in Smoke 831 (sm)
- 3 pipecleaners for legs and tail

Abbreviations

See page 172.
See page 172 for Color Knitting.
See page 172 for Wrap and Turn Method.
See page 173 for Loopy Stitch. Work 2-finger loopy stitch throughout this pattern.

Right Back Leg

With fr, cast on 11 sts.
Beg with a k row, work 2 rows st st.
Join in rd.
Row 4: Incfr, k2fr, k2togfr, k1fr, k2togfr, k2rd, incrd. (11 sts)
Row 4: P5rd, p6fr.
Row 5: Incfr, k2fr, k2togfr, k1fr, k2togrd, k2rd, incrd. (11 sts)

Row 6: P5rd, p6fr.*
Join in sm.
Row 7: K6fr, k3rd, k1sm, k1rd.
Row 8: P2rd, p1sm, p2rd, p6fr.
Row 9: K4fr, incfr, k1fr, incsm, k1sm, k3rd. (13 sts)
Row 10: P2rd, p2sm, p2rd, p7fr.
Row 11: K2togfr, k3fr, incfr, k1fr, incrd, k3rd, k2togsm. (13 sts)
Row 12: P2togrd, p3rd, incsm, p1fr, incfr, p3fr, p2togfr. (13 sts)
Row 13: K2togfr, k1fr, incfr, k1fr, incsm, k1sm, incsm, k1sm, incrd, k1rd, k2togrd. (15 sts)
Row 14: P3rd, p1sm, p3rd, p3fr, p1sm, p4fr.
Row 15: K2fr, k2sm, k2fr, incfr, k1fr, incrd, k3rd, k2sm, k1rd. (17 sts)
Row 16: P1sm, p4rd, p1sm, p2rd, p7fr, p2sm.
Row 17: K7fr, incfr, k1fr, incrd, k2rd, k1sm, k2rd, k2sm. (19 sts)
Row 18: P2rd, p2sm, p5rd, p1sm, p2fr, p1sm, p6fr.
Row 19: K5fr, k1sm, k2fr, incfr, k1fr, incsm, k8rd. (21 sts)
Row 20: P2sm, p4rd, p2sm, p2rd, p6fr, p2sm, p3fr.
Row 21: K3sm, k6fr, incfr, k1fr, incrd, k3rd, k4sm, k2rd. (23 sts)
Row 22: P5rd, p1sm, p5rd, p12fr.
Row 23: Bind off 11 sts fr, k1fr ibos, k4rd, k1sm, k6rd (hold 12 sts on spare needle for Right Side of Body).

Left Back Leg

With fr, cast on 11 sts.
Beg with a k row, work 2 rows st st.
Join in rd.
Row 3: Incrd, k2rd, k2togfr, k1fr, k2togfr, k2fr, incfr. (11 sts)
Row 4: P6fr, p5rd.
Row 5: Incrd, k2rd, k2togrd, k1fr, k2togfr, k2fr, incfr. (11 sts)
Row 6: P6fr, p5rd.**
Join in sm.

Row 7: K3rd, k1sm, k1rd, k6fr.

Row 8: P6fr, p2rd, p1sm, p2rd.

Row 9: K3rd, k1sm, incsm, k1fr, incfr, k4fr. (13 sts)

Row 10: P7fr, p2rd, p2sm, p2rd.

Row 11: K2togsm, k3rd, incrd, k1fr, incfr, k3fr, k2togfr. (13 sts)

Row 12: P2togfr, p3fr, incfr, p1fr, incsm, p3rd, p2togrd. (13 sts)

Row 13: K2togrd, k1rd, incrd, k1sm, incsm, k1sm, incsm, k1fr, incfr, k1fr, k2togfr. (15 sts)

Row 14: P3fr, p1sm, p3fr, p3rd, p1sm, p4rd.

Row 15: K1rd, k2sm, k3rd, incrd, k1fr, incfr, k2fr, k2sm, k2fr. (17 sts)

Row 16: P2sm, p7fr, p4rd, p1sm, p2rd, p1sm.

Row 17: K2rd, k1sm, k2rd, k2sm, incsm, k1fr, incfr, k7fr. (19 sts)

Row 18: P6fr, p1sm, p2fr, p1sm, p5rd, p2sm, p2rd.

Row 19: K8rd, incsm, k1fr, incfr, k2fr, k1sm, k5fr. (21 sts)

Row 20: P3fr, p2sm, p6fr, p2rd, p2sm, p4rd, p2sm.

Row 21: K3rd, k4sm, k2rd, incrd, k1fr, incfr, k6fr, k3sm. (23 sts)

Row 22: P12fr, p5rd, p1sm, p5rd.

Row 23: K6rd, k1sm, k4rd, k1fr, bind off 11 sts fr (hold 12 sts on spare needle for Left Side of Body).

Right Front Leg

Work as for Right Back Leg to *.

Row 7: K6fr, k5rd.

Row 8: P5rd, p6fr.

Rep rows 7–8 once more.

Join in sm.

Row 11: K6fr, k1rd, k1sm, k3rd.

Row 12: P2rd, p1sm, p2rd, p6fr.

Row 13: K6fr, k3rd, k2sm.

Row 14: P5rd, p6fr.

Row 15: Incfr, k5rd, k4rd, incrd. (13 sts)

Row 16: P7rd, p6fr.

Row 17: K6fr, k5rd, k2sm.

Row 18: P4rd, p1sm, p2rd, p6fr.

Row 19: Bind off 6 sts fr, k1fr ibos, k2rd, k1sm, k3rd (hold 7 sts on spare needle for Right Side of Body).

Left Front Leg

Work as for Left Back Leg to **.

Row 7: K5rd, k6fr.

Row 8: P6fr, p5rd.

Rep rows 7–8 once more.

Join in sm.

Row 11: K3rd, k1sm, k1rd, k6fr.

Row 12: P6fr, p2rd, p1sm, p2rd.

Row 13: K2sm, k3rd, k6fr.

Row 14: P6fr, p5rd.

Row 15: Incrd, k4rd, k5fr, incfr. (13 sts)

Row 16: P6fr, p7rd.

Row 17: K2sm, k5rd, k6fr.

Row 18: P6fr, p4rd, p1sm, p2rd.

Row 19: K3rd, k1sm, k3rd, cast (bind) off 6 sts fr (hold 7 sts on spare needle for Left Side of Body).

Right Side of Body

Row 1: With rd and with RS facing, k7rd from spare needle of Right Front Leg, cast on 1 st rd, join in fr, cast on 13 fr sts. (21 sts) Join in sm.

Row 2: P1sm, p3fr, p2sm, p2fr, p2sm, p3fr, p7rd, incfr. (22 sts)

Row 3: K2fr, k3rd, k1sm, k3rd, k4fr, k1sm, k3fr, k2sm, k2fr, k1sm, cast on 1 st sm, 3 sts fr, 1 st sm, 1 st fr. (28 sts)

Row 4: P1fr, p1sm, p3fr, p2sm, p2fr, p2sm, p3fr, p1sm, p6rd, p1sm, p4rd, p1fr, incfr. (29 sts)

Row 5: K3fr, k4rd, k1sm, k9rd, k2fr, k1sm, k2fr, k2sm, k3fr, k1sm, k1fr, cast on 4 sts fr, with RS facing k8rd, k1sm, k3rd from spare needle of Right Back Leg, then cast on 2 sts rd. (47 sts)

Row 6: P4rd, p1sm, p3rd, p1sm, p2rd, p1sm, p3rd, p1sm, p2fr, p1sm, p4rd, p1sm, p3rd, p1sm, p2rd, p1sm, p5rd, incrd, p1rd, p1sm, p3rd, incrd, p2rd, p1fr, incfr. (50 sts)

Legs

Stuff the feet well, to accentuate the paws.

Head and Neck

Tweek the loopy stitch to give the tiger a good ruff.

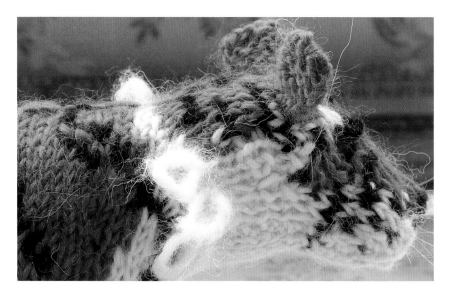

Row 7: K1sm, k2fr, k8rd, k1sm, k6rd, k2sm, k2rd, k1sm, k3rd, k1sm, k5rd, k1sm, k5rd, k1sm, k2rd, k1sm, k4rd, k1sm, k3rd.

Row 8: P2rd, p1sm, p2rd, p1sm, p1rd, p1sm, p3rd, p1sm, p5rd, p1sm, p4rd, p3sm, p2rd, p1sm, p3rd, p1sm, p5rd, incrd, p1sm, p4rd, incrd, p3rd, p1fr, p1sm, p1fr. (52 sts)

Row 9: K2fr, k2sm, k8rd, k2sm, k9rd, k2sm, k2rd, k1sm, k1rd, k1sm, k4rd, k1sm, k2rd, k1sm, k3rd, k1sm, k2rd, k1sm, k2rd, k1sm, k2rd, k1sm, k1rd.

Row 10: P1rd, p1sm, p2rd, p1sm, p1rd, p1sm, p6rd, p1sm, p3rd, p1sm, p4rd, p1sm, p1rd, p1sm, p3rd, p1sm, p4rd, p1sm, p3rd, incrd, p1sm, p6rd, incrd, p1rd, p2sm, p3fr. (54 sts)

Row 11: K3fr, k2rd, k1sm, k1rd, k1sm, k6rd, k2sm, k4rd, k1sm, k3rd, k1sm, k4rd, k2sm, k5rd, k1sm, k3rd, k1sm, k6rd, k1sm, k1rd, k1sm, k4rd.

Row 12: P4rd, p1sm, p1rd, p1sm, p5rd, p2sm, p3rd, p2sm, p4rd, p3sm, p3rd, p1sm, p2rd, p2sm, p4rd, p2sm, p4rd, p1sm, p2rd, p1sm, p2rd, p2fr, p2togfr. (53 sts, place contrast marker at neck end)

Row 13: K3fr, k2rd, k1sm, k2rd, k1sm, k5rd, k2sm, k4rd, k1sm, k2rd, k1sm, k3rd, k2sm, k5rd, k2sm, k3rd, k2sm, k5rd, k1sm, k1rd, k1sm, k4rd.

Row 14: P2rd, p1sm, p1rd, p1sm, p3rd, p1sm, p3rd, p2sm, p3rd, p1sm, p1rd, p1sm, p4rd, p2sm, p2rd, p1sm, p3rd, p1sm, p4rd, p1sm, p2togrd, p3rd, p1sm, p1rd, p2togsm, p1sm, p1rd, p2fr, p2togfr. (50 sts)

Row 15: K3fr, k3rd, k2togsm, k3rd, k2togsm, k10rd, k2sm, k5rd, k2sm, k3rd, k2sm, k3rd, k1sm, k3rd, k1sm, k2rd, k1sm, k2togrd. (47 sts)

Row 16: Bind off 1 st rd, 1 st sm, 2 sts rd, 1 st sm, 3 sts rd, 1 st sm, 3 sts rd,

2 sts sm, 3 sts rd, 2 sts sm, 5 sts rd, 2 sts sm, 10 sts rd, then p4rd ibos, p1sm, p3rd, p1fr, p2togfr. (10 sts)

Row 17: K2togrd, k3rd, k1sm, k2rd, k2togrd. (8 sts)

Bind off 3 sts rd, 1 st sm, 3 sts rd, 1 st fr.

Left Side of Body

Row 1: With rd and with WS facing, p7rd from spare needle of Left Front Leg, cast on 1 st rd, join in fr, cast on 13 sts fr. (21 sts) Join in sm.

Row 2: K1sm, k3fr, k2sm, k2fr, k2sm, k3fr, k7rd, incfr. (22 sts)

Row 3: P2fr, p3rd, p1sm, p3rd, p4fr, p1sm, p3fr, p2sm, p2fr, p1sm, cast on 1 st sm, 3 sts fr, 1 st sm, 1 st fr. (28 sts)

Row 4: K1fr, k1sm, k3fr, k2sm, k2fr, k2sm, k3fr, k1sm, k6rd, k1sm, k4rd, k1fr, incfr. (29 sts)

Row 5: P3fr, p4rd, p1sm, p9rd, p2fr, p1sm, p2fr, p2sm, p3fr, p1sm, p1fr, cast on 4 sts fr, with WS facing p8rd, p1sm, p3rd from spare needle of Left Back Leg, then cast on 2 sts rd. (47 sts)

Row 6: K4rd, k1sm, k3rd, k1sm, k2rd, k1sm, k3rd, k1sm, k2fr, k1sm, k4fr, k1sm, k3rd, k1sm, k2rd, k1sm, k5rd, incrd, k1rd, k1sm, k3rd, incrd, k2rd, k1fr, incfr. (50 sts)

Row 7: P1sm, p2fr, p8rd, p1sm, p6rd, p2sm, p2rd, p1sm, p3rd, p1sm, p5rd, p1sm, p5rd, p1sm, p2rd, p1sm, p4rd, p1sm, p3rd.

Row 8: K2rd, k1sm, k2rd, k1sm, k1rd, k1sm, k3rd, k1sm, k5rd, k1sm, k4rd, k3sm, k2rd, k1sm, k3rd, k1sm, k5rd, incrd, k1sm, k4rd, incrd, k3rd, k1fr, k1sm, k1fr. (52 sts)

Row 9: P2fr, p2sm, p8rd, p2sm, p9rd, p2sm, p2rd, p1sm, p1rd, p1sm, p4rd, p1sm, p2rd, p1sm, p3rd, p1sm, p2rd, p1sm, p2rd, p1sm, p2rd, p1sm, p1rd.

Row 10: K1rd, k1sm, k2rd, k1sm, k1rd, k1sm, k6rd, k1sm, k3rd, k1sm, k4rd, k1sm, k1rd, k1sm, k3rd, k1sm, k4rd, k1sm, k3rd, incrd, k1sm, k6rd, incrd, k1rd, k2sm, k3fr. (54 sts)

Row 11: P3fr, p2rd, p1sm, p1rd, p1sm, p6rd, p2sm, p4rd, p1sm, p3rd, p1sm, p4rd, p2sm, p5rd, p1sm, p3rd, p1sm, p6rd, p1sm, p1rd, p1sm, p4rd.

Row 12: K4rd, k1sm, k1rd, k1sm, k5rd, k2sm, k3rd, k2sm, k4rd, k3sm, k3rd, k1sm, k2rd, k2sm, k4rd, k2sm, k4rd, k1sm, k2rd, k1sm, k2rd, k2fr, k2togfr. (53 sts, place contrast marker at neck end)

Row 13: P3fr, p2rd, p1sm, p2rd, p1sm, p5rd, p2sm, p4rd, p1sm, p2rd, p1sm, p3rd, p2sm, p5rd, p2sm, p3rd, p2sm, p5rd, p1sm, p1rd, p1sm, p2rd, p1sm, p2togrd.

Row 14: K2rd, k1sm, k1rd, k1sm, k3rd, k1sm, k3rd, k2sm, k3rd, k1sm, k1rd, k1sm, k4rd, k2sm, k2rd, k1sm, k3rd, k1sm, k4rd, k1sm, k2togrd, k3rd, k1sm, k1rd, k2togsm, k1sm, k1rd, k2fr, k2togfr. (50 sts)

Row 15: P3fr, p3rd, p2togsm, p3rd, p2togsm, p10rd, p2sm, p5rd, p2sm, p3rd, p2sm, p3rd, p1sm, p3rd, p1sm, p2rd, p1sm, p2togrd. (47 sts)

Row 16: Bind off 1 st rd, 1 st sm, 2 sts rd, 1 st sm, 3 sts rd, 1 st sm, 3 sts rd, 2 sts sm, 3 sts rd, 2 sts sm, 5 sts rd, 2 sts sm, 10 sts rd, then k4rd ibos, k1sm, k3rd, k1fr, k2togfr. (10 sts)

Row 17: P2togfr, p3rd, p1sm, p2rd, p2togrd. (8 sts)

Bind off 3 sts rd, 1 st sm, 3 sts rd, 1 st fr.

Neck and Head

Row 1: With fr and with RS facing, pick up and knit 5 sts fr, 4 sts rd from row ends at neck from marker of Right Side of Body, then pick up and knit 4 sts rd, 5 sts fr from row ends at neck to marker of Left Side of Body. (18 sts)

Row 2: P4fr, p10rd, p4fr. Join in sm.

Row 3: Loopy st 4fr, incrd, k3sm, k2rd, k3sm, incrd, loopy st 4fr. (20 sts)

Row 4: P5fr, p4rd, p2sm, p4rd, p5fr.

Row 5: K4fr, k3sm, k6rd, k3sm, k1fr, wrap and turn (leave 3 sts on left-hand needle unworked).

Row 6: Working top of head on center 14 sts only, p1fr, p4sm, p4rd, p4sm, p1fr, w&t.

Row 7: K1fr, k5sm, k2rd, k5sm, k1fr, w&t.

Row 8: P1fr, p4sm, p4rd, p4sm, p1fr, w&t.

Row 9: K3fr, k3rd, k2sm, k3rd, k6fr. (20 sts in total)

Row 10: P2fr, p5sm, p6rd, p5sm, p2fr.

Row 11: K5fr, k4rd, k2sm, k4rd, k2fr, w&t (leave 3 sts on left-hand needle unworked).

Row 12: Working on center 14 sts only, p2fr, p2rd, p2sm, p2rd, p2sm, p2rd, p2fr, w&t.

Row 13: K2sm, k3fr, k4rd, k3fr, k2sm, w&t.

Row 14: P2rd, p3fr, p4rd, p3fr, p2rd, w&t.

Row 15: K3rd, k2fr, k4rd, k2fr, k3rd, w&t.

Row 16: P3rd, p3sm, p2rd, p3sm, p3rd, w&t.

Row 17: K2sm, k10rd, k2sm, k3fr. (20 sts in total)

Row 18: P3sm, p1fr, [p2togrd] twice, p4rd, [p2togrd] twice, p1fr, p3sm. (16 sts)

Row 19: K4fr, k2togsm, k4rd, k2togsm, k4fr. (14 sts)

Row 20: Incfr, p1sm, p1fr, incsm, p6rd, incsm, p1fr, p1sm, incfr. (18 sts)

Row 21: K3fr, k1sm, k2fr, k6rd, k2fr, k1sm, k3fr.

Row 22: P1fr, p1sm, p3fr, p1sm, p6rd, p1sm, p3fr, p1sm, p1fr.

Row 23: K3fr, k1sm, k3fr, k4rd, k3fr, k1sm, k3fr.

Row 24: P2togfr, p2fr, p2togfr, p1sm, p4rd, p1sm, p2togfr, p2fr, p2togfr. (14 sts)

Row 25: K2togfr, k3fr, k4rd, k3fr, k2togfr. (12 sts)

Row 26: P2togfr, p2fr, p4rd, p2fr, p2togfr. (10 sts)

Bind off 3 sts fr, 4 sts rd, 3 sts fr.

Tummy

With rd, cast on 6 sts.
Beg with a k row, work 2 rows st st.
Cont in fr.
Row 3: K2tog, k2, k2tog. (4 sts)
Work 15 rows st st.
Row 19: Inc, k2, inc. (6 sts)
Work 8 rows st st.
Join in sm.
Row 28: P2sm, p2fr, p2sm.
Work 4 rows st st in fr.
Row 33: K2sm, k2fr, k2sm.
Row 34: P2sm, p2fr, p2sm.
Cont in fr.
Work 4 rows st st.
Row 39: Inc, k4, inc. (8 sts)
Work 2 rows st st.
Join in sm.
Row 42: P3sm, p2fr, p3sm.
Cont in fr.
Work 4 rows st st.
Row 47: K2tog, k4, k2tog. (6 sts)

Work 5 rows st st.
Row 53: Inc, k4, inc. (8 sts)
Work 6 rows st st.
Join in sm.
Row 60: P2fr, p1sm, p2fr, p1sm, p2fr.
Row 61: K2sm, k4fr, k2sm.
Work 2 rows st st in fr.
Row 64: P2sm, p4fr, p2sm.
Cont in fr.
Work 10 rows st st.
Row 75: K2tog, k4, k2tog. (6 sts)
Work 3 rows st st.
Join in sm.
Row 79: K2sm, k2fr, k2sm.
Cont in fr.
Work 7 rows st st.
Row 87: K2tog, k2, k2tog. (4 sts)
Row 88: Purl.
Bind off.

Ear

(make 2 the same)
With rd, cast on 5 sts.
Knit 6 rows.
Row 7: K2tog, k1, k2tog. (3 sts)
Row 8: K3tog and fasten off.

Tail

With rd, cast on 8 sts.
Row 1: Knit.
***Row 2:** Purl.
Join in sm.
Row 3: K2sm, k4rd, k2sm.
Row 4: P3sm, p2rd, p3sm.
Row 5: K1rd, k6sm, k1rd.
Row 6: P3sm, p2rd, p3sm.
Row 7: K2sm, k4rd, k2sm.**
Rep from * to ** twice more.
Row 22: Purl in rd.
Row 23: K2togrd, k4rd, k2togrd. (6 sts)
Row 24: P1sm, p4rd, p1sm.
Row 25: K2sm, k2rd, k2sm.
Row 26: P6sm.
Row 27: K2sm, k2rd, k2sm.
Row 28: P1sm, p4rd, p1sm.
Row 29: K6rd.
Row 30: P2togrd, p2sm, p2togrd. (4 sts)
Cont in sm.
Row 31: Knit.
Row 32: [P2tog] twice.
Row 33: K2tog and fasten off.

Tail
Bend the tail into a soft curve.

To Finish

SEWING IN ENDS Sew in ends, leaving ends from cast on rows and bound off rows for sewing up.

LEGS With WS together, fold the leg in half. Starting at the paw, sew up leg on RS.

HEAD Fold bound off row of head in half and sew from nose to chin.

BODY Sew along the back of tiger and around bottom.

TUMMY Sew cast on row of tummy to base of bottom (to where back legs begin), and sew bound off row to nose. Ease and sew tummy to fit body. Leave a 1in (2.5cm) gap between front and back legs on one side.

STUFFING Pipecleaners are used to stiffen the legs and help bend them into shape. Fold a pipecleaner into a 'U' shape and measure against the front two legs. Cut to approximately fit, leaving an extra 1in (2.5cm) at both ends. Fold these ends over to stop pipecleaner poking out of paws. Roll a little stuffing around pipecleaner and slip into the body, one end down each front leg. Rep with second pipecleaner and back legs. Starting at the head, stuff the tiger firmly, then sew up the gap. Mold body into shape.

TAIL Cut a pipecleaner to approximately fit the tail, leaving an extra 1in (2.5cm) at both ends. Fold one end, place at tip of tail, wrap tail around pipecleaner, and sew up. Push protruding pipecleaner into tiger's bottom and attach.

EARS Attach the cast on row of ears to side of tiger's head, leaving 5 sts between ears.

EYES With sm, sew 3-loop French knots positioned as in photograph.

NOSE With sm, embroider nose in satin stitch.

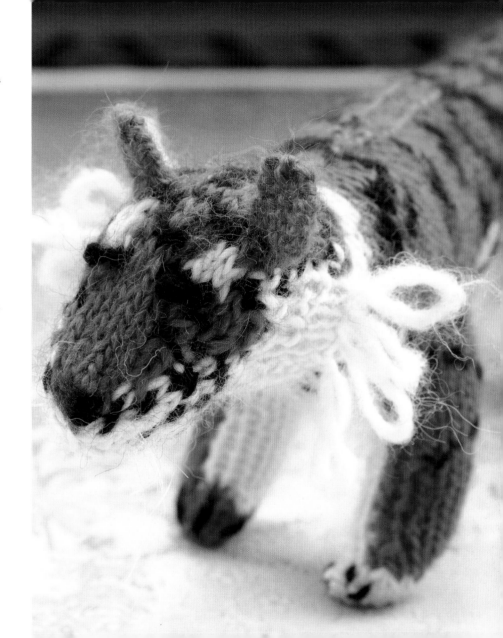

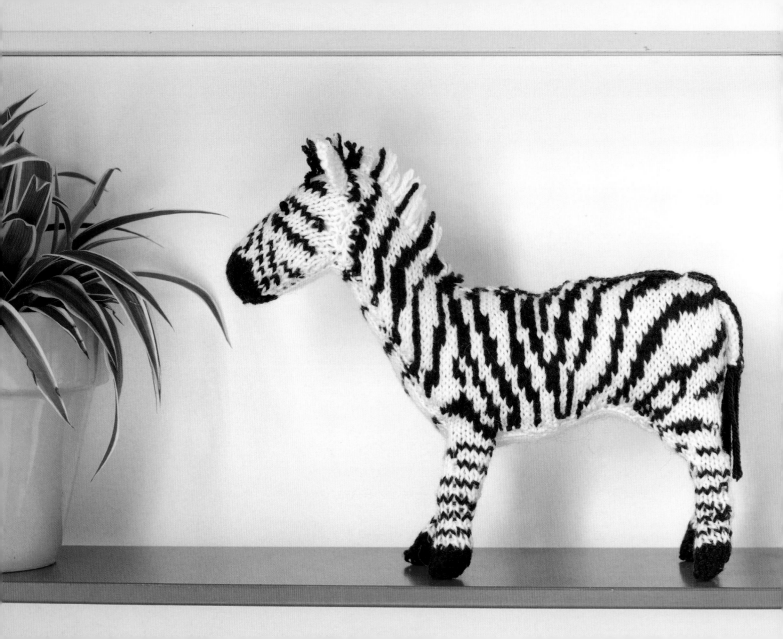

Zebra

A living, walking Bridget Riley, the zebra is instantly recognizable and much loved. They are part of the horse species, although they have never been domesticated. Some think the stripes developed to confuse predators—a herd of moving zebras can look like one large animal, making it difficult for a lion to pick off one zebra. Attempts have been made to ride zebras, mostly unsuccessful, except for Rosendo Riberio, the first doctor in Kenya, who used to ride a zebra to make house calls.

Zebra

Loads of Fair Isle, but rewarding once knitted.

Measurements
Length: 10in (25cm)
Height to top of head: 7in (18cm)

Materials
- Pair of US 2 (2¾mm) knitting needles
- Double-pointed US 2 (2¾mm) knitting needles (for holding stitches and for tail)
- ½oz (15g) of Rowan Pure Wool 4ply in Black 404 (bl)
- ¾oz (20g) of Rowan Pure Wool 4ply in Snow 412 (sn)
- 2 pipecleaners for legs
- Crochet hook for tail tassel

Abbreviations
See page 172.
See page 172 for Wrap and Turn Method.
See page 172 for Color Knitting.
See page 172 for I-cord Technique.

Right Back Leg
With bl, cast on 11 sts.
Beg with a k row, work 2 rows st st.
Row 3: Inc, k2, k2tog, k1, k2tog, k2, inc. (11 sts)
Row 4: Purl.
Join in and cont in sn.
Row 5: K3, k2tog, k1, k2tog, k3. (9 sts)
Row 6: Purl.*
Row 7: K2sn, k7bl.
Row 8: Purl in sn.
Row 9: Incsn, k1sn, k2togsn, k1sn, k2togsn, k1sn, incsn. (9 sts)
Row 10: P5bl, p4sn.

Row 11: Knit in sn.
Row 12: P2bl, p7sn.
Row 13: K2sn, k5bl, k2sn.
Row 14: Purl in sn.
Row 15: Knit in sn.
Row 16: P6bl, p3sn.
Row 17: Incsn, k7sn, incsn. (11 sts)**
Row 18: Incsn, p9sn, incsn. (13 sts)
Row 19: K4sn, k2togsn, k1sn, k2togbl, k4bl. (11 sts)
Row 20: P5sn, p3bl, p3sn.
Row 21: K2togsn, k2sn, incsn, k1sn, incsn, k2sn, k2togsn. (11 sts)
Row 22: Purl in sn.
Row 23: K4sn, incsn, k1sn, incsn, k4bl. (13 sts)
Row 24: P4sn, k4bl, p5sn.
Row 25: K5sn, incsn, k1sn, incsn, k5sn. (15 sts)
Row 26: Purl in sn.
Row 27: Incsn, k5sn, incsn, k1sn, incsn, k5bl, incbl. (19 sts)
Row 28: P3sn, p9bl, p7sn.
Row 29: K8sn, incsn, k1sn, incsn, k8sn. (21 sts)
Row 30: P8sn, p3bl, p10sn.
Row 31: Bind off 10 sts sn, k1sn ibos, k3bl, k7sn (hold 11 sts on spare needle for Right Side of Body).

Left Back Leg
Work as for Right Back Leg to *.
Row 7: K7bl, k2sn.
Row 8: Purl in sn.
Row 9: Incsn, k1sn, k2togsn, k1sn, k2togsn, k1sn, incsn. (9 sts)
Row 10: P4sn, p5bl.
Row 11: Knit in sn.
Row 12: P7sn, p2bl.
Row 13: K2sn, k5bl, k2sn.
Row 14: Purl in sn.
Row 15: Knit in sn.
Row 16: P3sn, p6bl.
Row 17: Incsn, k7sn, incsn. (11 sts)**

Front Leg
The legs quite thin, so it's easiest to wrap a little stuffing around the pipecleaner, wrap the leg around the pipecleaner, and then sew up on the right side.

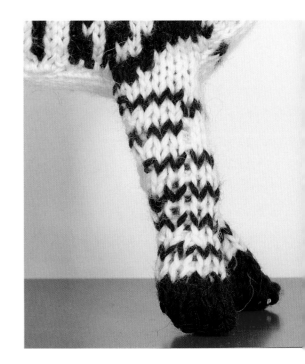

Row 18: Incsn, p9sn, incsn. (13 sts)
Row 19: K4bl, k2togbl, k1sn, k2togsn, k4sn. (11 sts)
Row 20: P3sn, p3bl, p5sn.
Row 21: K2togsn, k2sn, incsn, k1sn, incsn, k2sn, k2togsn. (11 sts)
Row 22: Purl in sn.
Row 23: K4bl, incsn, k1sn, incsn, k4sn. (13 sts)
Row 24: P5sn, k4bl, p4sn.
Row 25: K5sn, incsn, k1sn, incsn, k5sn. (15 sts)
Row 26: Purl in sn.
Row 27: Incbl, k5bl, incsn, k1sn, incsn, k5sn, incsn. (19 sts)
Row 28: P7sn, p9bl, p3sn.
Row 29: K8sn, incsn, k1sn, incsn, k8sn. (21 sts)
Row 30: P10sn, p3bl, p8sn.
Row 31: K7sn, k3bl, k1sn, bind off 10 sts sn (hold 11 sts on spare needle for Left Side of Body).

Right Front Leg

Work as for Right Back Leg to **.
Row 18: Purl in sn.
Row 19: K7sn, k4bl.
Row 20: Purl in sn.
Row 21: Incsn, k4sn, k3bl, k2sn, incsn. (13 sts)
Row 22: P5bl, p8sn.
Row 23: Incsn, k11sn, incsn. (15 sts)
Row 24: P1bl, p14sn.
Row 25: Bind off 7 sts sn, k5sn ibos, k2bl, k1sn (hold 8 sts on spare needle for Right Side of Body).

Left Front Leg

Work as for Left Back Leg to **.
Row 18: Purl in sn.
Row 19: K4bl, k7sn.
Row 20: Purl in sn.
Row 21: Incsn, k2sn, k3bl, k4sn, incsn. (13 sts)

Row 22: P8sn, p5bl.
Row 23: Incsn, k11sn, incsn. (15 sts)
Row 24: P14sn, p1bl.
Row 25: K1sn, k2bl, k5sn, bind off 7 sts sn (hold 8 sts on spare needle for Left Side of Body).

Right Side of Body

Row 1: With sn, cast on 1 st, with RS facing k4sn, k2bl, k1sn, k1bl from spare needle of Right Front Leg, cast on 1 st sn, 2 sts bl, 2 sts sn, 1 st bl, 2 sts sn. (17 sts)
Row 2: P2sn, p1bl, p2sn, p2bl, p1sn, p1bl, p2sn, p2bl, p3sn, incbl. (18 sts)
Row 3: Incsn, k2bl, k1sn, k3bl, k1sn, k2bl, k1sn, k2bl, k2sn, k1bl, k2sn, cast on 1 st bl, 1 st sn, 1 st bl, 1 st sn, 1 st bl, 2 sts sn. (26 sts)
Row 4: P2sn, p1bl, p1sn, p1bl, p1sn, p1bl, p2sn, p1bl, p2sn, p2bl, p2sn, p1bl, p2sn, p4bl, p2sn, incsn. (27 sts)
Row 5: K5sn, k3bl, k2sn, k1bl, k2sn, k2bl, k2sn, k1bl, k2sn, k1bl, k1sn, k1bl, k1sn, k2bl, k1sn, cast on 2 sts sn, 1 st bl. (30 sts)
Row 6: P1bl, p3sn, p1bl, p2sn, p1bl, p1sn, p1bl, p2sn, p2bl, p1sn, p3bl, p1sn, p2bl, p2sn, p1bl, p4sn, p1bl, incsn. (31 sts)
Row 7: K2sn, k1bl, k7sn, k1bl, k2sn, k2bl, k2sn, k2bl, k2sn, k1bl, k1sn, k1bl, k2sn, k2bl, k2sn, k1bl, cast on 1 st bl, 2 sts sn, 1 st bl, with RS facing k1bl, k3sn, k1bl, k2sn, k2bl, k2sn from spare needle of Right Back Leg, cast on 2 sts sn. (48 sts)
Row 8: P2sn, p3bl, p2sn, p2bl, p3sn, p2bl, p2sn, p1bl, p2sn, p2bl, p2sn, p3sn, p1bl, p1sn, p2bl, p2sn, p2bl, p1sn, p2bl, p2sn, p2bl, p1sn, p1bl, p3sn, p2bl, p1sn, p1bl. (48 sts)
Row 9: K1bl, k1sn, k2bl, k2sn, k2bl, k1sn, k1bl, k2sn, k2bl, k2sn, k2bl, k2sn, k2bl, k1sn, k1bl, k4sn, k1bl, k2sn, k2bl, k2sn, k2bl, k1sn, k1bl, k3bl, incbl. (49 sts)
Row 10: P3bl, p5sn, p1bl, p2sn, p2bl, p3sn, p1bl, p2sn, p2bl, p4sn, p1bl, p1sn, p2bl, p2sn, p2bl, p2sn, p2bl, p2sn, p1bl, p2sn, p1bl, p2sn, p1bl, p2sn, incbl. (50 sts)

Row 11: K1sn, k1bl, k2sn, k1bl, k2sn, k1bl, k1sn, k2bl, k1sn, k2bl, k2sn, k2bl, k2sn, k3bl, k2sn, k1bl, k4sn, k1bl, k2sn, k2bl, k3bl, k5bl, k6sn, incbl. (51 sts)
Row 12: P1bl, p6sn, p4bl, p4sn, p2bl, p2sn, p2bl, p3sn, p2bl, p1sn, p2bl, p1sn, p1bl, p2sn, p2bl, p2sn, p2bl, p2sn, p2bl, p3sn, p1bl, p2sn, p1bl, incsn. (52 sts)
Row 13: K2sn, k1bl, k2sn, k1bl, k3sn, k2bl, k2sn, k2bl, k2sn, k2bl, k1sn, k2bl, k2sn, k1bl, k2sn, k1bl, k4sn, k1bl, k2sn, k2bl, k7sn, k3bl, k4sn, incbl. (53 sts)
Row 14: P4sn, p3bl, p8sn, p2bl, p3sn, p1bl, p3sn, p2bl, p2sn, p1bl, p2sn, p2bl, p2sn, p1bl, p3sn, p1bl, p2sn, p2bl, p2sn, p2bl, p2sn, p1bl, p1sn, incsn. (54 sts)
Row 15: K3sn, k1bl, k2sn, k2bl, k2sn, k2bl, k1sn, k2bl, k3sn, k1bl, k2sn, k1bl, k3sn, k2bl, k2sn, k3bl, k2bl, k2sn, k2bl, k3bl, k9sn, k2bl, k3sn.
Row 16: P2sn, p2bl, p9sn, p3bl, p3sn, p1bl, p3sn, p2bl, p2sn, p2bl, p1sn, p1bl, p1sn, p2bl, p1sn, p1bl, p3sn, p2bl, p2sn, p2bl, p1sn, p1bl, p3sn, p1bl, p2sn, incbl. (55 sts)
Row 17: K2bl, k2sn, k1bl, k3sn, k1bl, k1sn, k2bl, k2sn, k1bl, k4sn, k1bl, k1sn, k2bl, k1sn, k1bl, k1sn, k2bl, k2sn, k2bl, k3sn, k1bl, k4sn, k2bl, k9sn, k3bl, k1sn.
Row 18: P1sn, p2bl, p9sn, p2bl, p4sn, p2bl, p3sn, p1bl, p3sn, p1bl, p2sn, p1bl, p1sn, p2bl, p1sn, p2bl, p3sn, p2bl, p1sn, p2bl, p1sn, p1bl, p3sn, p1bl, p2sn, p1bl, incsn. (56 sts)
Row 19: K2sn, k1bl, k2sn, k1bl, k3sn, k1bl, k1sn, k2bl, k2sn, k1bl, k3sn, k1sn, k2bl, k1sn, k1bl, k2sn, k2bl, k2sn, k2bl, k3sn, k1bl, k5sn, k3bl, k8sn, k2bl.
Row 20: P2bl, p5sn, p5bl, p5sn, p2bl, p3sn, p2bl, p2sn, p2bl, p1sn, p2bl, p1sn, p2bl, p1sn, p2bl, p3sn, p2bl, p2sn, p1bl, p1sn, p1bl, p3sn, p1bl, p2sn, p1sn, incsn. (57 sts)
Row 21: K3sn, k2bl, k1sn, k1bl, k3sn, k3bl, k2sn, k2bl, k2sn, k3bl, k2sn, k1bl, k1sn, k2bl, k2sn, k2bl, k2sn, k1bl, k3sn, k2bl, k6sn, k6bl, k3sn, k2togsn. (56 sts)

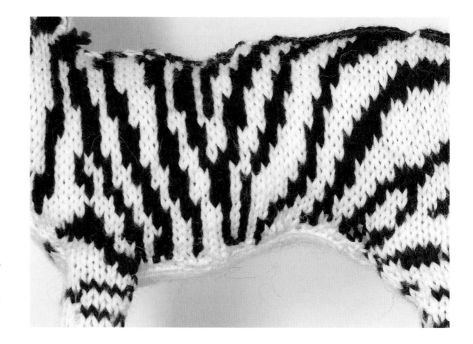

Body

Be careful not to pull the strands across the back of the work too tight or the body will pucker up; you can press the knitting to flatten it out.

Row 22: P3sn, p5bl, p6sn, p3bl, p4sn, p1bl, p2sn, p2bl, p1sn, p2bl, p2sn, p1bl, p1sn, p2bl, p1sn, p1bl, p2sn, p2bl, p2sn, p3bl, p2sn, p2bl, p1sn, p2bl, p2sn, incbl. (57 sts)

Row 23: K1sn, k1bl, k2sn, k2bl, k2sn, k1bl, k3sn, k2bl (hold 14 sts on spare needle for neck), bind off 2 sts sn, 2 sts bl, 2 sts sn, 1 st bl, 1 st sn, 2 sts bl, 1 st sn, 3 sts bl, k2bl ibos, k2sn, k2bl, k1sn, k2bl, k4sn, k4bl, k7sn, k2bl, k1sn, k2togsn.

Working on rem 28 sts:

Row 24: P2togbl, p1bl, p7sn, p4bl, p4sn, p2bl, p2sn, p2bl, p2sn, p2bl. (27 sts)

Row 25: Bind off 2 sts bl, 2 sts sn, 1 st bl, 1 st sn, k3sn ibos, k2bl, k4sn, k5bl, k5sn, k2togbl. (20 sts)

Row 26: Bind off 20 sts bl.

Left Side of Body

Row 1: With sn, cast on 1 st, with WS facing p4sn, p2bl, p1sn, p1bl from spare needle of Left Front Leg, cast on 1 st sn, 2 sts bl, 2 sts sn, 1 st bl, 2 sts sn. (17 sts)

Row 2: K2sn, k1bl, k2sn, k2bl, k1sn, k1bl, k2sn, k2bl, k3sn, incbl. (18 sts)

Row 3: Incsn, p2bl, p1sn, p3bl, p1sn, p2bl, p1sn, p2bl, p2sn, p1bl, p2sn, cast on 1 st bl, 1 st sn, 1 st bl, 1 st sn, 1 st bl, 2 st sn. (26 sts)

Row 4: K2sn, k1bl, k1sn, k1bl, k1sn, k1bl, k2sn, k1bl, k2sn, k2bl, k2sn, k1bl, k2sn, k4bl, k2sn, incsn. (27 sts)

Row 5: P5sn, p3bl, p2sn, p1bl, p2sn, p2bl, p2sn, p1bl, p2sn, p1bl, p1sn, p1bl, p1sn, p2bl, p1sn, cast on 2 sts sn, 1 st bl. (30 sts)
Row 6: K1bl, k3sn, k1bl, k2sn, k1bl, k1sn, k1bl, k2sn, k2bl, k1sn, k1bl, k3bl, k1sn, k2bl, k2sn, k1bl, k4sn, k1bl, incsn. (31 sts)
Row 7: P2sn, p1bl, p7sn, p1bl, p2sn, p2bl, p2sn, p2bl, p2sn, p1bl, p1sn, p1bl, p2sn, p2bl, p2sn, p1bl, cast on 1 st bl, 2 sts sn, 1 st bl, with WS facing p1bl, p3sn, p1bl, p2sn, p2bl, p2sn from spare needle of Left Back Leg, cast on 2 sts sn. (48 sts)
Row 8: K2sn, k3bl, k2sn, k2bl, k3sn, k2bl, k2sn, k1bl, k2sn, k2bl, k3sn, k1bl, k1sn, k2bl, k2sn, k2bl, k1sn, k2bl, k2sn, k2bl, k1sn, k1bl, k3sn, k2bl, k1sn, k1bl. (48 sts)
Row 9: P1bl, p1sn, p2bl, p2sn, p2bl, p1sn, p1bl, p2sn, p2bl, p2sn, p2bl, p2bl, p1sn, p1bl, p4sn, p1bl, p2sn, p2bl, p2bl, p3sn, p1bl, p3sn, p3bl, incbl. (49 sts)
Row 10: K3bl, k5sn, k1bl, k2sn, k2bl, k3sn, k1bl, k2sn, k2bl, k4sn, k1bl, k1sn, k2bl, k2sn, k2bl, k2sn, k2bl, k2sn, k1bl, k2sn, k1bl, k2sn, k1bl, k2sn, incbl. (50 sts)
Row 11: P1sn, p1bl, p2sn, p1bl, p2sn, p1bl, p1sn, p2bl, p1sn, p2bl, p2sn, p2bl, p3bl, p2sn, p1bl, p4sn, p1bl, p2bl, p2bl, p3sn, p5bl, p6sn, incbl. (51 sts)
Row 12: K1bl, k6sn, k4bl, k4sn, k2bl, k2sn, k2bl, k3sn, k2bl, k1sn, k2bl, k1sn, k1bl, k2sn, k2bl, k2sn, k2bl, k2sn, k2bl, k3sn, k1bl, k2sn, k1bl, incsn. (52 sts)
Row 13: P2sn, p1bl, p2sn, p1bl, p3sn, p2bl, p2sn, p2bl, p2sn, p2bl, p1sn, p2bl, p2sn, p1bl, p2sn, p1bl, p4sn, p1bl, p2sn, p2bl, p7sn, p3bl, p4sn, incbl. (53 sts)
Row 14: K4sn, k3bl, k8sn, k2bl, k3sn, k1bl, k3sn, k2bl, k2sn, k1bl, k2sn, k2bl, k2sn, k1bl, k3sn, k1bl, k2sn, k2bl, k2sn, k1bl, k1sn, incsn. (54 sts)
Row 15: P3sn, p1bl, p2sn, p2bl, p2sn, p2bl, p1sn, p2bl, p3sn, p1bl, p2sn, p1bl, p3sn, p2bl, p2sn, p1bl, p3sn, p2bl, p3bl, p9sn, p2bl, p3sn.

Row 16: K2sn, k2bl, k9sn, k3bl, k3sn, k1bl, k3sn, k2bl, k2sn, k2bl, k1sn, k1bl, k1sn, k2bl, k1sn, k1bl, k3sn, k2bl, k2sn, k2bl, k1sn, k1bl, k3sn, k1bl, k2sn, incbl. (55 sts)
Row 17: P2bl, p2sn, p1bl, p3sn, p1bl, p1sn, p2bl, p2sn, p1bl, p4sn, p1bl, p1sn, p2bl, p1sn, p1bl p1sn, p2bl, p2sn, p2bl, p3sn, p1bl, p4sn, p2bl, p9sn, p3bl, p1sn.
Row 18: K1sn, k2bl, k9sn, k2bl, k4sn, k2bl, k3sn, k1bl, k3sn, k1bl, k2sn, k1bl, k1sn, k2bl, k1sn, k2bl, k3sn, k1bl, k2sn, k2bl, k1sn, k1bl, k3sn, k1bl, k2sn, k2bl, k1sn, k1bl. (56 sts)
Row 19: P2sn, p1bl, p2sn, p1bl, p3sn, p1bl, p1sn, p2bl, p2sn, p1bl, p3sn, p2bl, p1sn, p2bl, p1sn, p1bl, p2sn, p2bl, p2sn, p2bl, p3sn, p1bl, p5sn, p3bl, p8sn, p2bl.
Row 20: K2bl, k5sn, k5bl, k5sn, k2bl, k3sn, k2bl, k2sn, k2bl, k1sn, k2bl, k1sn, k2bl, k1sn, k2bl, k3sn, k2bl, k1sn, k1bl, k3sn, k1bl, k1sn, k2bl, k1sn, incsn. (57 sts)
Row 21: P3sn, p2bl, p1sn, p1bl, p3sn, p3bl, p2sn, p2bl, p2sn, p3bl, p2sn, p1bl, p1sn, p2bl, p2sn, p2bl, p2sn, p1bl, p3sn, p2bl, p6sn, p6bl, p3sn, p2togsn. (56 sts)
Row 22: K3sn, k5bl, k6sn, k3bl, k4sn, k1bl, k2sn, k2bl, k1sn, k2bl, k2sn, k1bl, k1sn, k2bl, k1sn, k1bl, k2sn, k3bl, k2sn, k2bl, k1sn, k2bl, k2sn, incbl. (57 sts)
Row 23: P1sn, p1bl, p2sn, p2bl, p2sn, p1bl, p3sn, p2bl (hold 14 sts on spare needle for neck), bind off 2 sts sn, 2 sts bl, 2 sts sn, 1 st bl, 1 st sn, 2 sts bl, 1 st sn, 3 sts bl, p2bl ibos, p2sn, p2bl, p1sn, p4sn, p4bl, p7sn, p2bl, p1sn, p2togsn.
Working on rem 28 sts:
Row 24: K2togbl, k1bl, k7sn, k4bl, k4sn, k2bl, k2sn, k2bl, k2sn, k2bl. (27 sts)
Row 25: Bind off 2 sts bl, 2 sts sn, 1 st bl, 1 st sn, p3sn ibos, p2bl, p4sn, p5bl, p5sn, p2togbl. (20 sts)
Row 26: Bind off 20 sts bl.

Neck and Head

Row 1: With sn, cast on 1 st, k1sn, k2bl, k1sn, k2bl, k3sn, k1bl, k2sn, k2togsn from spare needle of Right Side of Body, then k2togsn, k2sn, k1bl, k3sn, k2bl, k1sn, k2bl, incsn from spare needle of Left Side of Body. (28 sts)
Row 2: P3sn, p1bl, p1sn, p2bl, p3sn, p2bl, [p2togbl] twice, p2bl, p3sn, p2bl, p1sn, p1bl, p3sn. (26 sts)
Row 3: K2bl, k2sn, k1bl, k3sn, k3bl, k4sn, k3bl, k3sn, k1bl, k2sn, k2bl.
Row 4: P1sn, p1bl, p2sn, p2bl, p4sn, p1bl, [p2togbl] twice, p1bl, p4sn, p2bl, p2sn, p1bl, p1sn. (24 sts)
Row 5: Incsn, k1bl, k3sn, k1bl, k12sn, k1bl, k3sn, k1bl, incsn. (26 sts)
Row 6: P2sn, p2bl, p2sn, p2bl, p3sn, [p2togsn] twice, p3sn, p2bl, p2sn, p2bl, p2sn. (24 sts)
Row 7: K3sn, k1bl, k3sn, k2bl, k6sn, k2bl, k3sn, k1bl, k2sn, wrap and turn (leave 1 st on left-hand needle unworked).
Row 8: P2sn, p2bl, p3sn, p2bl, p4sn, p2bl, p3sn, p2bl, p2sn, w&t.
Row 9: K3sn, k1bl, k5sn, [k2togsn] twice, k5sn, k1bl, k3sn, w&t.
Row 10: P2sn, p2bl, p10sn, p2bl, p2sn, w&t.
Row 11: K3sn, k1bl, k10sn, k1bl, k2sn, w&t.
Row 12: P2sn, p2bl, p8sn, p2bl, p2sn, w&t.
Row 13: K3sn, k3bl, k4sn, k3bl, k2sn, w&t.
Row 14: P4sn, p2bl, p2sn, p2bl, p4sn, w&t.
Row 15: K1bl, k5sn, k2bl, k5sn, w&t.
Row 16: P1bl, p10sn, p1bl, w&t.
Row 17: K2bl, k8sn, k1bl, w&t.
Row 18: P1sn, p2bl, p4sn, p2bl, p1sn, w&t.
Row 19: K4sn, k4bl, k3sn, w&t.
Row 20: P12sn, w&t.
Row 21: K13sn, w&t.
Row 22: P14sn, w&t.
Row 23: K2sn, k2bl, k6sn, k2bl, k3sn, w&t.
Row 24: P4sn, p2bl, p4sn, p2bl, p4sn, w&t.
Row 25: K5sn, k2bl, k2sn, k2bl, k6sn, w&t.

Row 26: P1sn, p1bl, p6sn, p2bl, p6sn, p2bl, w&t.
Row 27: K1sn, k3bl, k10sn, k2bl, k3sn, w&t.
Row 28: P5sn, p3bl, p4sn, p3bl, p5sn, w&t.
Row 29: K8sn, k4bl, k9sn. (22 sts in total)
Row 30: Incsn, p2bl, p16sn, p2bl, incsn. (24 sts)
Row 31: K4sn, k3bl, k10sn, k3bl, k4sn.
Row 32: P7sn, p3bl, p4sn, p3bl, p7sn.
Row 33: K11sn, k2bl, k11sn.
Row 34: P1bl, p9sn, p1bl, p2sn, p1bl, p9sn, p1bl.
Row 35: K2togbl, k2bl, k2sn, k1bl, k2sn, k1bl, k4sn, k1bl, k2sn, k1bl, k2sn, k2bl, k2togbl. (22 sts)
Row 36: P4sn, p1bl, p2sn, p1bl, p2sn, p2bl, p2sn, p1bl, p2sn, p1bl, p4sn.
Row 37: K2togsn, k1sn, k1bl, k2sn, k1bl, k2sn, k1bl, k2sn, k1bl, k2sn, k1bl, k2sn, k1bl, k1sn, k2togsn. (20 sts)
Row 38: P1sn, p1bl, p2sn, p1bl, p2sn, p1bl, p4sn, p1bl, p2sn, p1bl, p2sn, p1bl, p1sn.
Row 39: K3sn, k1bl, k3sn, k1bl, k4sn, k1bl, k3sn, k1bl, k3sn.
Row 40: P2sn, p1bl, p2sn, p1bl, p2sn, p1bl, p2sn, p1bl, p2sn, p1bl, p2sn, p1bl, p2sn.
Row 41: K2togsn, k2sn, k12bl, k2sn, k2togsn. (18 sts)
Cont in bl.
Work 2 rows st st.
Row 44: Bind off 5 sts, p to end. (13 sts)
Row 45: Bind off 5 sts, k to end. (8 sts)
Work 3 rows st st.
Row 49: [K2tog] 4 times. (4 sts)
Bind off.

Tummy

With sn, cast on 8 sts.
Beg with a k row, work 2 rows st st.
Row 3: K2tog, k4, k2tog. (6 sts)
Row 4: P2tog, p2, p2tog. (4 sts)
Work 10 rows st st.
Row 15: Inc, k2, inc. (6 sts)
Row 16: Inc, p4, inc. (8 sts)
Work 30 rows st st.
Row 47: K2tog, k4, k2tog. (6 sts)
Row 48: P2tog, p2, p2tog. (4 sts)
Work 6 rows st st.
Row 55: Inc, k2, inc. (6 sts)
Row 56: Purl.
Join in bl.
Row 57: K2sn, k2bl, k2sn.
Row 58: P2bl, p2sn, p2bl.
Cont in sn.
Row 59: Inc, k4, inc. (8 sts)
Work 5 rows st st.
Join in bl.
Row 65: K3sn, k2bl, k3sn.
Row 66: P2sn, p1bl, p2sn, p1bl, p2sn.
Row 67: K2bl, k4sn, k2bl.
Cont in sn.
Work 3 rows st st.
Join in bl.
Row 71: K3sn, k2bl, k3sn.
Row 72: P3bl, p2sn, p3bl.
Cont in sn.
Work 2 rows st st.
Row 75: K2tog, k4, k2tog. (6 sts)
Work 3 rows st st.
Join in bl.
Row 79: K2sn, k2bl, k2sn.
Row 80: P2bl, p2sn, p2bl.
Cont in sn.
Work 2 rows st st.
Join in bl.
Row 83: K2sn, k2bl, k2sn.
Row 84: P2bl, p2sn, p2bl.
Cont in sn.
Work 12 rows st st.
Row 97: K1, [k2tog] twice, k1. (4 sts)

Work 3 rows st st.
Cont in bl.
Work 3 rows st st.
Bind off.

Tail

With double-pointed needles and sn and bl, cast on 2 sts sn, 2 sts bl, 2 sts sn. (6 sts)
Keeping stripe patt as set, work in i-cord as folls:
Knit 12 rows.
Bind off.

Ear

(make 2 the same)
With sn, cast on 6 sts.
Knit 6 rows.
Row 7: K2tog, k2, k2tog. (4 sts)
Knit 2 rows.
Row 10: [K2tog] twice. (2 sts)
Row 11: K2tog and fasten off.

To Finish

SEWING IN ENDS Sew in ends, leaving ends from cast on rows and bound off rows for sewing up.
LEGS With WS together, fold leg in half. Starting at foot, sew up legs on RS.
BODY Sew along back of zebra and around bottom.
NOSE Sew center section of nose to the sides of nose to make a square shape.
TUMMY Sew cast on row of tummy to bottom of zebra's bottom (where legs begin), and sew bound off row to nose. Ease and sew tummy to fit body, matching curves of tummy to legs. Leave a 1in (2.5cm) gap between front and back legs on one side.
STUFFING Pipecleaners are used to stiffen the legs and help bend them into shape. Fold a pipecleaner into a 'U' shape and measure against front two legs. Cut to approximately fit, leaving an extra 1in (2.5cm) at both ends. Fold these ends over to

stop the pipecleaner poking out of the hooves. Roll a little stuffing around pipecleaner and slip into body, one end down each front leg. Repeat with second pipecleaner and back legs. Starting at the head, stuff the zebra firmly, then sew up the gap. Mold body into shape.

TAIL Attach cast on row of tail to start of bottom. With bl, cut 5 4in (10cm) lengths and use crochet hook and scarf fringe method (see page 173) to attach tassels at the end of the tail. Trim.

EARS Sew cast on row of each ear to head, with 4 stitches between ears.

EYES With bl, sew 3 slanting satin stitches, positioned as in photograph.

MANE Cut approx 15 2in (5cm) lengths of sn and approx 13 2in (5cm) lengths of bl. Use crochet hook and scarf fringe method (see page 173) to attach tassels along the center of the neck and between the ears, matching black tassels with black stripes. Trim to shape as in photograph.

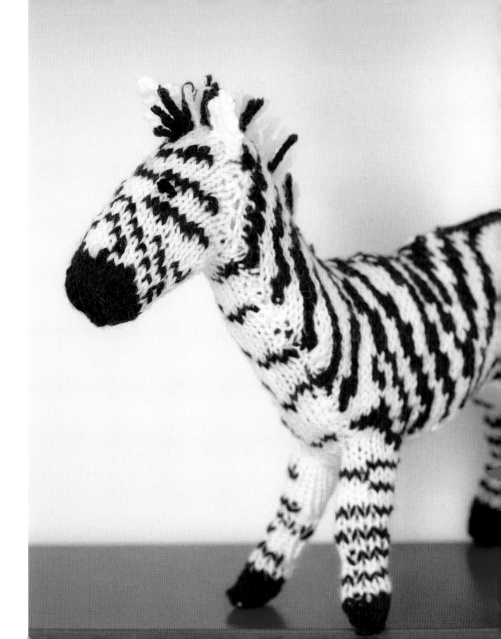

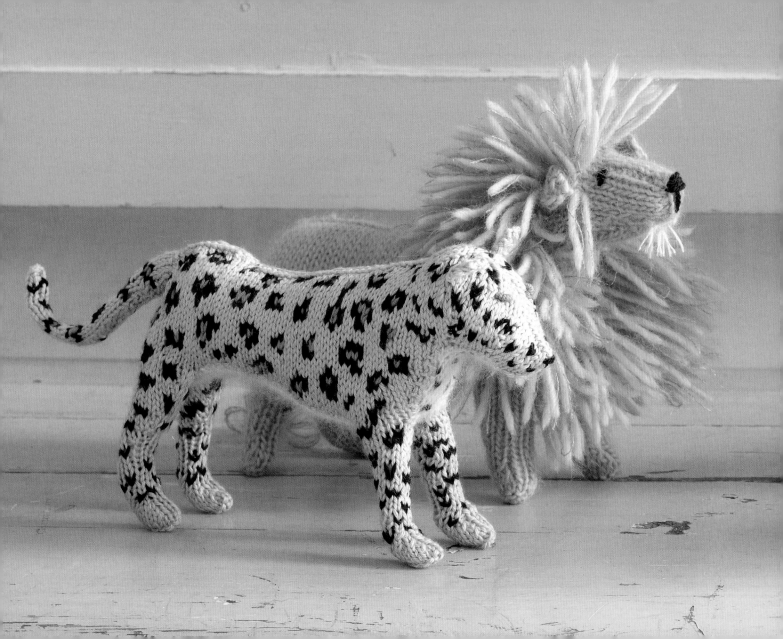

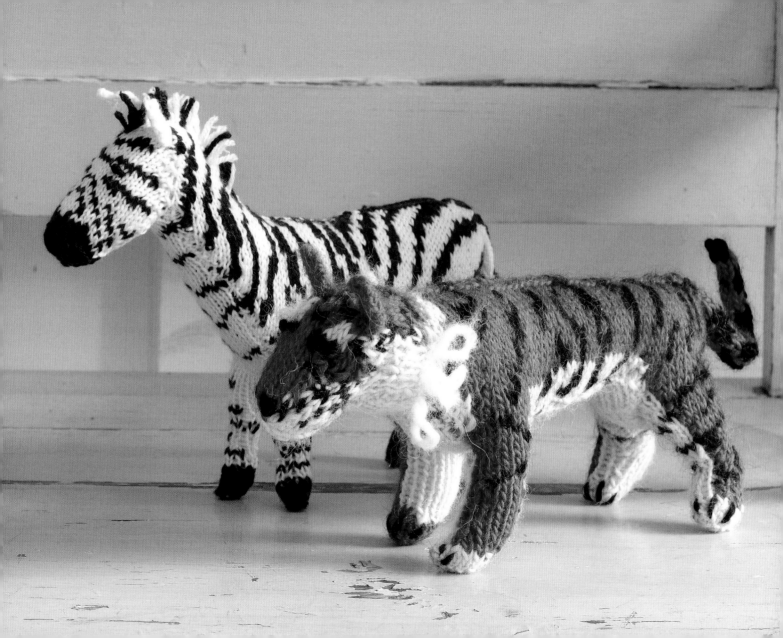

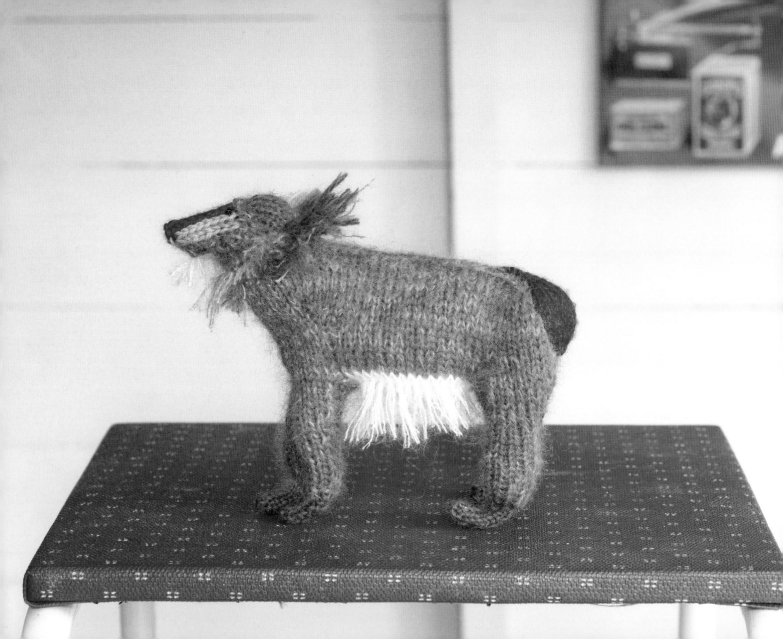

Mandrill

The mandrill is probably the most colorful of all primates. They live in 'hordes' led by a dominant male, who, it goes without saying, is more brightly colored than the females. Rafiki, Simba's adviser in *The Lion King*, was a mandrill, although not a strictly accurate one as he had a tail and is sometimes referred to as a baboon. Mandrills are considered vulnerable due to deforestation and because they are hunted for bushmeat.

Mandrill

Crazy-looking animal, complicated but worthwhile for the satisfaction of having made your very own knitted mandrill.

Measurements
Length: 6¾in (17cm)
Height to top of head: 6in (15cm)

Materials
- Pair of US 2 (2¾mm) knitting needles
- Double-pointed US 2 (2¾mm) knitting needles (for holding stitches)
- ¾oz (20g) of Rowan Kid Classic in Bitter Sweet 866 (bs)
- ¼oz (10g) of Rowan Kidsilk Haze in Ember (em)

NOTE: most of this animal uses 1 strand of em and 1 strand of bs held together, and this is called bsem
- ⅙oz (5g) of Rowan Kidsilk Haze in Cream (cr)
- ¼oz (10g) of Rowan Pure Wool 4ply in Kiss 436 (ki)
- ⅙oz (5g) of Rowan Pure Wool 4ply in Blue Iris 455 (bi)
- 2 pipecleaners for legs
- 2 tiny black beads for eyes and sewing needle and black thread for sewing on

Abbreviations
See page 172.

See page 172 for Color Knitting.
See page 172 for Wrap and Turn Method.
See page 173 for Loopy Stitch. Work 2-finger loopy stitch on body and head and 1-finger loopy stitch on tummy.
NOTE: this animal has no tail.

Right Back Leg
With bs, cast on 6 sts.
Beg with a k row, work 10 rows st st.
Join in em (1 strand).
Cont in bsem.
Row 11: Inc, k1, [inc] twice, k1, inc. (10 sts)
Work 13 rows st st.
Row 25: Inc, k8, inc. (12 sts)
Row 26: Purl.
Row 27: Inc, k10, inc. (14 sts)
Row 28: Purl.
Work 2 rows st st.
Row 31: Inc, k12, inc. (16 sts)
Row 32: Purl.*
Row 33: Bind off 8 sts, k to end (hold 8 sts on spare needle for Right Side of Body).

Left Back Leg
Work as for Right Back Leg to *.
Row 33: K8, bind off 8 sts (hold 8 sts on spare needle for Left Side of Body).

Right Front Leg
With bs, cast on 5 sts.
Beg with a k row, work 6 rows st st.
Join in em (1 strand).
Cont in bsem.
Row 7: Inc, k1, inc, k1, inc. (8 sts)
Row 8: Purl.
Row 9: Inc, k6, inc. (10 sts)
Row 10: Purl.
Work 8 rows st st.
Row 19: Inc, k8, inc. (12 sts)
Row 20: Purl.
Work 6 rows st st.**
Row 27: Bind off 6 sts, k to end (hold 6 sts on spare needle for Right Side of Body).

Left Front Leg
Work as for Right Front Leg to **.
Row 27: K6, bind off 6 sts (hold 6 sts on spare needle for Left Side of Body).

Right Side of Body
With 2 strands of cr, cast on 12 sts.
Row 1: Knit.
Row 2: Inc, p10, inc. (14 sts)
Row 3: Inc, k12, inc. (16 sts)
Row 4: Purl.
Row 5: K1, loopy st 14, k1.
Cont in bsem.
Row 6: P16, with WS facing p6 from spare needle of Right Front Leg. (22 sts)
Work 2 rows st st.
Row 9: K22, with RS facing k8 from spare needle of Right Back Leg. (30 sts)
Row 10: Purl.
Row 11: K6, inc, k23. (31 sts)
Row 12: P24, inc, p6. (32 sts)
Row 13: K6, inc, k25. (33 sts)
Row 14: P26, inc, p6. (34 sts)
Row 15: K6, inc, k27. (35 sts)
Row 16: P28, inc, p6. (36 sts)
Row 17: K34, k2tog. (35 sts)
Row 18: Purl.
Row 19: K33, k2tog. (34 sts)
Row 20: Purl.
Row 21: K32, k2tog. (33 sts)
Row 22: Bind off 22 sts, p to end (hold 11 sts on spare needle for neck).

Left Side of Body
With 2 strands of cr, cast on 12 sts.
Row 1: Knit.
Row 2: Inc, p10, inc. (14 sts)
Row 3: Inc, k12, inc. (16 sts)
Row 4: Purl.
Row 5: K1, loopy st 14, k1.
Cont in bsem.
Row 6: With WS facing p6 from spare needle of Left Front Leg, p16. (22 sts)
Work 2 rows st st.

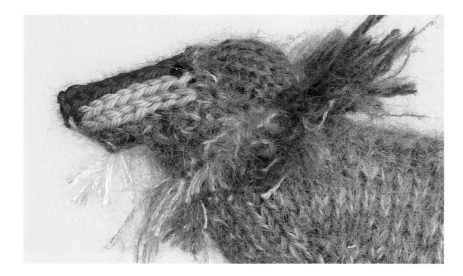

Head

The mandrill has a ruff of cut loopy stitch.

Row 9: With RS facing k8 from spare needle of Left Back Leg, k22. (30 sts)
Row 10: Purl.
Row 11: P6, inc, p23. (31 sts)
Row 12: K24, inc, k6. (32 sts)
Row 13: P6, inc, p25. (33 sts)
Row 14: K26, inc, k6. (34 sts)
Row 15: P6, inc, p27. (35 sts)
Row 16: K28, inc, k6. (36 sts)
Row 17: P34, p2tog. (35 sts)
Row 18: Knit.
Row 19: P33, p2tog. (34 sts)
Row 20: Knit.
Row 21: P32, p2tog. (33 sts)
Row 22: Bind off 22 sts, k to end (hold 11 sts on spare needle for neck).

Neck and Head

With bsem and with RS facing, k11 from spare needle of Right Side of Body, then k11 from spare needle of Left Side of Body. (22 sts)
Row 1: Purl.
Row 2: K1, loopy st 20, k1.
Row 3: Purl.
Join in another strand of em.
Row 4: With 2 strands of em loopy st 8em, loopy st 6bs, loopy st 8em.
Cont in bsem.
Row 5: P2tog, p2, p2tog, p10, p2tog, p2, p2tog. (18 sts)
Row 6: K6bsem, k6bs, wrap and turn (leave 6 sts on left-hand needle unworked).
Row 7: Working on center 6 sts only and cont in bs, p6, w&t.
Row 8: K6, w&t.
Row 9: P6, w&t.
Row 10: K5, w&t.
Row 11: P4, w&t.
Row 12: K3, w&t.
Row 13: P2, w&t.
Row 14: K3, w&t.
Row 15: P4, w&t.
Row 16: K5, w&t.
Row 17: P6, w&t.
Row 18: K12. (18 sts in total)
Cont in bsem.
Row 19: P2tog, p2, p2tog, k6, p2tog, p2, p2tog. (14 sts)
Join in bi and ki.
Row 20: K2togbsem, k1bsem, k2togbi, k2ki, k2bi, k2togbi, k1bsem, k2togbsem. (10 sts)
Row 21: P2bsem, p2bi, p2ki, p2bi, p2bsem.
Row 22: K2bsem, k2bi, k2ki, k2bi, k2bsem.
Rep rows 21–22 twice more.
Row 27: P2togbsem, p2bi, p2ki, p2bi, p2togbsem. (8 sts)
Row 28: K2togbi, k4ki, k2togbi. (6 sts)
Bind off 1 st bi, 4 sts ki, 1 st bi.

119

Tummy

(starting at chin)

With cr, cast on 4 sts.

Beg with a k row, work 2 rows st st.

Row 3: Loopy st 4.

Row 4: Purl.

Change to bsem.

Work 26 rows st st.

Row 31: Inc, k2, inc. (6 sts)

Work 9 rows st st.

Change to cr.

Work 20 rows st st.

Change to bsem.

Work 12 rows st st.

Change to ki.

Row 73: [Inc] 6 times. (12 sts)

Row 74: Purl.

Row 75: Inc, k3, inc, k2, inc, k3, inc. (16 sts)

Row 76: Purl.

Row 77: Inc, k4, inc, k4, inc, k4, inc. (20 sts)

Row 78: Purl.

Work 4 rows st st.

Row 83: [K2tog] 10 times. (10 sts)

Row 84: Purl.

Row 85: [K2tog] 5 times. (5 sts)

Row 86: Purl.

Row 87: K2tog, k1, k2tog. (3 sts)

Row 88: Purl.

Row 89: K3tog and fasten off.

Body

Manipulate the stuffing so
that the mandrill's bottom is
as large as possible.

To Finish

SEWING IN ENDS Sew in ends, leaving ends from cast on rows and bound off rows for sewing up.

LEGS With WS together, fold leg in half. Starting at paw end, sew up legs on RS. Pipecleaners are used to stiffen the legs and help bend them into shape. Fold a pipecleaner into a 'U' shape and measure against front two legs. Cut to approximately fit, leaving an extra ½in (1.5cm) at both ends, and fold these over to prevent them poking out through paws. Roll a little stuffing around pipecleaner and slip into legs. Rep with second pipecleaner and back legs. Bend paws forward so mandrill stands up as in photograph.

BODY AND HEAD Sew up back, then sew down bottom below red part. Fold nose in half and sew up.

TUMMY Attach bound off row of tummy at back of back legs and sew along body to chin, leaving a 1in (2.5cm) gap in side for stuffing. Cut loops on tummy.

STUFFING Starting at the head, stuff firmly, then sew up the gap.

RUFF Cut loops on ruff and cut into diamond-like shape, shorter on sides with a point on top (see photograph).

EYES Sew on 2 black beads for eyes either side of top of red stripe.

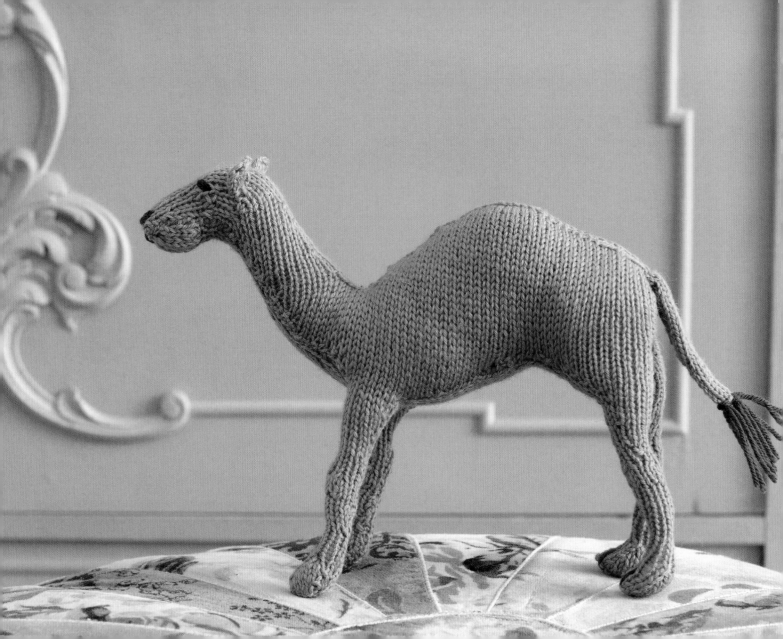

Camel

The workhorse of the desert, the camel is a remarkably versatile animal. Their fatty humps mean they can survive in a hot climate without water for a long period of time. Through evolution, the camel has adapted perfectly to extreme conditions: long-legged, a leathery mouth for eating thorny plants, a thick coat for cold desert nights, dry poos that Bedouins use to fuel fires. The camel has been used by the army in both Africa and India; now they provide milk, meat, transport for locals, and photo opportunities for tourists. Strangely, 'Camel' is also a brand of cigarettes.

Camel

A simple one-color animal, the camel has a well-stuffed hump and very large hooves.

Measurements

Length: 9in (23cm)
Height to top of head: 7in (18cm)

Materials

- Pair of US 2 (2¾mm) knitting needles
- Double-pointed US 2 (2¾mm) knitting needles (for holding stitches and for tail)
- 1¼oz)30g) of Rowan Pure Wool 4ply in Ochre 461 (oc)
- Small amount of Rowan Pure Wool 4ply in Mocha 417 (mo) for tail tufts, eyes, nose, and feet
- 3 pipecleaners for legs, head and neck

Abbreviations

See page 172.
See page 172 for I-cord Technique.
See page 172 for Wrap and Turn Method.

Right Back Leg

With oc, cast on 13 sts.
Beg with a k row, work 2 rows st st.
Row 3: Inc, k3, k2tog, k1, k2tog, k3, inc. (13 sts)
Row 4: Purl.
Rep rows 3–4 once more.
Row 7: K2, [k2tog] twice, k1, [k2tog] twice, k2. (9 sts)
Row 8: P2, p2tog, p1, p2tog, p2. (7 sts)*
Work 8 rows st st.

Row 17: Inc, k5, inc. (9 sts)
Work 5 rows st st.
Row 23: K2, [inc] twice, k1, [inc] twice, k2. (13 sts)
Work 3 rows st st.
Row 27: K2, [k2tog] twice, k1, [k2tog] twice, k2. (9 sts)
Row 28: Purl.
Row 29: K2tog, k1, inc, k1, inc, k1, k2tog. (9 sts)
Row 30: Purl.
Row 31: K3, inc, k1, inc, k3. (11 sts)
Work 3 rows st st.
Row 35: K4, inc, k1, inc, k4. (13 sts)
Work 3 rows st st.
Row 39: K5, inc, k1, inc, k5. (15 sts)
Row 40: Purl.
Row 41: K6, inc, k1, inc, k6. (17 sts)
Row 42: Purl.
Row 43: K7, inc, k1, inc, k7. (19 sts)
Row 44: Purl.
Row 45: K8, inc, k1, inc, k8. (21 sts)
Row 46: Purl.
Row 47: K9, inc, k1, inc, k9. (23 sts)
Row 48: Purl.**
Row 49: Bind off 11 sts, k to end (hold 12 sts on spare needle for Right Side of Body).

Left Back Leg

Work as for Right Back Leg to **.
Row 49: K12, bind off 11 sts (hold 12 sts on spare needle for Left Side of Body).

Right Front Leg

Work as for Right Back Leg to *.
Work 6 rows st st.
Row 15: Inc, k5, inc. (9 sts)
Work 5 rows st st.
Row 21: K2, [inc] twice, k1, [inc] twice, k2. (13 sts)
Work 3 rows st st.
Row 25: K2, [k2tog] twice, k1, [k2tog] twice, k2. (9 sts)
Work 3 rows st st.

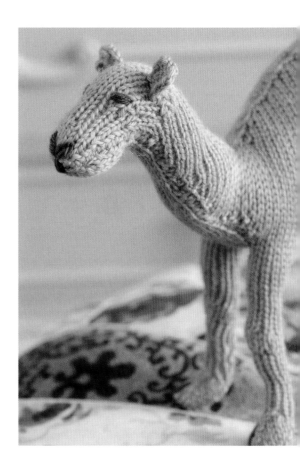

Legs

The camel's long legs must be stiffened with pipecleaners so he can stand up.

Row 29: Inc, k7, inc. (11 sts)
Work 3 rows st st.
Row 33: Inc, k9, inc. (13 sts)
Work 3 rows st st.
Row 37: Inc, k11, inc. (15 sts)
Row 38: Purl.***
Row 39: Bind off 7 sts, k to end (hold 8 sts on spare needle for Right Side of Body).

Left Front Leg

Work as for Right Front Leg to ***.
Row 39: K8, bind off 7 sts (hold 8 sts on spare needle for Left Side of Body).

Right Side of Body

Row 1: With oc, cast on 1 st, with RS facing k8 from spare needle of Right Front Leg, cast on 5 sts. (14 sts)
Row 2: Purl.
Row 3: Inc, k13, cast on 4 sts. (19 sts)
Row 4: Purl.
Row 5: Inc, k18, cast on 2 sts. (22 sts)
Row 6: P22, cast on 5 sts. (27 sts)
Row 7: K27, cast on 2 sts. (29 sts)
Row 8: Purl.
Row 9: Inc, k28, cast on 2 sts. (32 sts)
Row 10: Purl.
Row 11: Inc, k31, cast on 2 sts, with RS side facing k12 from spare needle of Right Back Leg, cast on 2 sts. (49 sts)
Row 12: Purl.
Row 13: Knit.
Row 14: Purl.
Row 15: Inc, k48. (50 sts)
Row 16: P39, cast (bind) off 3 sts, p to end (hold 8 sts on spare needle for right neck).
Row 17: Working on 39 sts for body, rejoin yarn and k39.
Row 18: Purl.
Row 19: Knit.
Row 20: P37, p2tog. (38 sts)
Row 21: Knit.
Row 22: P2tog, p34, p2tog. (36 sts)
Row 23: Knit.

Row 24: P34, p2tog. (35 sts)
Row 25: Bind off 2 sts, k31 ibos, k2tog. (32 sts)
Row 26: Bind off 3 sts, p27 icos, p2tog. (28 sts)
Row 27: K2tog, k24, k2tog. (26 sts)
Row 28: Bind off off 2 sts, p to end. (24 sts)
Row 29: K2tog, k20, k2tog. (22 sts)
Row 30: P2tog, p18, p2tog. (20 sts)
Row 31: Bind off off 2 sts, k16 ibos, k2tog. (17 sts)
Row 32: P2tog, p15. (16 sts)
Row 33: K2tog, k12, k2tog. (14 sts)
Row 34: P2tog, p10, p2tog. (12 sts)
Row 35: K2tog, k8, k2tog. (10 sts)
Row 36: P2tog, p6, p2tog. (8 sts)
Bind off.

Left Side of Body

Row 1: With oc, cast on 1 st, with WS facing p8 from spare needle of Left Front Leg, cast on 5 sts. (14 sts)
Row 2: Knit.
Row 3: Inc, k13, cast on 4 sts. (19 sts)
Row 4: Knit.
Row 5: Inc, p18, cast on 2 sts. (22 sts)
Row 6: K22, cast on 5 sts. (27 sts)
Row 7: P27, cast on 2 sts. (29 sts)
Row 8: Knit.
Row 9: Inc, p28, cast on 2 sts. (32 sts)
Row 10: Knit.
Row 11: Inc, p31, cast on 2 sts, with WS facing p12 from spare needle of Left Back Leg, cast on 2 sts. (49 sts)
Row 12: Knit.
Row 13: Purl.
Row 14: Knit.
Row 15: Inc, p48. (50 sts)
Row 16: K39, bind off 3 sts, k to end (hold 8 sts on spare needle for left neck).
Row 17: Working on 39 sts for body, rejoin yarn and p39.
Row 18: Knit.
Row 19: Purl.

Row 20: K37, k2tog. (38 sts)
Row 21: Purl.
Row 22: K2tog, k34, k2tog. (36 sts)
Row 23: Purl.
Row 24: K34, k2tog. (35 sts)
Row 25: Bind off 2 sts, p31 ibos, p2tog. (32 sts)
Row 26: Bind off 3 sts, k27 ibos, k2tog. (28 sts)
Row 27: P2tog, p24, p2tog. (26 sts)
Row 28: Bind off 2 sts, k to end. (24 sts)
Row 29: P2tog, p20, p2tog. (22 sts)
Row 30: K2tog, k18, k2tog. (20 sts)
Row 31: Bind off 2 sts, p16 ibos, p2tog. (17 sts)
Row 32: K2tog, k15. (16 sts)
Row 33: P2tog, p12, p2tog. (14 sts)
Row 34: K2tog, k10, k2tog. (12 sts)
Row 35: P2tog, p8, p2tog. (10 sts)
Row 36: K2tog, k6, k2tog. (8 sts)
Bind off.

Neck and Head

Row 1: With oc, k8 held for neck from spare needle of Right Side of Body, then k8 held for neck from spare needle of Left Side of Body. (16 sts)
Row 2: Purl.
Row 3: Inc, k14, inc. (18 sts)
Row 4: Purl.
Row 5: Knit.
Row 6: Purl.
Row 7: Inc, k5, k2tog, k2, k2tog, k5, inc. (18 sts)
Row 8: Purl.
Row 9: Knit.
Row 10: Purl.
Row 11: Knit.
Row 12: Purl.
Row 13: Inc, k5, k2tog, k2, k2tog, k5, inc. (18 sts)
Row 14: Purl.
Row 15: Knit.
Row 16: P6, p2tog, p2, p2tog, p6. (16 sts)

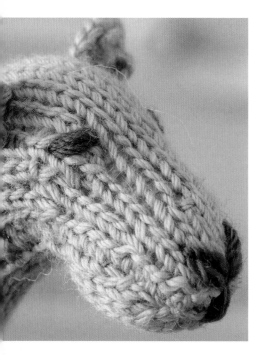

Nostrils

The camel's nostrils are embroidered in chain stitch.

Row 17: K13, wrap and turn (leave 3 sts on left-hand needle unworked).
Row 18: Working on top of head, on center 10 sts only, p10, w&t.
Row 19: K10, w&t.
Row 20: P10, w&t.
Rep rows 19–20 once more.
Row 23: K13. (16 sts in total)
Row 24: Purl.
Row 25: K2tog, k12, k2tog. (14 sts)
Row 26: Purl.
Row 27: K11, w&t (leave 3 sts on left-hand needle unworked).
Row 28: P8, w&t.
Row 29: K8, w&t.
Row 30: P8, w&t.
Row 31: K11. (14 sts in total)
Row 32: P2, p2tog, p2, p2tog, p2, p2tog, p2. (11 sts)
Work 4 rows st st.
Row 37: K2tog, k2, inc, k1, inc, k2, k2tog. (11 sts)
Work 3 rows st st.
Row 41: K2tog, k1, k2tog, k1, k2tog, k1, k2tog. (7 sts)
Bind off.

Tummy

With oc, cast on 6 sts.
Beg with a k row, work 2 rows st st.
Row 3: K2tog, k2, k2tog. (4 sts)
Work 11 rows st st.
Row 15: Inc, k2, inc. (6 sts)
Work 9 rows st st.
Row 25: K1, inc, k2, inc, k1. (8 sts)
Work 19 rows st st.

Row 45: K2tog, k4, k2tog. (6 sts)
Work 7 rows st st.
Row 53: Inc, k4, inc. (8 sts)
Work 7 rows st st.
Row 61: K1, k2tog, k2, k2tog, k1. (6 sts)
Work 9 rows st st.
Row 71: K1, [k2tog] twice, k1. (4 sts)
Work 19 rows st st.
Row 91: [Inc] 4 times. (8 sts)
Row 92: P2, inc, p2, inc, p2. (10 sts)
Work 4 rows st st.
Row 97: [K2tog] 5 times. (5 sts)
Bind off.

Ear

(make 2 the same)
With oc, cast on 5 sts.
Beg with a k row, work 4 rows st st.
Row 5: K2tog, k1, k2tog. (3 sts)
Row 6: P3tog and fasten off.

Tail

With double-pointed needles and oc, cast on 8 sts.
Work in i-cord as folls:
Knit 16 rows.
Row 17: K2tog, k4, k2tog. (6 sts)
Knit 8 rows
Bind off.

To Finish
SEWING IN ENDS Sew in ends, leaving ends from cast on rows and bound off rows for sewing up.

LEGS With WS together, fold leg in half. Starting at foot, sew up legs on RS.

BODY Sew along back of camel and around bottom.

TUMMY Sew cast on row of tummy to bottom of camel's bottom (where legs begin), and sew bound off row to chin. Ease and sew tummy to fit body, matching curves of tummy to legs. Leave a 1in (2.5cm) gap between front and back legs on one side.

STUFFING Pipecleaners are used to stiffen the legs and help bend them into shape. Fold a pipecleaner into a 'U' shape and measure against front two legs. Cut to approximately fit, leaving an extra 1in (2.5cm) at both ends. Fold these ends over to stop the pipecleaner poking out of the paws. Roll a little stuffing around pipecleaner and slip into body, one end down each front leg. Rep with second pipecleaner and back legs. Cut final pipecleaner to approximately 3in (8cm), roll a little stuffing around it, and insert into neck. Starting at the head, stuff the camel firmly, then sew up the gap. Mold body into shape.

TAIL Attach cast on row of tail to start of bottom. With mo, cut 6 3in (7.5cm) lengths and attach 3 tassels with a crochet hook at the end of the tail. Trim.

EARS Sew cast on row of each ear to head, rev st st side facing forward, with 3 stitches between the ears.

EYES With mo, sew 3 slanting satin stitches, positioned as in photograph.

NOSE With mo, embroider nose with 2 vertical satin stitches. For nostrils, make 2 diagonal chain stitches.

FEET With mo, make 2 satin stitches in the center of each foot.

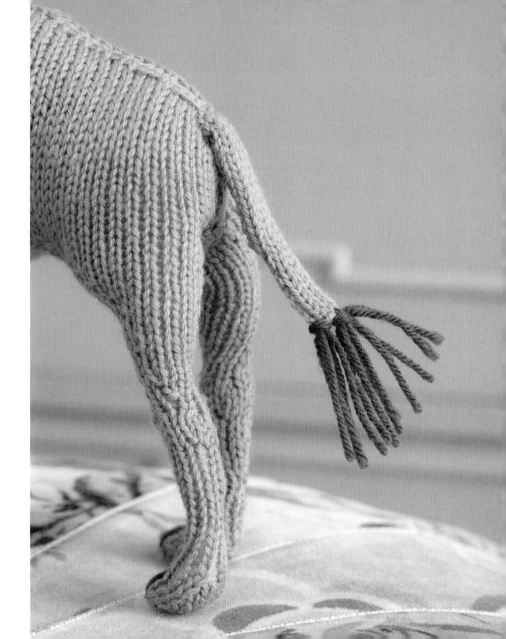

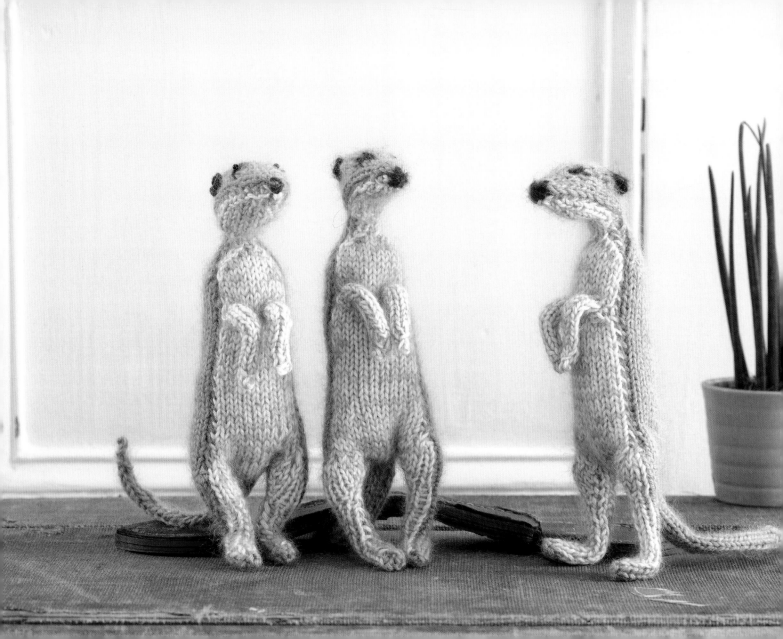

Meerkat

The much-loved meerkat is a sociable animal. They live in large groups, performing different roles— sentry, babysitter, digger, and forager. Meerkats are quite vocal, producing a range of noises; they can chirrup, trill, growl, or bark, depending on circumstances. Timon in *The Lion King* is a meerkat, and meerkats have also been used in advertising. The knitted meerkat is ideal; the real versions make bad pets because they are aggressive and prone to biting visitors.

Meerkat

Irresistible and fairly simple—so you can make a whole gang.

Measurements

Width at widest point (hips): 2½in (6cm)
Height: 7in (18cm)

Materials

- Pair of US 2 (2¾mm) knitting needles
- Double-pointed US 2 (2¾mm) knitting needles (for holding stitches)
- ¼oz (10g) of Rowan Kidsilk Haze in Mud (mu)
- ½oz (15g) of Rowan Pure Wool 4ply in Toffee 453 (tf)
NOTE: some of this animal uses 1 strand of mu and 1 strand of tf held together, and this is called mutf
- ½oz (15g) of Rowan Pure Wool 4ply in Porcelaine 451 (pr)
NOTE: some of this animal uses 1 strand of mu and 1 strand of pr held together, and this is called mupr
- ¼oz (5g) of Rowan Kidsilk Haze in Blackcurrant 641 (bl) used DOUBLE throughout
- 4 pipecleaners for front and back legs, tail, and spine
- 2 tiny black beads for eyes and sewing needle and black thread for sewing on

Abbreviations

See page 172.
See page 172 for Color Knitting.
See page 172 for Wrap and Turn Method.

Right Back Leg

With mutf, cast on 6 sts.
Join in mupr.
Row 1: K3mupr, k3mutf.
Row 2: P3mutf, p3mupr.
Rep rows 1–2, 8 times more.
Row 19: K1mupr, incmupr, k1mupr, k1mutf, incmutf, k1mutf. (8 sts)
Row 20: P4mutf, 4mupr.
Row 21: K1mupr, incmupr, k2mupr, k2mutf, incmutf, k1mutf. (10 sts)
Row 22: P5mutf, p5mupr.
Row 23: K1mupr, incmupr, k3mupr, k3mutf, incmutf, k1mutf. (12 sts)
Row 24: P6mutf, 6mupr.
Row 25: K1mupr, incmupr, k4mupr, k4mutf, incmutf, k1mutf. (14 sts)
Row 26: P7mutf, [p2togmupr] 3 times, p1mupr (hold 11 sts on spare needle for Right Side of Body).

Left Back Leg

With mutf, cast on 6 sts.
Join in mupr.
Row 1: K3mutf, k3mupr.
Row 2: P3mupr, p3mutf.
Rep rows 1–2, 8 times more.
Row 19: K1mutf, incmutf, k1mutf, k1mupr, incmupr, k1mupr. (8 sts)
Row 20: P4mupr, p4mutf.
Row 21: K1mutf, incmutf, k2mutf, k2mupr, incmupr, k1mupr. (10 sts)
Row 22: P5mupr, p5mutf.
Row 23: K1mutf, incmutf, k3mutf, k3mupr, incmupr, k1mupr. (12 sts)
Row 24: P6mupr, p6mutf.
Row 25: K1mutf, incmutf, k4mutf, k4mupr, incmupr, k1mupr. (14 sts)
Row 26: P1mupr, [p2togmupr] 3 times, p7mutf (hold 11 sts on spare needle for Left Side of Body).

Tummy

With mupr, cast on 6 sts.
Beg with a k row, work 4 rows st st.
Row 5: K6, k4 mupr sts from spare needle of Right Back Leg. (10 sts)
Row 6: P10, p4 mupr sts from spare needle of Left Back Leg. (14 sts)
(Rem 7 sts on each spare needle are held for Tail and Back.)
Work 4 rows st st.
Row 11: K3, k2tog, k4, k2tog, k3. (12 sts)
Work 17 rows st st.
Row 29: K1, bind off 3 sts, k4 ibos, bind off 3 sts, k to end.
Row 30: P1, cast on 3 sts, p4, cast on 3 sts, p1.
(Rows 29–30 create holes for Front Paws.)
Work 8 rows st st.
Row 39: K1, k2tog, k6, k2tog, k1. (10 sts)
Row 40: P1, p2tog, p4, p2tog, p1. (8 sts)
Row 41: K1, k2tog, k2, k2tog, k1. (6 sts)
Row 42: P1, [p2tog] twice, p1. (4 sts)
Work 4 rows st st.
Row 47: K1, [inc] twice, k1. (6 sts)
Row 48: P1, inc, p2, inc, p1. (8 sts)
Work 8 rows st st.
Row 57: K2, k2tog, k2tog, k2. (6 sts)
Row 58: Purl.
Row 59: K2, k2tog, k2. (5 sts)
Row 60: Purl.
Row 61: K2tog, k1, k2tog. (3 sts)
Row 62: P3tog and fasten off.

Front Paws

(make 2 the same)
With mupr and with RS facing and holding tummy upside down, pick up and k5 sts from top edge of holes bound off, beg in loop to right of hole and end in loop to left of hole.
Work 13 rows st st.
Row 14: K2tog, k1, k2tog. (3 sts)
Row 15: P2tog, p1. (2 sts)
Row 16: K2tog and fasten off.

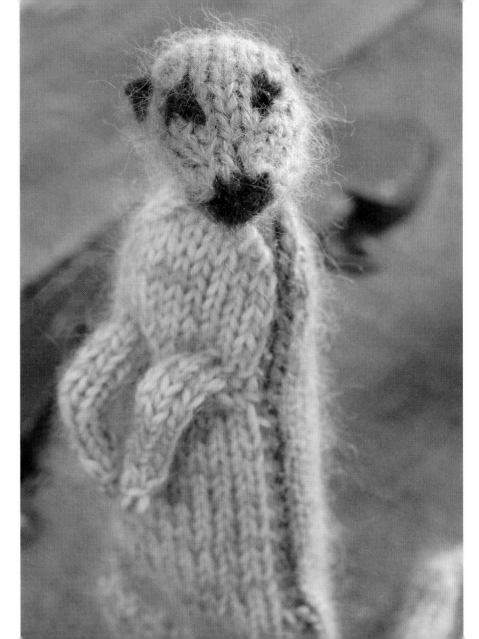

Head

The meerkat has a pipecleaner in his neck so that you can turn his head.

Tail and Back

With mutf, cast on 1 st.
Beg with a k row, work 2 rows st st.
Row 3: Inc. (2 sts)
Row 4: Purl.
Row 5: Inc, k1. (3 sts)
Row 6: Purl.
Row 7: K1, inc, k1. (4 sts)
Row 8: Purl.
Row 9: K1, [inc] twice, k1. (6 sts)
Row 10: Purl.
Work 20 rows st st.
Row 31: K1, inc, k2, inc, k1. (8 sts)
Work 13 rows st st.
Row 45: K8, cast on 1 st, with RS facing k7mutf from spare needle of Left Back Leg. (16 sts)
Row 46: P16, cast on 1 st, with WS facing p7mutf from spare needle of Right Back Leg. (24 sts)
Row 47: K11, k2tog, k11. (23 sts)
Work 5 rows st st.
Row 53: K7, k2tog, k5, k2tog, k7. (21 sts)
Work 3 rows st st.
Row 57: K6, k2tog, k5, k2tog, k6. (19 sts)
Work 7 rows st st.
Row 65: K5, k2tog, k5, k2tog, k5. (17 sts)
Work 15 rows st st.
Row 81: K1, k2tog, k11, k2tog, k1. (15 sts)
Row 82: P1, p2tog, p9, p2tog, p1. (13 sts)
Row 83: K1, k2tog, k7, k2tog, k1. (11 sts)
Row 84: P1, p2tog, p5, p2tog, p1. (9 sts)
Row 85: K1, k2tog, k3, k2tog, k1. (7 sts)
Row 86: P1, p2tog, p1, p2tog, p1. (5 sts)
Work 4 rows st st.
Row 91: [Inc] 5 times. (10 sts)
Row 92: Purl.
Row 93: K1, inc, k6, inc, k1. (12 sts)
Row 94: Purl.
Row 95: K1, inc, k8, inc, k1. (14 sts)
Row 96: Purl.
Row 97: K10, wrap and turn (leave 4 sts on left-hand needle unworked).

Row 98: Working top of head on center 6 sts only, p6, w&t.
Row 99: K6, w&t.
Row 100: P6, w&t.
Row 101: K6, w&t.
Row 102: P6, w&t.
Row 103: K10. (14 sts in total)
Row 104: Purl.
Join in bl.
Row 105: K2mutf, k2togmutf, k2bl, k2mutf, k2bl, k2togmutf, k2mutf. (12 sts)
Row 106: P3mutf, p2bl, p2mutf, p2bl, p3mutf.
Row 107: K2mutf, k2togmutf, k1bl, k2mutf, k1bl, k2togmutf, k2mutf. (10 sts)
Cont in mutf.
Row 108: Purl.

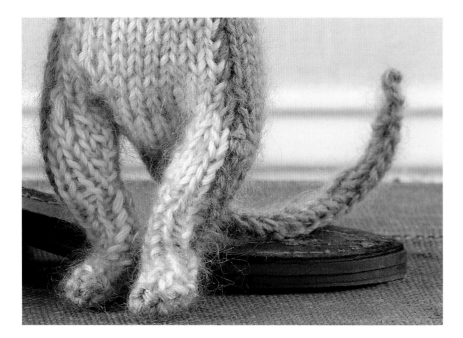

Tail

The meerkat's tail acts as an extra leg to help him stand upright.

Row 109: K2, k2tog, k2, k2tog, k2. (8 sts)
Row 110: Purl.
Row 111: K2, [k2tog] twice, k2. (6 sts)
Row 112: Purl.
Cont in bl.
Row 113: K1, [k2tog] twice, k1. (4 sts)
Row 114: [P2tog] twice. (2 sts)
Row 115: K2tog and fasten off.

Ear

(make 2 the same)
With 2 strands of bl, cast on 3 sts.
Knit 1 row.
Bind off.

To Make Up

SEWING IN ENDS Sew in ends, leaving ends from cast on rows and bound off rows for sewing up.

BODY Insert pipecleaner into back of neck, then bend ends over, leaving approx 3in (8cm) in body. With WS together and starting at nose, sew two parts of head together and down side seam, leaving a 1in (2.5cm) gap on one side. Stuff firmly. It is easier to stuff the head before you've sewn up the neck as it is quite hard to get the stuffing through the neck. Don't overstuff head as it's supposed to be quite delicate. Mold into shape. Stuff body firmly.

FRONT LEGS Fold a pipecleaner into a 'U' shape and measure against front two legs. Cut to approximately fit, leaving an extra 1in (2.5cm) at both ends. Fold these ends over to stop the pipecleaner poking out of the paws. Sew up paws on outside round pipecleaner. Sew up holes below paws. Bend into shape.

BACK LEGS Sew up on RS. Cut a pipecleaner to fit as for front legs, roll a little stuffing around pipecleaner, and slip into back legs. Sew up bween legs. Stuff legs firmly. Bend legs into shape.

TAIL Bend end of pipecleaner over and insert into tail approx 1in (2.5cm) from tip of tail. Insert other end into body, then sew up tail round pipecleaner. If you can, wrap end of tail pipecleaner nearest body in a little stuffing; this will help it stand up.

EARS Sew cast on row of ears to head, 5 rows back from top of bl for eyes with 4.5 rows between ears.

EYES Sew black beads onto bl eye patches.

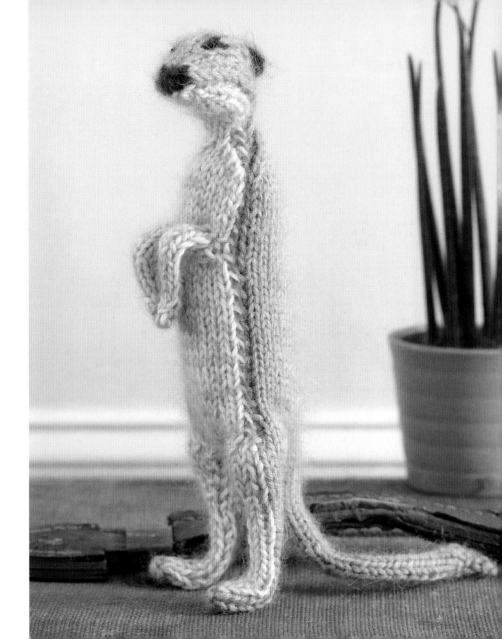

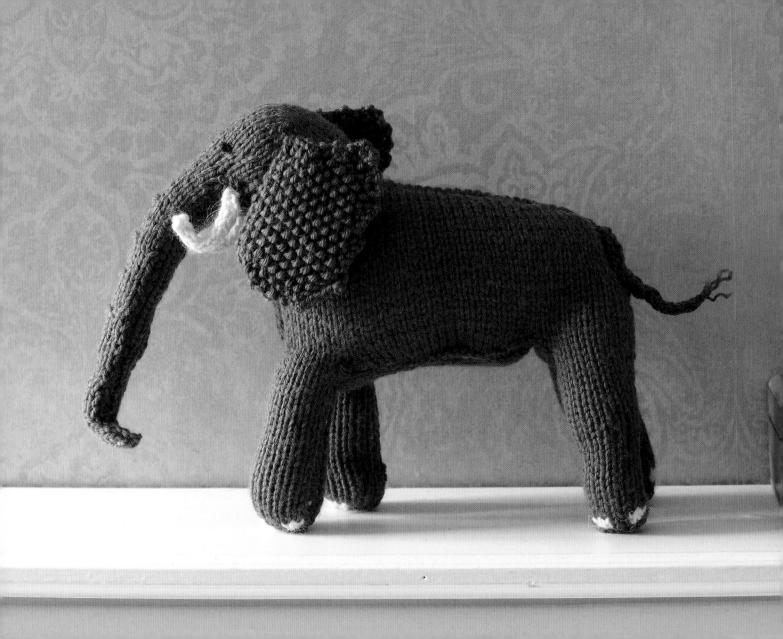

Elephant

The African elephant is the largest living land mammal on earth. Ours is an African elephant, distinguished from the Indian by its larger ears, said to be shaped like the African continent. The elephant's trunk is used for smelling, breathing, trumpeting, drinking, plucking, and grabbing and is made up of about 40,000 muscles. Elephants have huge brains and are said to be capable of sadness, joy, love, jealousy, fury, grief, compassion, and distress.

Elephant

The elephant is fairly simple to make and looks splendid when finished.

Measurements

Length (including trunk): 12in (30cm)
Height to top of head: 9in (23cm)

Materials

- Pair of US 3 (3¼mm) needles
- Double-pointed US 3 (3¼mm) needles (for holding stitches)
- 3½oz (100g) of Rowan Pure Wool Aran in Charcoal 684 (ch)
- ⅙oz (5g) of Rowan Creative Worsted in Natural 100 (na)
- Tiny amount of Rowan Pure Wool 4ply in Black 404 (bl) for eyes.
- 5 pipecleaners for legs and trunk

Abbreviations

See page 172.
See page 172 for Wrap and Turn Method.

Right Front Leg

With ch, cast on 16 sts.
Join in na.
Row 1: K5ch, k2na, k2ch, k2na, k2ch, k2na, k1ch.
Row 2: P1ch, p2na, p2ch, p2na, p2ch, p2na, p5ch.
Cont in ch.
Work 2 rows st st.
Row 5: K7, k2tog, k7. (15 sts)
Work 21 rows st st.

Row 27: Bind off 7 sts, k to end (hold 8 sts on spare needle for Right Side of Body).

Left Front Leg

With ch, cast on 16 sts.
Join in na.
Row 1: K1ch, k2na, k2ch, k2na, k2ch, k2na, k5ch.
Row 2: P5ch, p2na, p2ch, p2na, p2ch, p2na, p1ch.
Cont in ch.
Work 2 rows st st.
Row 5: K7, k2tog, k7. (15 sts)
Work 21 rows st st.
Row 27: K8, bind off 7 sts (hold 8 sts on spare needle for Left Side of Body).

Right Back Leg

With ch, cast on 16 sts.
Join in na.
Row 1: K5ch, k2na, k2ch, k2na, k2ch, k2na, k1ch.
Row 2: P1ch, p2na, p2ch, p2na, p2ch, p2na, p5ch.
Cont in ch.
Work 2 rows st st.
Row 5: K7, k2tog, k7. (15 sts)
*Work 13 rows st st.
Row 19: K1, inc, k11, inc, k1. (17 sts)
Work 3 rows st st.
Row 23: K1, inc, k13, inc, k1. (19 sts)
Work 3 rows st st.
Row 27: K1, inc, k15, inc, k1. (21 sts)
Work 3 rows st st.*
Row 31: Bind off 10 sts, k to end (hold 11 sts on spare needle for Right Side of Body).

Left Back Leg

With ch, cast on 16 sts.
Join in na.
Row 1: K1ch, k2na, k2ch, k2na, k2ch, k2na, k5ch.
Row 2: P5ch, p2na, p2ch, p2na, p2ch, p2na,

Legs

Make sure the elephant's legs are well stuffed.

p1ch.

Cont in ch.

Work 2 rows st st.

Row 5: K7, k2tog, k7. (15 sts)

Work as for Right Back Leg from * to *.

Row 31: K11, bind off 10 sts (hold 11 sts on spare needle for Left Side of Body).

Right Side of Body

With ch, cast on 12 sts.

Row 1: Inc, k10, inc. (14 sts)

Row 2: Inc, p12, inc. (16 sts)

Row 3: Inc, k14, inc. (18 sts)

Row 4: Purl.

Row 5: With RS facing k8 from spare needle of Right Front Leg, k18, with RS facing k11 from spare needle of Right Back Leg. (37 sts)

Row 6: P36, inc. (38 sts)

Work 10 rows st st.

Row 17: K36, k2tog. (37 sts)

Work 3 rows st st.

Row 21: K35, k2tog. (36 sts)

Row 22: Purl.

Row 23: K34, k2tog. (35 sts)

Row 24: Bind off 4 sts, p to end. (31 sts)

Row 25: K29, k2tog. (30 sts)

Row 26: Bind off 4 sts, p to end. (26 sts)

Row 27: K24, k2tog. (25 sts)

Row 28: Bind off 12 sts, p to end (hold 13 sts on spare needle for neck).

Left Side of Body

With ch, cast on 12 sts.

Row 1: Inc, p10, inc. (14 sts)

Row 2: Inc, k12, inc. (16 sts)

Row 3: Inc, p14, inc. (18 sts)

Row 4: Knit.

Row 5: With WS facing p8 from spare needle of Left Front Leg, p18, with WS facing p11 from spare needle of Left Back Leg. (37 sts)

Row 6: K36, inc. (38 sts)

Work 10 rows st st.

Row 17: P36, p2tog. (37 sts)

Work 3 rows st st.

Row 21: P35, p2tog. (36 sts)

Row 22: Knit.

Row 23: P34, p2tog. (35 sts)

Row 24: Bind off 4 sts, k to end. (31 sts)

Row 25: P29, p2tog. (30 sts)

Row 26: Bind off 4 sts, k to end. (31 sts)

Row 27: P24, p2tog. (25 sts)

Row 28: Bind off 12 sts, k to end (hold 13 sts on spare needle for neck).

Neck and Head

Row 1: With ch and with RS facing, k13 from spare needle of Right Side of Body, then k13 from spare needle of Left Side of Body. (26 sts)

Row 2: P2tog, p22, p2tog. (24 sts)

Work 2 rows st st.

Row 5: K2tog, k20, k2tog. (22 sts)

Row 6: Purl.

Row 7: K18, wrap and turn (leave 4 sts on left-hand needle unworked).

Row 8: Working on top of head center 14 sts only, p14, w&t.

Row 9: K14, w&t.

Row 10: P14, w&t.

Row 11: K13, w&t.

Row 12: P12, w&t.

Row 13: K11, w&t.

Row 14: P10, w&t.

Row 15: K9, w&t.

Row 16: P8, w&t.

Row 17: K9, w&t.

Row 18: P10, w&t.

Row 19: K11, w&t.

Row 20: P12, w&t.

Row 21: K13, w&t.

Row 22: P14, w&t.

Row 23: K18. (22 sts in total)

Row 24: P1, p2tog, p1, p2tog, p10, p2tog, p1, p2tog, p1. (18 sts)

Work 2 rows st st.

Row 27: K1, k2tog, k1, k2tog, k6, k2tog, k1, k2tog, k1. (14 sts)

Work 9 rows st st.

Row 37: K1, k2tog, k8, k2tog, k1. (12 sts)

Row 38: P4, k4, p4.

Work 5 rows st st.

Row 44: P4, k4, p4.

Row 45: K1, k2tog, k6, k2tog, k1. (10 sts)

Work 4 rows st st.

Row 50: P3, k4, p3.

Work 4 rows st st.

Row 55: K1, k2tog, k4, k2tog, k1. (8 sts)

Row 56: P2, k4, p2.

Work 5 rows st st.

Row 62: P3, k2, p3.

Work 6 rows st st.

Row 69: K1, k2tog, k2, k2tog, k1. (6 sts)

Work 10 rows.

Row 80: P2tog, p2, p2tog. (4 sts)

Row 81: [K2tog] twice. (2 sts)

Row 82: P2tog and fasten off.

Tail

The little tuft at the end of the elephant's tail is made by untwisting the yarn.

Tummy

With ch, cast on 8 sts.
Beg with a k row, work 98 rows st st.
Row 99: K2tog, k4, k2tog. (6 sts)
Work 21 rows st st.
Row 121: K2tog, k2, k2tog. (4 sts)
Work 15 rows st st.
Row 137: [K2tog] twice. (2 sts)
Work 5 rows st st.
Row 143: K2tog and fasten off.

Ear

(make 2 the same)
With ch, cast on 16 sts.
Work 4 rows seed st.
Row 5: Inc, seed st to end. (17 sts)
Row 6: Bind off 3 sts, seed st to end. (14 sts)
Row 7: Inc, seed st to end. (15 sts)
Row 8: Seed st.
Row 9: Inc, seed st to end. (16 sts)
Row 10: Seed st.
Row 11: Inc, seed st to end. (17 sts)
Row 12: Seed st.
Row 13: Inc, seed st to last st, inc. (19 sts)
Row 14: Seed st.
Row 15: K2tog, seed st to end. (18 sts)

Row 16 : Seed st.
Row 17: K2tog, seed st to end. (17 sts)
Row 18: K2tog, seed st to end. (16 sts)
Row 19: K2tog, seed st to end. (15 sts)
Row 20: Seed st.
Row 21: Bind off 4 sts, seed st to end. (11 sts)
Row 22: Seed st.
Row 23: Bind off 4 sts, seed st to end. (7 sts)
Bind off 7 sts.

Tail

With ch, cast on 5 sts.
Beg with a k row, work 3 rows st st.
Row 4: P2tog, p1, p2tog. (3 sts)
Work 10 rows st st.
Row 15: K2tog, k1. (2 sts)
Work 10 rows st st.
Row 26: P2tog and fasten off.
Cut yarn to 1in (2.5cm) and unravel to make little tuft on end of tail.

Tusks

(make 2 the same)
With na, cast on 3 sts.
Beg with a k row, work 16 rows st st.
Row 17: K2tog, k1. (2 sts)
Row 18: Purl.
Row 19: K2tog and fasten off.

To Finish

SEWING IN ENDS Sew in ends, leaving ends from cast on rows and bound off rows for sewing up.
BODY Sew along back and down bottom.
TUMMY AND UNDERSIDE OF TRUNK Sew cast on row of tummy to bottom of elephant's bottom (where legs begin); the bound off row will be sewn to end of trunk. Measure a pipecleaner against the trunk, then fold the ends over to prevent them poking out through the knitting. Roll a little stuffing round pipecleaner and sew trunk up around it; you can use this to bend the

trunk into shape. Ease and sew tummy to fit body, leaving a 1in (2.5cm) gap between front and back legs on one side.

LEGS With WS together, fold each leg in half and sew up on RS. Pipecleaners are used to stiffen the legs and help bend them into shape. Join two pipecleaners by twisting ends arounds one another. Fold over 1in (2.5cm) at each free end to stop the pipecleaner poking out of the feet. Roll a little stuffing around joined pipecleaners and slip into body, one end down each front leg. Rep with second pipecleaner and back legs.

STUFFING Stuff body firmly starting at trunk, then sew up gap in side.

TAIL It's not necessary to sew up tail as it curls round naturally. Sew tail to top of elephant's bottom; if necessary catch tail down with a stitch approx ¾in (2cm) down its length.

EARS Attach cast on row of ear to side of head approx ¾in (2cm) down from top of head, with 8 sts between ears. Starting at the top, sew them angled slightly toward trunk and follow tummy seam.

TUSKS You don't need to sew edges of tusks together; like the tail, they will curl inward naturally. Sew to side of trunk with natural curl upward, as in photograph.

EYES With bl, sew 3-loop French knots positioned as in photograph with 4 sts between them.

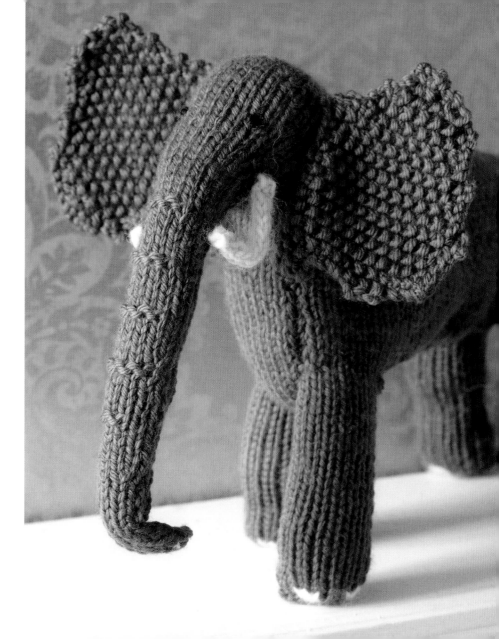

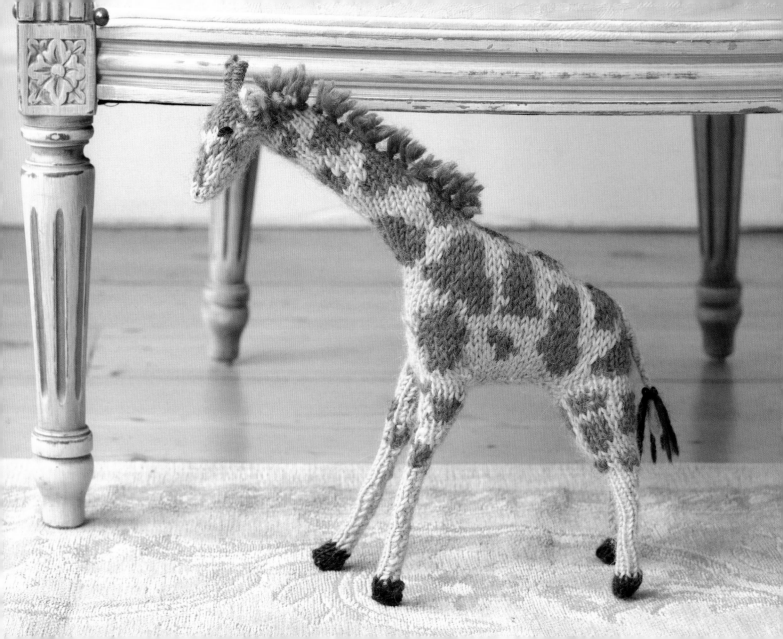

Giraffe

Deceptively vulnerable-looking, giraffes are well designed for survival: not only are they the tallest terrestrial animals in the world, but they also have camouflage coats, can gallop faster than a horse, only need a few hours' sleep, and can kick their predators to death. They have bluish-purple bristly tongues that are two feet long, the same number of vertebrae as us and their little horns are called ossicones. Giraffes give birth standing up—in fact they do almost everything standing up—and the babies fall about six feet when they are born. The collective noun for a group of giraffes is a tower.

Giraffe

The giraffe is quite complicated to make, using several techniques, but well worth the effort.

Measurements

Length (chest to tail): 5in (13cm)
Height to top of head: 12½in (32cm)

Materials

- Pair of US 3 (3¼mm) knitting needles
- Double-pointed US 3 (3¼mm) knitting needles (for holding stitches)
- ¼oz (10g) Rowan Creative Focus Worsted in Espresso 410 (es)
- 1¼oz (30g) Rowan Kid Classic in Mellow 877 (ml)
- ¾oz (20g) Rowan Creative Focus Worsted in Golden Heather 018 (gh)
- Tiny amount of Rowan Pure Wool 4ply in Black 404 (bl) for eyes and nostrils (or use es)
- 9 pipecleaners for legs and horns
- Crochet hook for tufts

Abbreviations

See page 172.
See page 172 for Color Knitting.
See page 172 for Wrap and Turn Method.

Right Back Leg

With es, cast on 10 sts.
Row 1: Knit.
Row 2: P2tog, p6, p2tog. (8 sts)
Row 3: K2tog, k4, k2tog. (6 sts)
Join in ml.

Work 17 rows st st.
Row 21: Inc, k4, inc. (8 sts)
Row 22: Purl.
Row 23: Inc, k6, inc. (10 sts)
Row 24: Purl.
Join in gh.
Row 25: Incml, k6ml, k2gh, incml. (12 sts)
Row 26: P2ml, p2gh, p1ml, p2gh, p1ml, p1gh, p3ml.
Row 27: Incml, k4ml, k2gh, k4ml, incml. (14 sts)
Row 28: P10ml, p2gh, p2ml.
Row 29: Incml, k1ml, k3gh, k2ml, k2gh, k4ml, incml. (16 sts)
Row 30: P1ml, p3gh, p1ml, p3gh, p2ml, p3gh, p3ml.
Row 31: Incml, k7ml, k3gh, k1ml, k3gh, incml. (18 sts)
Row 32: P2ml, p2gh, p2ml, p3gh, p1ml, p2gh, p6ml.
Row 33: Incml, k2gh, k1ml, k4gh, k6ml, k3gh, incml. (20 sts)
Row 34: P2ml, p3gh, p1ml, p4gh, p1ml, p4gh, p1ml, p3gh, p1ml.
Row 35: Incml, k3gh, k1ml, k4gh, k1ml, k4gh, k5ml, incml. (22 sts)
Cont in ml.
Row 36: Purl.*
Row 37: Bind off 11 sts, k to end (hold 11 sts on spare needle for Right Side of Body).

Left Back Leg

Work as for Right Back Leg to *.
Row 37: K11, bind off 11 sts (hold 11 sts on spare needle for Left Side of Body).

Right Front Leg

With es, cast on 10 sts.
Row 1: Knit.
Row 2: P2tog, p6, p2tog. (8 sts)
Row 3: K2tog, k4, k2tog. (6 sts)
Cont in ml.
Work 17 rows st st.
Row 21: Inc, k4, inc. (8 sts)

Row 22: Purl.
Row 23: K2tog, k4, k2tog. (6 sts)
Row 24: Purl.
Join in gh.
Row 25: K1ml, k2gh, k3ml.
Row 26: P4ml, p1gh, p1ml.
Row 27: K4ml, k2gh.
Row 28: P2gh, p4ml.
Row 29: K4ml, k1gh, k1ml.
Row 30: P6ml.
Row 31: Incml, k1ml, k2gh, k1ml, incml. (8 sts)
Row 32: P3ml, p2gh, p3ml.
Row 33: K2ml, k3gh, k3ml.
Row 34: P8ml.
Row 35: Incml, k5ml, k1gh, incgh. (10 sts)
Row 36: P3gh, p3ml, p3gh, p1ml.
Row 37: Incml, k3gh, k3ml, k2gh, incgh. (12 sts)
Row 38: P12ml.
Row 39: K6ml, k2gh, k4ml.
Row 40: P5ml, p1gh, p6ml.**
Cont in ml.
Row 41: Bind off 6 sts, k to end (hold 6 sts on spare needle for Right Side of Body).

Left Front Leg

Work as for Right Front Leg to **.
Cont in ml.
Row 41: K6, bind off 6 sts (hold 6 sts on spare needle for Left Side of Body).

Right Side of Body

With ml, cast on 10 sts.
Row 1: Knit.
Row 2: Inc, p8, inc, p6 from spare needle of Right Front Leg. (18 sts)
Join in gh.
Row 3: K2ml, k3gh, k13ml, cast on 2 sts ml, then k4ml, k3gh, k4ml across sts on spare needle of Right Back Leg. (31 sts)
Row 4: P3ml, p5gh, p3ml, p3gh, p5ml, p2gh, p4ml, p4gh, p2ml.
Row 5: Incml, k1ml, k4gh, k4ml, k3gh, k3ml, k5gh, k2ml, k6gh, k2toggh.

Row 6: P7gh, p2ml, p6gh, p3ml, p3gh, p2ml, p6gh, p2ml.
Row 7: K1ml, k7gh, k2ml, k2gh, k4ml, k6gh, k3ml, k4gh, k2toggh. (30 sts)
Row 8: P4gh, p5ml, p4gh, p10ml, p5gh, p2ml.
Row 9: Incml, k1ml, k4gh, k11ml, k4gh, k6ml, k3gh. (31 sts)
Row 10: P3gh, p1ml, p3gh, p2ml, p4gh, p1ml, p5gh, p1ml, p3gh, p1ml, p3gh, p4ml.
Row 11: K8ml, k3gh, k2ml, k3gh, k3ml, k3gh, k2ml, k3gh, k1ml, k1gh, k2toggh. (30 sts)
Row 12: P2ml, p4gh, p2ml, p4gh, p2ml, p4gh, p1ml, p5gh, p6ml.
Row 13: K5ml, k6gh, k1ml, k4gh, k3ml, k3gh, k2ml, k4gh, k2togml. (29 sts)
Row 14: P5gh, p8ml, p4gh, p2ml, p6gh, p4ml.
Row 15: Incml, k2ml, k7gh, k3ml, k3gh, k9ml, k2gh, k2toggh.

Row 16: Bind off 5 sts ml, p3ml icos, p2gh, p2ml, p3gh, p3ml, p7gh, p4ml. (24 sts)
Row 17: K3gh, k3ml, k5gh, k8ml, k3gh, k2togml. (23 sts)
Row 18: Bind off 5 sts ml, p8ml icos, p3gh, p3ml, p4gh. (18 sts)
Row 19: Incgh, k3gh, k8ml, k4gh, k2toggh.
Row 20: Bind off 5 sts ml, p8ml icos, p5gh. (13 sts)
Row 21: K5gh, k1ml, k3gh, k2ml, k2togml. (12 sts)
Row 22: P2ml, p4gh, p2ml, p4gh.
Row 23: Incgh, k2gh, k3ml, k4gh, k2togml.
Row 24: P2togml, p3gh, p3ml, p4gh. (11 sts)
Row 25: K4gh, k4ml, k3gh.
Row 26: P2toggh, p1gh, p8ml. (10 sts)
Row 27: Incml, k7ml, k2togml.
Row 28: P2ml, p2gh, p6ml.
Row 29: K4ml, k4gh, k2ml.
Row 30: P2togml, p5gh, p3ml. (9 sts)
Row 31: Incml, k2ml, k4gh, k2toggh.
Row 32: P5gh, p2ml, p2gh.
Row 33: K3gh, k2ml, k4gh.
Row 34: P4gh, p2ml, p3gh.
Row 35: K3gh, k3ml, k3gh.
Row 36: P2toggh, p1gh, p4ml, p2gh. (8 sts)
Row 37: Incgh, k1gh, k4ml, k2togml.
Row 38: P2ml, p2gh, p4ml.
Row 39: K3ml, k4gh, k1ml,
Row 40: P5gh, p3ml.
Row 41: K3ml, k5gh.
Row 42: P2toggh, p2gh, p4ml. (7 sts)
Row 43: K2gh, k5ml.
Row 44: P4ml, p3gh.
Row 45: K3gh, k4ml.
Row 46: P2togml, p2ml, p2gh, incgh.

Markings

The giraffe's markings are made using the intarsia and Fair Isle methods.

Row 47: K4ml, k2gh, k1ml.
Row 48: P2togml, p2gh, p3ml. (6 sts)
Row 49: K2ml, k3gh, k1ml.
Row 50: P1ml, p3gh, p2ml (hold 6 sts on spare needle for neck).

Left Side of Body

With ml, cast on 10 sts.
Row 1: Purl.
Row 2: Inc, k8, inc, k6 from spare needle of Left Front Leg. (18 sts)
Join in gh.
Row 3: P2ml, p3gh, p13ml, cast on 2 sts ml, then p4ml, p3gh, p4ml across sts on spare needle of Left Back Leg. (31 sts)
Row 4: K3ml, k5gh, k3ml, k3gh, k5ml, k2gh, k4ml, k4gh, k2ml.
Row 5: Incml, p1ml, p4gh, p4ml, p3gh, p3ml, p5gh, p2ml, p6gh, p2toggh.
Row 6: K7gh, k2ml, k6gh, k3ml, k3gh, k2ml, k6gh, k2ml.
Row 7: P1ml, p7gh, p2ml, p2gh, p4ml, p6gh, p3ml, p4gh, p2toggh. (30 sts)
Row 8: K4gh, k5ml, k4gh, k10ml, k5gh, k2ml.
Row 9: Incml, p1ml, p4gh, p11ml, p4gh, p6ml, p3gh. (31 sts)
Row 10: K3gh, k1ml, k3gh, k2ml, k4gh, k1ml, k5gh, k1ml, k3gh, k1ml, k3gh, k4ml.
Row 11: P8ml, p3gh, p2ml, p3gh, p3ml, p3gh, p2ml, p3gh, p1ml, p1gh, p2toggh. (30 sts)
Row 12: K2ml, k4gh, k2ml, k4gh, k2ml, k4gh, k1ml, k5gh, k6ml.
Row 13: P5ml, p6gh, p1ml, p4gh, p3ml, p3gh, p2ml, p4gh, p2togml. (29 sts)
Row 14: K5gh, k8ml, k4gh, k2ml, k6gh, k4ml.
Row 15: Incml, p2ml, p7gh, p3ml, p3gh, p9ml, p2gh, p2toggh.
Row 16: Bind off 5 sts ml, k3ml ibos, k2gh, k2ml, k3gh, k3ml, k7gh, k4ml. (24 sts)
Row 17: P3ml, p8gh, p8ml, p3gh, p2togml. (23 sts)
Row 18: Bind off 5 sts ml, k8ml ibos, k3gh, k3ml, k4gh. (18 sts)

143

Row 19: Incgh, p3gh, p8ml, p4gh, p2toggh.
Row 20: Bind off 5 sts ml, k8ml ibos, k5gh. (13 sts)
Row 21: P5gh, p1ml, p3gh, p2ml, p2togml. (12 sts)
Row 22: K2ml, k4gh, k2ml, k4gh.
Row 23: Incgh, p2gh, p3ml, p4gh, p2togml.
Row 24: K2togml, k3gh, k3ml, k4gh. (11 sts)
Row 25: P4gh, p4ml, p3gh.
Row 26: K2toggh, k1gh, k8ml. (10 sts)
Row 27: Incml, p7ml, p2togml.
Row 28: K2ml, k2gh, k6ml.
Row 29: P4ml, p4gh, p2ml.
Row 30: K2togml, k5gh, k3ml. (9 sts)
Row 31: Incml, p2ml, p4gh, p2toggh.
Row 32: K5gh, k2ml, k2gh.
Row 33: P3gh, p2ml, p4gh.
Row 34: K4gh, k2ml, k3gh.
Row 35: P3gh, p3ml, p3gh.
Row 36: K2toggh, k1gh, k4ml, k2gh. (8 sts)
Row 37: Incgh, p1gh, p4ml, p2togml.
Row 38: K2ml, k2gh, k4ml.
Row 39: P3ml, p4gh, p1ml.
Row 40: K5gh, k3ml.
Row 41: P3ml, p5gh.
Row 42: K2toggh, k2gh, k4ml. (7 sts)
Row 43: P2gh, p5ml.
Row 44: K4ml, k3gh.
Row 45: P3gh, p4ml.
Row 46: K2togml, k2ml, k2gh, incgh.
Row 47: P4gh, p3ml.
Row 48: K2togml, k2gh, k3ml. (6 sts)
Row 49: P2ml, p3gh, p1ml.
Row 50: K1ml, k3gh, k2ml (hold 6 sts on spare needle for neck).

Head

With RS facing, k3ml, k2gh, k1ml from spare needle of Right Side of Body, then k1ml, k2gh, k3ml from spare needle of Left Side of Body. (12 sts)
Row 2: P12ml.
Row 3: K3ml, k6gh, wrap and turn (leave 3 sts on left-hand needle unworked).

Row 4: Working top of head on center 6 sts only, p6gh, w&t.
Row 5: K6gh, w&t.
Row 6: P6gh, w&t.
Row 7 K5gh, w&t.
Row 8: P4gh, w&t.
Row 9: K5gh, w&t.
Row 10: P6gh, w&t.
Row 11: K6gh, k3ml. (12 sts in total)
Row 12: Incml, p2ml, p6gh, p2ml, incml. (14 sts)
Row 13: K6ml, k2gh, k6ml.
Row 14: P2ml, p2gh p6ml, p2gh, p2ml.
Row 15: K2togml, k3gh, k4ml, k3gh, k2togml. (12 sts)
Row 16: P3ml, p1gh, p1ml, p2gh, p1ml, p1gh, p3ml.
Row 17: K2togml, k3ml, k2gh, k3ml, k2togml. (10 sts)
Row 18: P2togml, p1ml, [p2toggh] twice, p1ml, p2togml. (6 sts)
Row 19: K2ml, k2gh, k2ml.
Row 20: P2ml, p2gh, p2ml.
Cont in ml.
Row 21: K1, [k2tog] twice, k1. (4 sts)
Row 22: Purl.
Row 23: Knit.
Row 24: Purl.
Row 25: Knit.
Row 26: Purl.
Row 27: Inc, k2, inc. (6 sts)
Row 28: Purl.
Row 29: Knit.
Row 30: Purl.
Row 31: Inc, k1, [inc] twice, k1, inc. (10 sts)
Row 32: Purl.
Row 33: Knit.
Row 34: Purl.
Row 35: K2tog, k6, k2tog. (8 sts)
Row 36: P2tog, p4, p2tog. (6 sts)
Row 37: K2tog, k2, k2tog. (4 sts)
Row 38: [P2tog] twice. (2 sts)
Row 39: K2tog and fasten off.

Tummy

With ml, cast on 2 sts.
Beg with a k row, work 2 rows st st.
Row 3: [Inc] twice. (4 sts)
Row 4: Purl.
Work 6 rows st st.
Row 11: Inc, k2, inc. (6 sts)
Work 35 rows st st.
Row 47: K2tog, k2, k2tog. (4 sts)
Row 48: Purl.
Row 49: [K2tog] twice. (2 sts)
Row 50: P2tog and fasten off.

Ear

(make 2 the same)
With ml, cast on 3 sts.
Join in gh.
Row 1: K1ml, k1gh, k1ml.
Row 2: P1ml, p1gh, p1ml.
Row 3: K1ml, k1gh, k1ml.
Row 4: P3ml.
Row 5: K3ml.
Bind off.

To Finish

SEWING IN ENDS Sew in ends, leaving ends from cast on rows and bound off rows for sewing up.
STUFFING Two pipecleaners are used to stiffen each of the legs and help bend them into shape. Twist two pipecleaners to join together and bend into a 'U' shape, then use a further two pipecleaners to extend them by wrapping them round each other. Measure against front two legs, leaving an extra 1in (2.5cm) at both ends. Fold these ends over to stop the pipecleaner poking out through the knitting. Repeat with another four pipecleaners for the back legs.
LEGS With WS together, fold leg in half. As the legs are very thin, it is easiest to sew the leg up around the double pipecleaners, and you probably won't have enough room for any stuffing until you get to where the leg

starts to get wider. Starting at foot, sew up legs on RS with es for the hooves and ml for the rest. If your giraffe won't stand up—and it is quite hard to make them stable—you can put kabob sticks or bamboo knitting needles (cut to fit) down the legs.

HEAD Sew chin to head.

BODY Sew up bottom, back, and neck on inside. Turn RS out and, starting at the head, stuff the giraffe. Don't overstuff the head, as it should look quite delicate, but stuff the rest of the giraffe firmly as it will help it stand up. Mold body into shape.

TUMMY Attach bound off row behind legs and cast on row approx 1½in (3cm) up chest. Sew tummy to body, leaving a 1in (2.5cm) gap between front and back legs on one side for stuffing. When you have stuffed body, sew up gap.

TAIL With ml, make a loop 3in (8cm) long where back meets bottom. Using same yarn and starting at the end near bottom, cover loop with tightly packed buttonhole stitch to cover whole loop. When complete, thread yarn up through tail and trim. Make 3 loops at free end with es using crochet hook and scarf fringe method (see page 173).

EARS Attach ears where top of neck meets head, with RS facing forward and with 5 sts between ears.

MANE With gh, crochet hook, and scarf fringe method (see page 173), hook 15 double strands of yarn through top center of neck to form mane. Cut to length, but don't cut too short or the tufts might pop out.

EYES With bl, make 3 satin sts for eyes and 2 tiny sts for nostrils at end of nose, with 2 sts between nostrils.

OSSICONES (That's what the horns are called.) Cut a pipecleaner to 2¼in (6cm) long. Thread it through the top of the head, 3 sts apart, and bend the protruding ends into a 'U' shape. Wrap with gh, making it thicker at the tips.

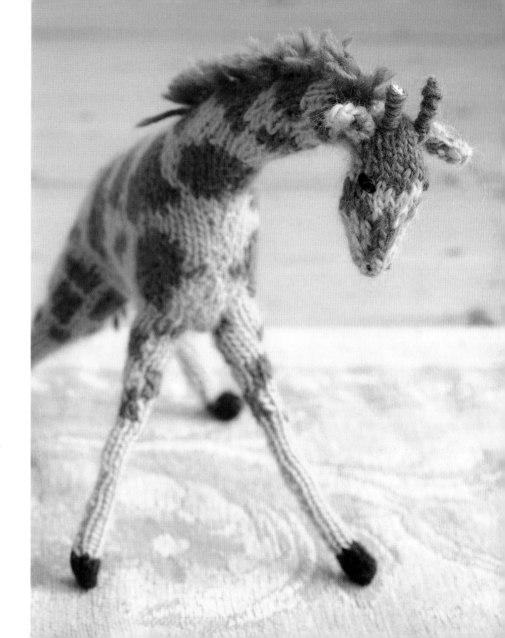

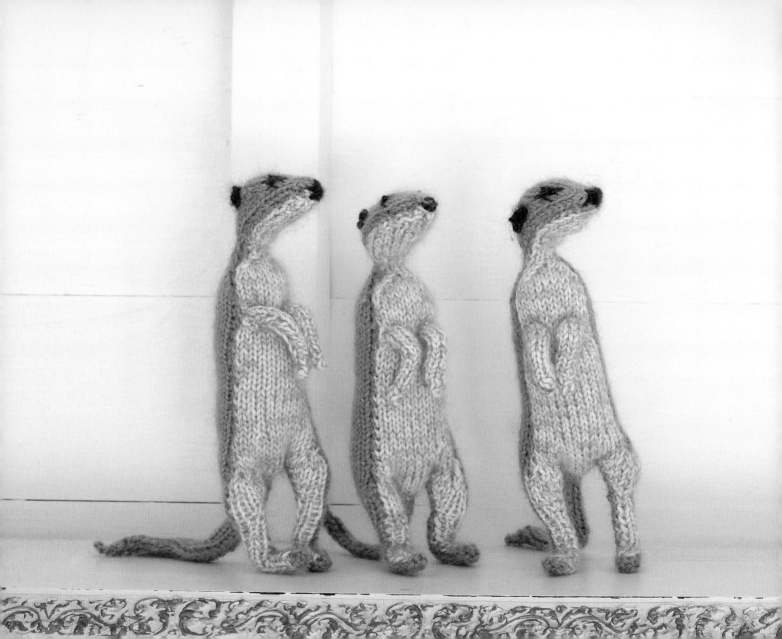

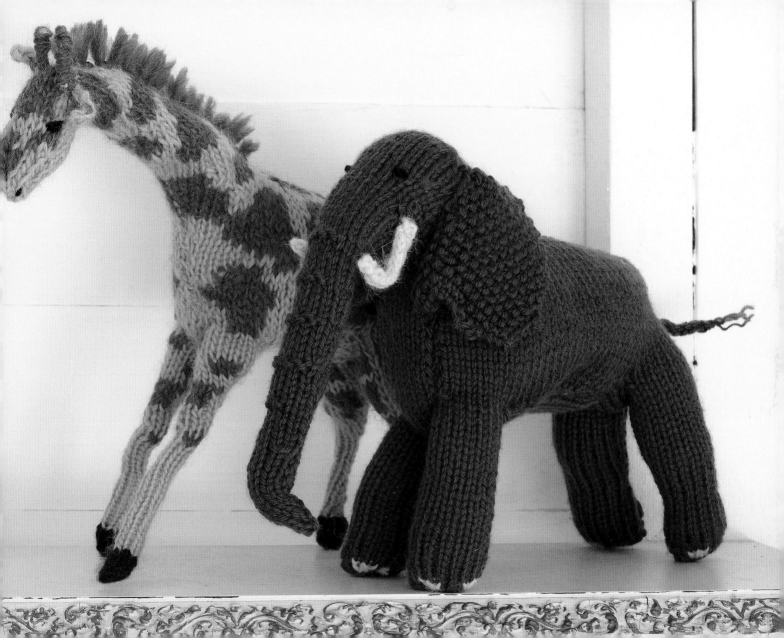

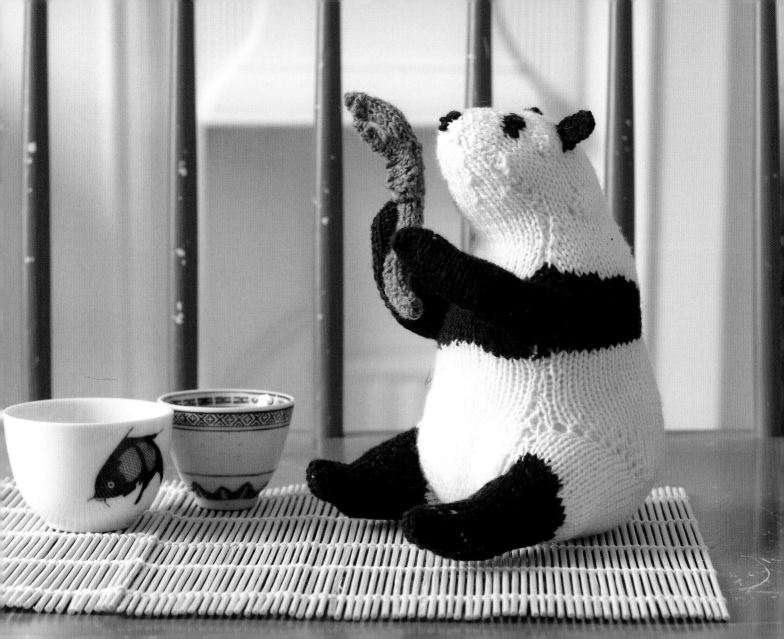

Panda

With a simple diet of bamboo, the rare and endangered giant panda lives in China. In the 1970s China used the panda as a diplomatic tool, giving them to Western zoos; this has now stopped but the Chinese still loan pandas to the West. Chi Chi was a star attraction at London Zoo until her death in 1972, and was the inspiration for the World Wildlife Fund logo. The panda is so adored that a themed hotel, offering everything panda, has opened in Sichuan Province in China.

Panda

Plenty of stuffing is needed for this chunky animal.

Measurements
Depth at bottom (including legs): 6in (15cm)
Height to top of head: 7in (18cm)

Materials
- Pair of US 2 (2¾mm) knitting needles
- Double-pointed US 2 (2¾mm) knitting needles (for holding stitches)
- ½oz (15g) of Rowan Pure Wool 4ply in Black 404 (bl)
- 1¼oz (30g) of Rowan Pure Wool 4ply in Snow 412 (sn)
- ⅙oz (5g) of Rowan Fine Tweed in Richmond 381 (ri)
- 3 pipecleaners for legs and bamboo
- Rice or dried lentils for stuffing
- 2 tiny black beads for eyes and sewing needle and black thread for sewing on

Abbreviations
See page 172.
See page 172 for Color Knitting.
See page 172 for Wrap and Turn Method.
See page 172 for Short Row Patterning.
NOTE: this animal has no tail.

Right Back Leg
With bl, cast on 13 sts.
Beg with a k row, work 2 rows st st.
Row 3: Inc, k3, k2tog, k1, k2tog, k3, inc. (13 sts)
Row 4: Purl.
Rep rows 3–4 twice more.
Row 9: K2tog, k9, k2tog. (11 sts)

Row 10: Purl.
Row 11: Inc, k9, inc. (13 sts)
Row 12: Purl.
Row 13: K5, inc, k1, inc, k5. (15 sts)
Row 14: Purl.*
Row 15: K6, inc, k1, inc, k3, inc, k2. (18 sts)
Row 16: Purl.
Row 17: K14, inc, k3. (19 sts)
Row 18: Purl.
Row 19: K7, inc, k1, inc, k4, inc, k4. (22 sts)
Row 20: Purl.
Row 21: K16, inc, k5. (23 sts)
Row 22: Purl.
Join in sn.
Row 23: K4sn, k4bl, incbl, k1bl, incbl, k6bl, incbl, k5sn. (26 sts)
Row 24: P7sn, p12bl, p7sn.
Row 25: K9sn, incsn, k1bl, incbl, k3bl, k4sn, incsn, k6sn. (29 sts)
Cont in sn.
Row 26: Purl.
Row 27: Bind off 11 sts, k to end (hold 18 sts on spare needle for Back).

Left Back Leg
Work as for Right Back Leg to *.
Row 15: K2, inc, k3, inc, k1, inc, k6. (18 sts)
Row 16: Purl.
Row 17: K3, inc, k14. (19 sts)
Row 18: Purl.
Row 19: K4, inc, k4, inc, k1, inc, k7. (22 sts)
Row 20: Purl.
Row 21: K5, inc, k16. (23 sts)
Row 22: Purl.
Join in sn.
Row 23: K5sn, incbl, k6bl, incbl, k1bl, incbl, k4bl, k4sn. (26 sts)
Row 24: P7sn, p12bl, p7sn.
Row 25: K6sn, incsn, k4sn, k3bl, incbl, k1bl, incsn, k9sn. (29 sts)
Cont in sn.
Row 26: Purl.
Row 27: K18, bind off 11 sts (hold 18 sts on spare needle for Back).

Eyes
The panda has huge eyes, with black beads for the pupils.

Back, Front Legs, and Head

Row 1: With sn and WS facing, p18 from spare needle of Right Back Leg, cast on 16 sts, p18 from spare needle of Left Back Leg. (52 sts)
Row 2: Knit.
Row 3: P50, wrap and turn (leave 2 sts on left-hand needle unworked).
Row 4: K48, w&t.
Row 5: P47, w&t.
Row 6: K46, w&t.
Row 7: P45, w&t.
Row 8: K44, w&t.
Row 9: P43, w&t.
Row 10: K42, w&t.
Row 11: P41, w&t.
Row 12: K40, w&t.
Row 13: P39, w&t.
Row 14: K38, w&t.
Row 15: P37, w&t.
Row 16: K36, w&t.
Row 17: P35, w&t.
Row 18: K11, k2tog, k8, k2tog, k11, w&t.
Row 19: P31, w&t.
Row 20: K30, w&t.
Row 21: P31, w&t.
Row 22: K32, w&t.
Row 23: P33, w&t.
Row 24: K34, w&t.
Row 25: P35, w&t
Row 26: K36, w&t.
Row 27: P37, w&t.
Row 28: K12, k2tog, k10, k2tog, k12, w&t.
Row 29: P37, w&t.
Row 30: K38, w&t.
Row 31: P39, w&t.
Row 32: K40, w&t.
Row 33: P41, w&t.
Row 34: K42, w&t.
Row 35: P43, w&t.
Row 36: K46. (48 sts in total)
Row 37: Purl.
Row 38: K17, k2tog, k10, k2tog, k17. (46 sts)
Work 5 rows st st.

Row 46: K2tog, k42, k2tog. (44 sts)
Row 47: Purl.
Row 48: Knit.

Shape front legs

Join in bl.
Row 49: P14bl, p16sn, p14bl, cast on 16 sts bl. (60 sts)
Row 50: K34bl, k8sn, k18bl, cast on 16 sts bl. (76 sts)
Cont in bl.
Row 51: Purl.
Row 52: Inc, k74, inc. (78 sts)
Row 53: Purl.
Row 54: Inc, k31, k2tog, k10, k2tog, k31, inc. (78 sts)
Join in sn.
Row 55: P37bl, p4sn, p37bl.
Row 56: Incbl, k33bl, k10sn, k33bl, incbl. (80 sts)
Row 57: P32bl, p16sn, p32bl.
Row 58: Incbl, k29bl, k20sn, k29bl, incbl. (82 sts)
Cont in bl.
Row 59: P5, p2tog, p12 (hold rem 63 sts on spare needle).
Row 60: Working on 18 sts for Left Front Leg, k18.
Row 61: P5, inc, p12. (19 sts)
Row 62: K17, k2tog. (18 sts)
Row 63: Purl.
Row 64: K16, k2tog. (17 sts)
Row 65: Purl.
Row 66: Knit.
Row 67: Bind off 7 sts, p to end. (10 sts)
Row 68: Knit.
Row 69: Bind off 3 sts, p to end. (7 sts)
Row 70: Knit.
Bind off and break off yarn.
Next row: Rejoin bl, p7bl, p30sn, p19bl, p2togbl, p5bl. (62 sts)
Cont in bl.
Next row: K18 for Left Front Leg (hold rem 44 sts on spare needle).
Next row: P12, inc, p5. (19 sts)

Next row: K2tog, k17. (18 sts)
Next row: Purl.
Next row: K2tog, k16. (17 sts)
Next row: Purl.
Next row: Bind off 7 sts, k to end. (10 sts)
Next row: Purl.
Next row: Bind off 3 sts, k to end. (7 sts)
Next row: Purl.
Bind off, break yarn.

Shape shoulders

Next row: Rejoin bl and sn to center 44 sts, k4bl, k12sn, k2togsn, k8sn, k2togsn, k12sn, k4bl. (42 sts)
Next row: P2bl, p38sn, p2bl.
Cont in sn.
Next row: K2tog, k12, k2tog, k10, k2tog, k12, k2tog. (38 sts)
Next row: Purl.
Next row: K2tog, k11, k2tog, k8, k2tog, k11, k2tog. (34 sts)
Next row: Purl.
Next row: K2tog, k9, k2tog, k8, k2tog, k9, k2tog. (30 sts)
Next row: Purl.
Next row: K2tog, k8, k2tog, k6, k2tog, k8, k2tog. (26 sts)
Next row: Purl.
Next row: K22, wrap and turn (leave 4 sts on left-hand needle unworked).
Next row: Working top of head on center 18 sts only, p18, w&t.
Next row: K18, w&t.
Rep last 2 rows once more.
Next row: P18, w&t.
Next row: K22. (26 sts in total)
Next row: Purl.
Next row: Inc, k24, inc. (28 sts)
Next row: Purl.
Next row: Inc, k26, inc. (30 sts)
Next row: Purl.
Next row: Inc, k8, k2tog, k8, k2tog, k8, inc. (30 sts)
Next row: Purl.
Next row: K23, w&t (leave 7 sts on left-hand

needle unworked).
Next row: P16, w&t.
Next row: K16, w&t.
Rep last 2 rows once more.
Next row: P16, w&t.
Next row: K23. (30 sts in total)
Next row: P2tog, p4, p2tog, p3, p2tog, p4, p2tog, p3, p2tog, p4, p2tog. (24 sts)
Join in bl for eye patches.
Next row: K2togsn, k4sn, k2togbl, k1bl, k2togsn, k2sn, k2togsn, k1bl, k2togbl, k4sn, k2togsn. (18 sts)
Next row: P3sn, p2togbl, p2bl, p4sn, p2bl, p2togbl, p3sn. (16 sts)
Next row: K3sn, k2bl, k2togsn, k2sn, k2togsn, k2bl, k3sn. (14 sts)
Cont in sn.
Work 3 rows st st.
Next row: K4, k2tog, k2, k2tog, k4. (12 sts)
Work 3 rows st st.
Next row: K3, k2tog, k2, k2tog, k3. (10 sts)
Bind off.

Tummy

With sn, cast on 18 sts.
Beg with a k row, work 18 rows st st.
Row 19: K2tog, k14, k2tog. (16 sts)
Join in bl.
Work 9 rows st st in bl.
Row 29: K4bl, k8sn, k4bl.
Row 30: P6bl, p4sn, p6bl.
Work 8 rows st st.
Row 39: K5bl, k6sn, k5bl.
Row 40: P3bl, p10sn, p3bl.
Row 41: K2bl, k12sn, k2bl.
Row 42: P1bl, p14sn, p1bl.
Row 43: K1bl, k14sn, k1bl.
Cont in sn.
Row 44: P2tog, p12, p2tog. (14 sts)
Work 14 rows st st.

Row 59: K2tog, k2, k2tog, k2, k2tog, k2, k2tog. (10 sts)
Work 3 rows st st.
Row 63: K2, k2tog, k2, k2tog, k2. (8 sts)
Work 3 rows st st.
Row 67: K1, k2tog, k2, k2tog, k1. (6 sts)
Work 2 rows st st.
Cast (bind) off.

Ear

(make 2 the same)
With bl, cast on 5 sts.
Knit 4 rows.
Row 5: K2tog, k1, k2tog. (3 sts)
Bind off.

Bamboo Stalk

With ri, cast on 6 sts.
Beg with a k row, work 13 rows st st.
Row 14: Knit.
Beg with a k row, work 11 rows st st.
Row 26: Knit.
Beg with a k row, work 11 rows st st.
Row 38: Knit.
Beg with a k row, work 12 rows st st.
Bind off.

Bamboo Leaf

With ri, cast on 4 sts.
Knit 20 rows.
Row 21: [K2tog] twice. (2 sts)
Knit 4 rows.
Row 26: K2tog and fasten off.

To Finish

SEWING IN ENDS Sew in ends, leaving ends from cast on rows and bound off rows for sewing up.

LEGS With WS together, fold leg in half. Starting at paw, sew up legs on RS.

HEAD Fold bound off row of head in half and sew from nose to chin.

TUMMY Sew cast on row of tummy to panda's bottom, between his back legs, and sew bound off row to his chin. Ease and sew tummy to fit body, matching curves and black markings to leg, and leaving a 1in (2.5cm) gap between front and back legs on one side.

STUFFING Pipecleaners are used to stiffen the legs and help bend them into shape. Fold a pipecleaner into a 'U' shape and measure against front two legs. Cut to approximately fit, leaving an extra 1in (2.5cm) at both ends. Fold these ends over to stop the pipecleaner poking out of the paws. Roll a little stuffing around pipecleaner and slip into body, one end down each front leg. Rep with second pipecleaner and back legs. Starting at the head, stuff the panda firmly, add some rice or lentils to the panda's bottom to give him weight, then sew up the gap. Mold body into shape, pushing the head down.

EARS Sew cast on row of each ear to head with 6 sts between ears.

EYES With black thread, sew a black bead onto center of black eye patch.

NOSE With bl, embroider nose in satin stitch.

BAMBOO Cut a pipecleaner to match length of bamboo and fold over ends. Wrap the bamboo round the pipecleaner and sew up. Sew on the bamboo leaf. Attach the bamboo to the panda's front paws.

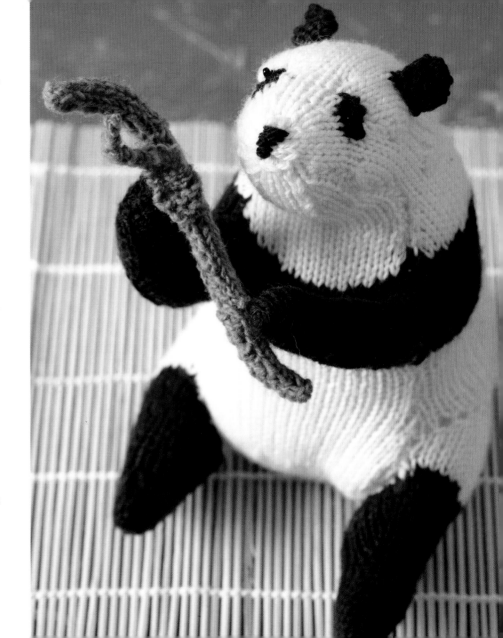

Orangutan

Orangutan means 'person of the forest'; along with chimpanzees and gorillas, orangutans are apes. You can tell an ape from a monkey as apes have no tails. There is a legend that orangutans can speak, but they choose not to for fear of being made to work. King Louie, one of the stars of *The Jungle Book* cartoon, wasn't in the original book, but popped up in the film to sing 'I Wan'na Be Like You' to Mowgli. Bornean orangutans are endangered, and Sumatran critically endangered, largely due to deforestation.

Orangutan

The orangutan is an addition to any home.

Measurements
Height to top of head: 10in (25cm)
Height (hanging from one arm): 14in (36cm)

Materials
- Pair of US 2 (2¾mm) knitting needles
- ½oz (10g) of Rowan Pure Wool 4ply in Mocha 417 (mo)
- ¾oz (20g) of Rowan Kidsilk Haze in Brick 649 (bk)
- 1¼oz (30g) of Rowan Felted Tweed in Ginger 154 (gn)

NOTE: some of this animal uses 1 strand of mo and 1 strand of gn held together, and this is called mogn
Other parts of this animal use 1 strand of bk and 1 strand of gn held together, and this is called bkgn

- Tiny amount of Rowan Pure Wool 4ply in Black 404 (bl) for eyes
- 4 pipecleaners for arms and legs
- 2 tiny black beads for eyes and sewing needle and black thread for sewing on

Abbrevations
See page 172.
See page 172 for Wrap and Turn Method.
See page 173 for Loopy Stitch. Work 3-finger loopy stitch throughout this pattern.
When working with bkgn, loops are made with bk only.

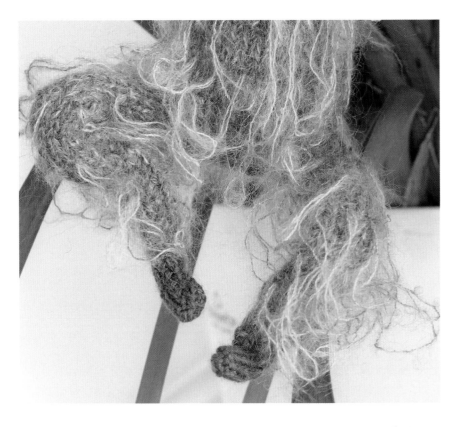

Back Legs
(make 2 the same)
With mo, cast on 8 sts.
Beg with a k row, work 10 rows st st.
Cont in bkgn.
Row 11: Inc, k6, inc. (10 sts)
Work 5 rows st st.
Row 17: Inc, k8, inc. (12 sts)
Work 3 rows st st.

Arms and Legs
The orangutan is made to sit or hang from something; all his limbs can be manipulated into shape.

Row 21: K2, [loopy st 1, k1] to end.
Work 5 rows st st.
Row 27: As row 21.
Work 5 rows st st.
Row 33: As row 21.
Work 7 rows st st.
Row 41: As row 21.
Work 7 rows st st.
Row 49: Inc, k10, inc. (14 sts)
Row 50: Purl.
Row 51: K2, [loopy st 1, k1] to end.
Work 3 rows st st.
Bind off.

Arms

(make 2 the same)
With mo, cast on 8 sts.
Beg with a k row, work 8 rows st st.
Cont in bkgn.
Row 9: Inc, k6, inc. (10 sts)
Work 9 rows st st.
Row 19: K2, [loopy st 1, k1] to end.
Work 7 rows st st.
Row 27: As row 19.
Work 5 rows st st.
Row 33: As row 19.
Work 7 rows st st.
Row 41: As row 19.
Work 5 rows st st.
Row 47: Inc, k8, inc. (12 sts)
Work 5 rows st st.
Row 53: K1, loopy st 10, k1.
Work 5 rows st st.
Bind off.

Back of Body and Head

With bkgn, cast on 14 sts.
Beg with a k row, work 2 rows st st.
Row 3: Inc, k12, inc. (16 sts)
Work 7 rows st st.
Row 11: Inc, k14, inc. (18 sts)
Row 12: Purl.
Row 13: K2, [loopy st 1, k1] to end.
Work 7 rows st st.

Row 21: Inc, k16, inc. (20 sts)
Row 22: Purl.
Row 23: As row 13.
Work 9 rows st st.
Row 33: As row 13.
Work 7 rows st st.
Row 41: K2tog, k16, k2tog. (18 sts)
Row 42: Purl.
Row 43: As row 13.
Work 3 rows st st.
Row 47: K2tog, k14, k2tog. (16 sts)
Row 48: Purl.
Row 49: As row 13.
Row 50: Purl.*

Shape shoulders

Row 51: Bind off 6 sts, k to end. (10 sts)
Row 52: Bind off 6 sts, p to end. (4 sts)
Work 2 rows st st.
Cont in mogn.
Row 55: [Inc] 4 times. (8 sts)
Row 56: Purl.
Row 57: Inc, k6, inc. (10 sts)
Row 58: Purl.
Row 59: Inc, k1, inc, k4, inc, k1, inc. (14 sts)
Row 60: Purl.
Join in bk.
Row 61 (make loops in bk, k sts in mogn):
Inc, k1, loopy st 1, inc, [loopy st 1, k1] 3
times, inc, loopy st 1, k1, inc. (18 sts)
Row 62: Purl.
Row 63: K14, wrap and turn (leave 4 sts on
left-hand needle unworked).
Row 64: Working top of head on center
10 sts only, p10, w&t.
Row 65: K10, w&t.
Row 66: P10, w&t.
Row 67: K10, w&t.
Row 68: P10, w&t.
Row 69: K14. (18 sts in total)
Row 70: Purl.
Row 71: K2tog, k1, k2tog, k8, k2tog, k1,
k2tog. (14 sts)
Row 72: P2tog, p10, p2tog. (12 sts)
Row 73: K9, w&t (leave 3 sts on left-hand

Head

The orangutan's loopy stitch fur can be smoothed down over his head.

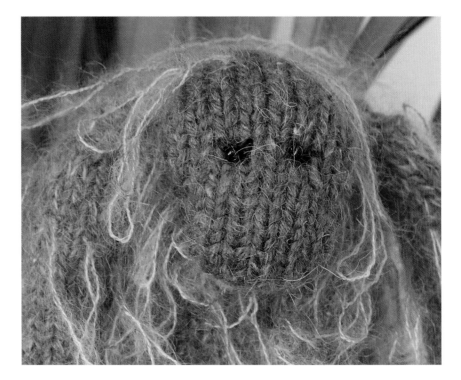

needle unworked).

Row 74: Working top of head on center 6 sts only, p6, w&t.

Row 75: K6, w&t.

Row 76: P6, w&t.

Row 77: K6, w&t.

Row 78: P6, w&t.

Row 79: K9. (12 sts in total)

Row 80: [P2tog] 6 times. (6 sts)

Bind off.

Front

Work as for Back of Body and Head to *.

Shape shoulders

Row 51: K6, k2tog, turn.

Row 52: Working on this side only, p2tog, p5.

Bind off.

Row 51: Rejoin yarn, k2tog, k6.

Row 52: P5, p2tog.

Bind off.

To Finish

SEWING IN ENDS Sew in ends, leaving ends from cast on rows and bound off rows for sewing up.

HEAD With WS together, sew two sides of head and neck together, leaving a 1in (2.5cm) gap in side. Stuff firmly, then sew up gap.

BODY With WS together, sew up shoulders with mattress st.

LEGS AND BODY Pipecleaners are used to stiffen the arms and legs and help bend them into shape. Measure pipecleaners to fit arms and legs, leaving an extra 1in (2.5cm) at paw ends. Fold these ends over to stop the pipecleaner poking out of the paws. Roll a little stuffing around pipecleaner and wrap knitted piece around it, then sew up on outside. Twist other end of the pipecleaners around each other inside body. Sew arms to side of the body below shoulder seam. Sew down one side of body on outside, attaching legs to bottom of side seam with inside ends of pipecleaner attached to each other as before. Sew along bottom of body and up second side, leaving a 1in (2.5cm) gap in side for stuffing.

STUFFING Stuff body, but don't overstuff as it needs to be slightly floppy. Sew up gap.

POSITION Head will flop down onto chest; catch down with a stitch underneath chin.

EYES With bl, sew 2-loop French knots positioned as in photograph, with 2 sts between eyes. Sew tiny black beads on top of knots.

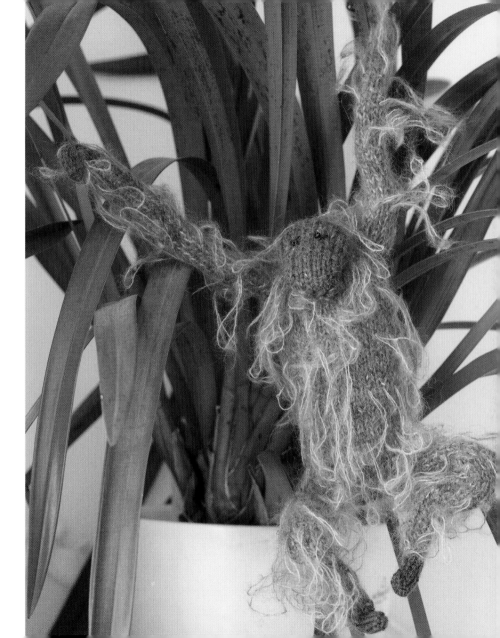

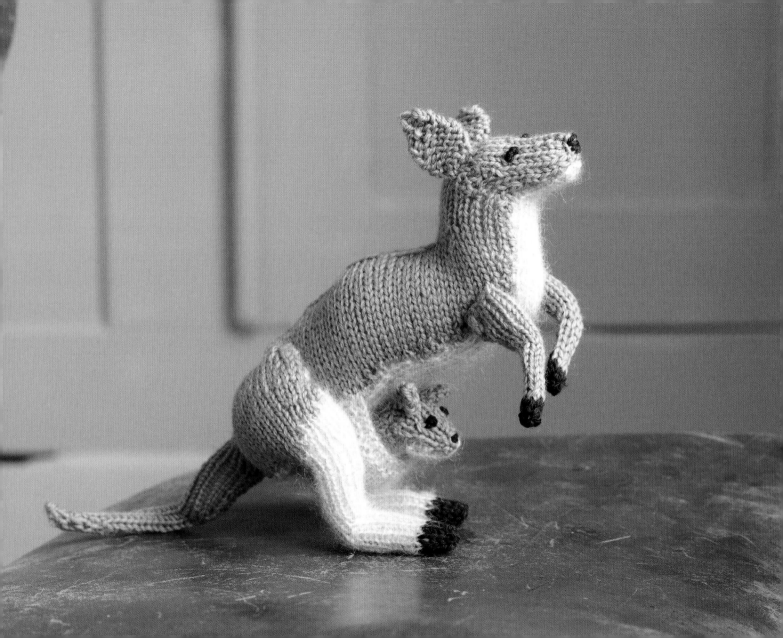

Kangaroo

Unique to Australia, the kangaroo has powerful hind legs, large feet for leaping, and a long, muscular tail for balance. Kanga is a kindly character in A. A. Milne's *Winnie-the-Pooh*. Her joey is Roo, a playful and energetic friend to Tigger, the tiger. Kangaroos live happily in groups, called a mob, and during the mating season the males 'box' over the females to see who is going to sire the most joeys. Young joeys box too, but in a playful way.

Kangaroo and Joey

Our knitted kangaroo has a removable joey in her pouch.

Measurements
Length to tip of tail: 8¾in (22cm)
Height to top of head (seated): 6¾in (17cm)

Materials
- Pair of US 2 (2¾mm) knitting needles
- Double-pointed US 2 (2¾mm) knitting needles (for holding stitches)
- 1¼oz (30g) of Rowan Pure Wool 4ply in Toffee 453 (tf)
- ⅙oz (5g) of Rowan Kidsilk Haze in Pearl 590 (pe) used DOUBLED throughout
- Small amount of Rowan Pure Wool 4ply in Black 404 (bl) for eyes and nose
- 3 pipecleaners for legs and tail

Abbreviations
See page 172.
See page 172 for Color Knitting.
See page 172 for Wrap and Turn Method.
See page 172 for Short Row Patterning.

Kangaroo

Right Back Leg
With bl, cast on 9 sts.
Beg with a k row, work 3 rows st st.
Change to pe.
Work 11 rows st st.
Row 15: K1, wrap and turn (leave 8 sts on left-hand needle unworked).
Row 16: P1.
Row 17: K2, w&t.
Row 18: P2.
Row 19: K3, w&t.
Row 20: P3.
Row 21: K4, w&t.
Row 22: P4.
Row 23: K9. (9 sts in total)
Row 24: P1, w&t (leave 8 sts on left-hand needle unworked).
Row 25: K1.
Row 26: P2, w&t.
Row 27: K2.
Row 28: P3, w&t.
Row 29: K3.
Row 30: P4, w&t.
Row 31: K4. (9 sts in total)
Work 11 rows st st.*
Join in tf.
Row 43: K7pe, k2tf.
Row 44: P2tf, p7pe.
Row 45: Incpe, k2pe, incpe, k1pe, incpe, k2tf, inctf. (13 sts)
Row 46: P4tf, p9pe.
Row 47: K8pe, k5tf, cast on 6 sts tf. (19 sts)
Row 48: P6tf, p13pe, cast on 6 sts pe. (25 sts)
Row 49: K13pe, k12tf.
Row 50: P13tf, p12pe.
Row 51: Incpe, k11pe, k12tf, inctf. (27 sts)
Row 52: P15tf, p12pe.
Row 53: K12pe, inctf, k1tf, inctf, k12tf. (29 sts)
Row 54: P17tf, p12pe.
Row 55: K2togpe, k10pe, k15tf, k2togtf. (27 sts)
Row 56: P16tf, p11pe.
Row 57: K2togpe, k10pe, inctf, k1tf, inctf, k10tf, k2togtf. (27 sts)
Row 58: P16tf, p11pe.
Row 59: K2togpe, k8pe, k15tf, k2togtf. (25 sts)
Row 60: P15tf, p10pe.
Row 61: K2togpe, k8pe, k2togtf, k1tf, k2togtf, k8tf, k2togtf. (21 sts)
Row 62: P11tf, p10pe.
Row 63: K2togpe, k6pe, k2togpe, k1tf, k2togtf, k6tf, k2togtf. (17 sts)
Row 64: Bind off 9 sts tf, 8 sts pe.

Left Back Leg
Work as for Right Back Leg to *.
Join in tf.
Row 43: K2tf, k7pe.
Row 44: P7pe, p2tf.
Row 45: Inctf, k2tf, incpe, k1pe, incpe, k2pe, incpe. (13 sts)
Row 46: P9pe, p4tf.
Row 47: K5tf, k8pe, cast on 6 sts pe. (19 sts)
Row 48: P13pe, p6tf, cast on 6 sts tf. (25 sts)
Row 49: K12tf, k13pe.
Row 50: P12pe, p13tf.
Row 51: Inctf, k12tf, k11pe, incpe. (27 sts)
Row 52: P12pe, p15tf.
Row 53: K12tf, inctf, k1tf, inctf, k12pe. (29 sts)
Row 54: P12pe, p17tf.
Row 55: K2togtf, k15tf, k10pe, k2togpe. (27 sts)
Row 56: P11pe, p16tf.
Row 57: K2togtf, k10tf, inctf, k1tf, inctf, k10pe, k2togpe. (27 sts)
Row 58: P11pe, p16tf.
Row 59: K2togtf, k15tf, k8pe, k2togpe. (25 sts)
Row 60: P9pe, p16tf.
Row 61: K2togtf, k8tf, k2togtf, k1tf, k2togtf, k8pe, k2togpe. (21 sts)
Row 62: P10pe, p11tf.
Row 63: K2togtf, k6tf, k2togtf, k1tf, k2togpe, k6pe, k2togpe. (17 sts)
Row 64: Bind off 8 sts pe, 9 sts tf.

Front Legs
(make 2 the same)
With bl, cast on 7 sts.
Beg with a k row, work 2 rows st st.
Cont in tf.
Row 3: Knit.

Row 4: P1, p2tog, p1, p2tog, p1. (5 sts)
Work 4 rows st st.
Row 9: Inc, k3, inc. (7 sts)
Row 10: Purl.
Row 11: Inc, k5, inc. (9 sts)
Work 5 rows st st.
Row 17: Inc, k7, inc. (11 sts)
Row 18: Purl.
Row 19: Inc, k9, inc. (13 sts)
Row 20: Purl.
Row 21: K2tog, k9, k2tog. (11 sts)
Bind off.

Tail

Starting at the tip of the tail, with tf, cast on 2 sts.
Beg with a k row, work 2 rows st st.
Row 3: [Inc] twice. (4 sts)
Row 4: Purl.
Row 5: Inc, k2, inc. (6 sts)
Work 5 rows st st.
Row 11: Inc, k4, inc. (8 sts)
Work 15 rows st st.
Row 27: Inc, k6, inc. (10 sts)
Work 9 rows st st.
Row 37: Inc, k8, inc. (12 sts)
Work 5 rows st st (hold 12 sts on spare needle for body).

Right Side of Body

Row 1: With tf, cast on 3 sts, with RS facing k6 from spare needle of tail (hold rem 6 sts on spare needle for Left Side of Body). (9 sts)
Row 2: P8, inc. (10 sts)
Row 3: Inc, k9. (11 sts)
Row 4: P10, inc. (12 sts)
Row 5: Inc, k9, k2tog. (12 sts)
Row 6: P11, inc. (13 sts)
Row 7: Inc, k12. (14 sts)
Row 8: P13, inc. (15 sts)
Row 9: Inc, k12, k2tog. (15 sts)
Row 10: P15, cast on 5 sts. (20 sts)
Row 11: K18, k2tog. (19 sts)
Row 12: P19, cast on 8 sts. (27 sts)

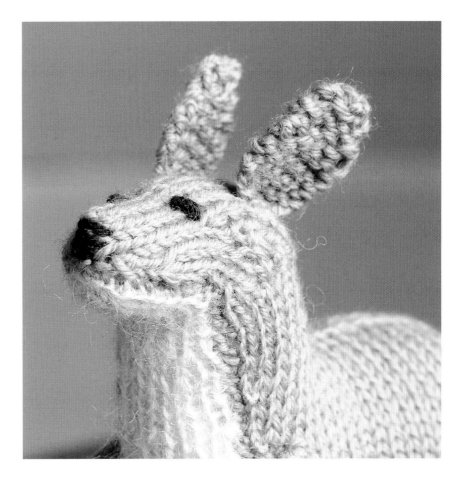

Ears

The kangaroo has enquiringly alert ears that sit high on her head.

Joey

The little joey has no legs, but tucked in the pouch he doesn't need them.

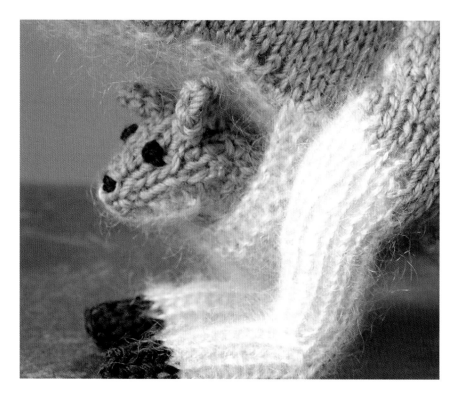

Row 13: K25, k2tog. (26 sts)
Row 14: P26, cast on 3 sts. (29 sts)
Row 15: K27, k2tog. (28 sts)
Row 16: Purl.
Row 17: Inc, k25, k2tog. (28 sts)
Row 18: Purl.
Row 19: K26, k2tog. (27 sts)
Row 20: P2tog, p25. (26 sts)
Row 21: Inc, k23, k2tog. (26 sts)
Row 22: P2tog, p24. (25 sts)
Row 23: K23, k2tog. (24 sts)
Row 24: P2tog, p22. (23 sts)

Row 25: Inc, k20, k2tog. (23 sts)
Row 26: Bind off 3 sts, p to end. (20 sts)
Row 27: K9 (hold these 9 sts on spare needle for neck), bind off 3 sts, k to end. (8 sts)
Row 28: Working on 8 sts of back only, p2tog, p4, p2tog. (6 sts)
Row 29: Bind off.

Left Side of Body

Row 1: With tf, cast on 3 sts, with WS facing p6 from spare needle of tail. (9 sts)

Row 2: K8, inc. (10 sts)

Row 3: Inc, p9. (11 sts)

Row 4: K10, inc. (12 sts)

Row 5: Inc, p9, p2tog. (12 sts)

Row 6: K11, inc. (13 sts)

Row 7: Inc, p12. (14 sts)

Row 8: K13, inc. (15 sts)

Row 9: Inc, p12, p2tog. (15 sts)

Row 10: K15, cast on 5 sts. (20 sts)

Row 11: P18, p2tog. (19 sts)

Row 12: K19, cast on 8 sts. (27 sts)

Row 13: P25, p2tog. (26 sts)

Row 14: K26, cast on 3 sts. (29 sts)

Row 15: P27, p2tog. (28 sts)

Row 16: Knit.

Row 17: Inc, p25, p2tog. (28 sts)

Row 18: Knit.

Row 19: P26, p2tog. (27 sts)

Row 20: K2tog, k25. (26 sts)

Row 21: Inc, p23, p2tog. (26 sts)

Row 22: K2tog, k24. (25 sts)

Row 23: P23, p2tog. (24 sts)

Row 24: K2tog, k22. (23 sts)

Row 25: Inc, p20, p2tog. (23 sts)

Row 26: Bind off 3 sts, k to end. (20 sts)

Row 27: P9 (hold these 9 sts on spare needle for neck), bind off 3 sts, p to end. (8 sts)

Row 28: Working on back only, k2tog, k4, k2tog. (6 sts)

Row 29: Bind off 6 sts on back.

Neck and Head

Row 1: With tf, k9 from spare needle of Right Side of Body, then k9 from spare needle of Left Side of Body. (18 sts)

Row 2: Purl.

Row 3: K5, k2tog, k4, k2tog, k5. (16 sts)

Work 3 rows st st.

Row 7: K12, wrap and turn (leave 4 sts on left-hand needle unworked).

Row 8: Working top of head on center 8 sts only, p8, w&t.

Row 9: K8, w&t.

Rep rows 8–9 once more.

Row 12: P8, w&t.

Row 13: K12. (16 sts in total)

Row 14: P2tog, p12, p2tog. (14 sts)

Row 15: K11, w&t (leave 3 sts on left-hand needle unworked).

Row 16: Working on center 8 sts only, p8, w&t.

Row 17: K8, w&t.

Rep rows 16–17 once more.

Row 20: P8, w&t.

Row 21: K11. (14 sts in total)

Row 22: P2, p2tog, p2, p2tog, p2, p2tog, p2. (11 sts)

Work 4 rows st st.

Row 27: K2tog, k7, k2tog. (9 sts)

Work 2 rows st st.

Row 30: P2tog, p5, p2tog. (7 sts)

Bind off.

Tummy

With pe, cast on 6 sts.

Beg with a k row, work 2 rows st st.

Row 3: Inc, k4, inc. (8 sts)

Work 51 rows st st.

Row 55: K1, k2tog, k2, k2tog, k1. (6 sts)

Work 7 rows st st.

Row 63: K1, [K2tog] twice, k1. (4 sts)

Work 15 rows st st.

Bind off.

Pouch

With pe, cast on 8 sts.

Beg with a k row, work 2 rows st st.

Row 3: Inc, k6, inc. (10 sts)

Row 4: Purl.

Row 5: Inc, k2, inc, k2, inc, k2, inc. (14 sts)

Row 6: Purl.

Row 7: K3, inc, k6, inc, k3. (16 sts)

Row 8: Purl.

Row 9: Inc, k3, inc, k6, inc, k3, inc. (20 sts)
Work 11 rows st st.
Row 19: Knit.
Row 20: Purl.
Row 21: Bind off.

Ear

(make 2 the same)
With tf, cast on 6 sts.
Knit 8 rows.
Next row: K2tog, k2, k2tog. (4 sts)
Knit 3 rows.
Next row: [K2tog] twice. (2 sts)
Next row: K2tog and fasten off.

Joey

Body

With tf, cast on 10 sts.
Beg with a k row, work 12 rows st st.
Row 13: K2tog, k6, k2tog. (8 sts)
Work 3 rows st st.
Row 17: K6, wrap and turn (leave 2 sts on left-hand needle unworked).
Row 18: Working on center 4 sts only, p4, w&t.
Row 19: K4, w&t.
Row 20: P4, w&t.
Row 21: K6. (8 sts in total)
Row 22: Purl.
Row 23: K6, w&t (leave 2 sts on left-hand needle unworked).
Row 24: P4, w&t.
Row 25: K4, w&t.
Row 26: P4, w&t.
Row 27: K6. (8 sts in total)
Row 28: P1, p2tog, p2, p2tog, p1. (6 sts)
Work 2 rows st st.
Row 31: K2, k2tog, k2. (5 sts)
Row 32: Bind off.

Tummy

With pe, cast on 5 sts.
Beg with a k row, work 16 rows st st.
Row 17: K2tog, k1, k2tog. (3 sts)
Work 3 rows st st.
Row 21: Inc, k1, inc. (5 sts)
Work 4 rows st st.
Row 26: P2tog, p1, p2tog. (3 sts)
Work 2 rows st st.
Row 29: K3tog and fasten off.

Ear

(make 2 the same)
With tf, cast on 4 sts.
Knit 4 rows.
Next row: [K2tog] twice. (2 sts)
Next row: K2tog and fasten off.

To Finish

Kangaroo

SEWING IN ENDS Sew in ends but leave ends around edges of the head, body, legs, and paws for sewing up.
HEAD Fold bound off row of head in half and sew from nose to chin with whip stitch.
TAIL Sew up the tail using mattress or whip stitch on outside.
BODY With RS together, sew around the back of kangaroo using mattress or whip stitch.
POUCH Using whip stitch, attach pouch to RS of tummy, cast on row to cast on row. Leave open at the top for joey to slip into.
TUMMY Using mattress or whip stitch, sew cast on row of tummy to base of bottom, just behind back legs, and sew bound off row to nose. Ease and sew tummy to fit body. Leave a 1in (2.5cm) gap on one side. Turn right side out.

STUFFING Cut a pipecleaner 1in (2.5cm) longer than the tail. Fold over one end. Slip the folded end into the tail, adding a little stuffing. The end of the pipecleaner will poke out and will vanish into the body stuffing. Starting at the head, stuff the body firmly, sew up the gap with mattress stitch. Mold into shape.

LEGS Fold the leg in half. Starting at the paw, sew up leg using whip or mattress stitch on outside. Cut a pipecleaner to approximately fit length of leg, leaving an extra 1in (2.5cm) at both ends. These ends are folded over to stop them poking out of the paws. Roll a little stuffing around the pipecleaner and slip into the leg. Lightly stuff the leg and sew along top edge. Less stuffing is needed for the front legs. Attach front legs at beginning of curve toward neck, and attach back legs as in photograph. Secure on the underside of the leg to stop the legs splaying.

EARS Attach the bound off row of ears to side of kangaroo's head, at an angle sloping down towards back, leaving 4 sts between ears.

EYES With bl, sew 3-loop French knots, as shown in photograph.

NOSE With bl, embroider nose using satin stitch.

Joey

Work as for kangaroo, following:

SEWING IN ENDS

HEAD

TUMMY Note that joey has no legs.

STUFFING Note that no pipecleaners are used.

EARS Leave a 1-st gap between ears.

EYES

NOSE

Pop joey into the kangaroo's pouch.

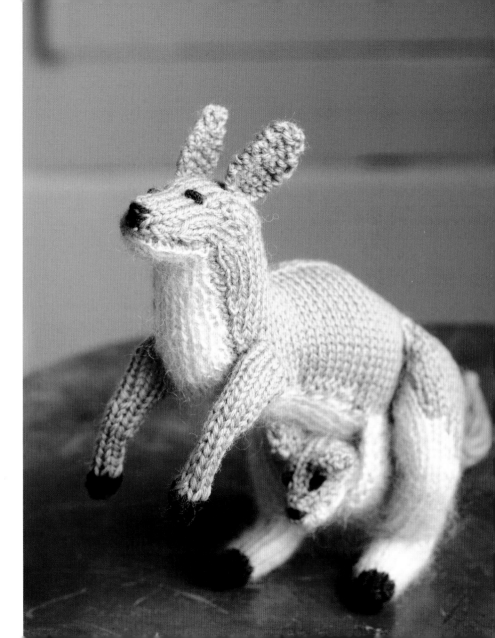

Knit your own chameleon?
Visit www.LoveCrafts.co.uk
for a free bonus pattern.

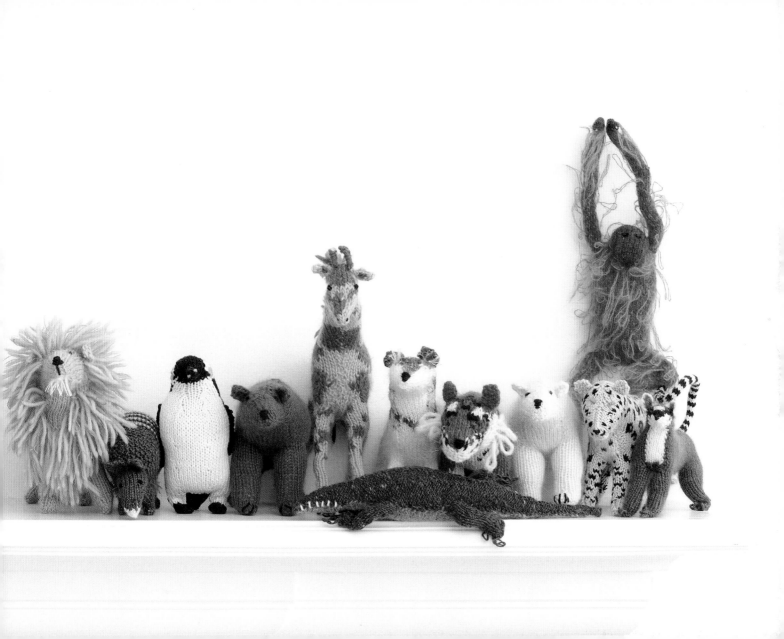

Hints

Choosing Yarns

We recommend Rowan Yarns, but as each animal takes only a small amount of yarn, any yarn can be used, either different colors or thicknesses. If using thicker yarns, refer to the ball band for needle size, but use needles that are at least two sizes smaller than recommended as the gauge needs to be tight so the stuffing doesn't show. If using thicker yarn and larger needles, your animal will be considerably bigger. We feel that finer yarns create a more refined animal.

Yarn companies are constantly updating their ranges and unfortunately since we started writing this book a yarn we used, Cashsoft 4ply, has been discontinued. We have substituted other yarns in the Materials section for each pattern but some of the photographs will be slightly different colors to your knitted animals.

Knitting the Body and Head

When holding stitches to use later on in the pattern, such as on the final row of the legs, work the last row on a spare double-pointed needle. This means you can pick up and knit or purl the stitches from either end of the needle.

After you have sewn up the back of the animal, there may be a hole at the nape of the neck. Work a couple of Swiss darning stitches to fill the hole.

Carefully follow the instructions when picking up and knitting the first row of Neck and Head. The right side of the body is knitted first, then the left side. The backbone of the animal is in the middle of this row. If picked up incorrectly, the head will be facing toward the tail.

Holes can develop around the short row shaping at the top of the head. When sewing on the ears, use the sewing-up end to patch up any holes. Swiss darning can also be used to cover up any untidy stitches.

Stuffing the Animal

Stuffing the animal is as important as the actual knitting.

Use a knitting needle point to push the stuffing into the paws, and into the nose of the animal. Even after the animal is sewn up you can manipulate the stuffing with a knitting needle. If the stitches are distorted, you have overstuffed your animal.

We recommend using 100% polyester or kapok stuffing, which is available from craft stores and online retailers. An animal takes ¾–2¼oz (20–60g) of stuffing, depending on size.

An Important Note

The animals aren't toys, but if you intend to give them to small children do not use pipecleaners in the construction. Instead, you will need to densely stuff the legs to make the animal stand up.

Unfortunately, for some animals the pipecleaners are essential to sculpt their unique shape—for instance, the giraffe and fruit bat.

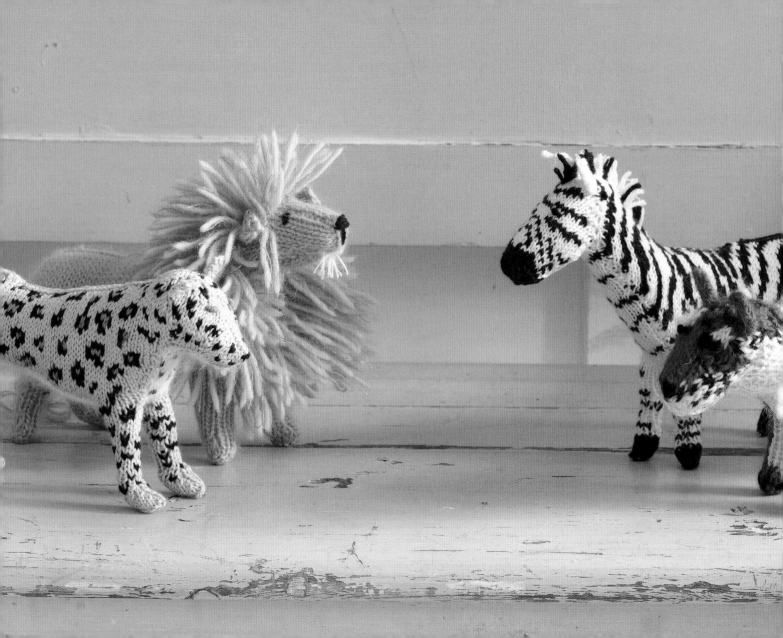

Methods

Abbreviations

alt alternate
approx approximately
beg begin(ning)
cm centimeter
cont continue
foll(s) follow(s)(ing)
g grams
ibos including bound off stitch. After binding off the stated number of stitches, one stitch remains on the right-hand needle. This stitch is included in the number of the following group of stitches.
in inches
inc work into front and back of next stitch to increase by one stitch
k knit
k2(3)tog knit next two (three) stitches together
oz ounces
p purl
p2(3)tog purl next two (three) stitches together
rem remain(ing)
rep repeat
rev reverse
RS right side
sk2po slip one stitch, knit two stitches together, pass slipped stitch over
st(s) stitch(es)
st st stockinette stitch
w&t wrap and turn. See Wrap and Turn Method, right.
WS wrong side
[] work instructions within square brackets as directed
***** work instructions after asterisk(s) as directed

Color Knitting

There are two main techniques for working with more than one color in the same row of knitting – the intarsia technique and the stranding technique. For some animals, such as the giraffe, you use a combination of both methods, but here is a guide.

Intarsia Technique

This method is used when knitting individual, large blocks of color. It is best to use a small ball (or long length) for each area of color, otherwise the yarns will easily become tangled. When changing to a new color, twist the yarns on the wrong side of the work to prevent holes forming.

When starting a new row, turn the knitting so that the yarns that are hanging from it untwist as much as possible. If you have several colors you may occasionally have to reorganize the yarns at the back of the knitting. Your work may look messy, but once the ends are all sewn in it will look fine.

Stranding (or Fair Isle) Technique

If there are no more than four stitches between colors, you can use the stranding technique. Begin knitting with the first color, then drop this when you introduce the second color. When you come to the first color again, take it under the second color to twist the yarns. When you come to the second color again, take it over the first color. The secret is not to pull the strands on the wrong side of the work too tightly or the work will pucker.

I-cord Technique

With double-pointed needles, *knit a row. Slide the stitches to the other end of the needle. Do not turn the knitting. Repeat from *, pulling the yarn tight on the first stitch so that the knitting forms a tube.

Wrap and Turn Method (w&t)

Knit the number of stitches in the first short row. Slip the next stitch purlwise from the left-hand to the right-hand needle. Bring the yarn forward, then slip the stitch back onto the left-hand needle. Return the yarn to the back. On a purl row use the same method, taking the yarn back, then forward.

Short Row Patterning

This is worked by wrapping the stitch as for Wrap and Turn (above), but the number of stitches worked is decreased by one for as many rows as given in the pattern, then increased to the original number of stitches.

Loopy Stitch

On a knit row, knit one stitch as normal, but leave the stitch on the left-hand needle. Bring the yarn from the back to the front between the two needles. Loop the yarn around the fingers of your left hand; the number of fingers needed is specified in each pattern. Take the yarn back between the two needles to the back of the work. Knit the stitch from the left-hand needle as normal. You now have two stitches on the right-hand needle and a loop between them. Pass the first stitch over the second stitch to trap the loop, which is now secure. The end of the loop can be cut when finishing the animal.

As a guide, a 1-finger loop should be about ¾in (2cm) long, a 2-finger loop 1¼–1½in (3–4cm), a 3-finger loop 2½in (6cm), and a 4-finger loop 2¾in (7cm).

Scarf Fringe Method

Use this method for the zebra's mane and tail, koala's claws, camel's tail, giraffe's mane and tail, and wolf's ears.
Cut two 2in (5cm) pieces of yarn and fold them in half. Slip a crochet hook through a knitted stitch, hook the folded end of yarn through the stitch, slip the ends through the loops and pull the yarn tightly. Once all fringing has been done, cut to the required length.

Wrapping Pipecleaners in Yarn

This method is used for very thin legs and for claws. If possible, use colored pipecleaners and try to match the color of the wrapping yarn. Leaving a 2in (5cm) tail of free yarn, tightly wrap the yarn around the pipecleaner, making sure no pipecleaner chenille pokes through. Continue wrapping down the pipecleaner to as close to the tip as possible, then wrap the yarn back up to the top of the pipecleaner. Knot the two ends and slip them into the body. If there is a little bit of white pipecleaner chenille showing, colour it in with a matching marker. A little dab of clear glue will stop the wrapping slipping off the end of the pipecleaner.

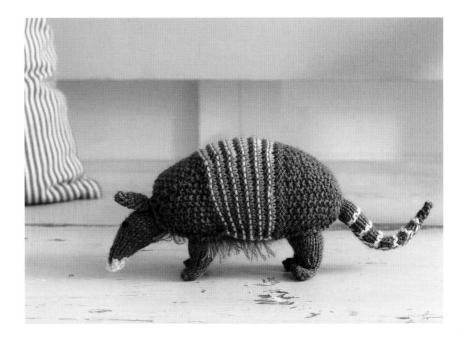

Index of Animals

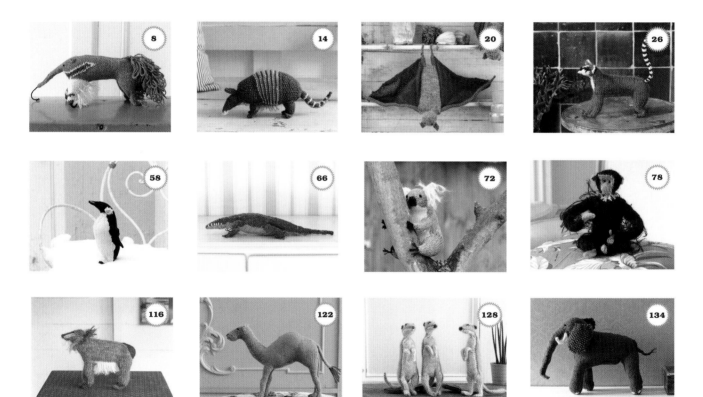

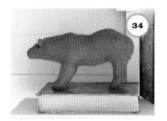
34

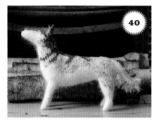
40

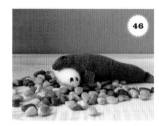
46

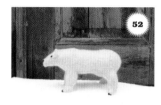
52

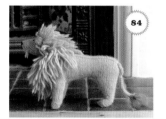
84

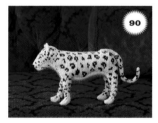
90

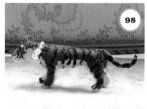
98

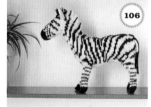
106

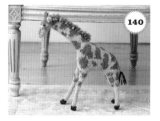
140

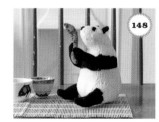
148

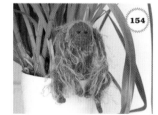
154

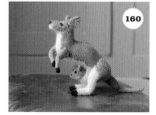
160

Resources

All the animals are knitted in Rowan Yarns; for stockists please refer to the Rowan website: www.knitrowan.com. Note that by the time this book is printed some colours may have been discontinued.

We recommend using 100 percent polyester or kapok stuffing, available from craft stores and online retailers. An animal takes ¾–2¼oz (20g–60g) of stuffing, depending on size.

We are selling knitting kits for some of the wild animals. The kits are packaged in a knitting bag and contain yarn, all needles required, stuffing, pipecleaners, and a pattern.

For those who cannot knit but would like a wild animal, we are selling some of the animals ready-made. You can see the wild animals on our website: www.muirandosborne.co.uk.

The Authors

Sally Muir and Joanna Osborne run their own knitwear business, Muir and Osborne. They export their knitwear to stores in the United States, United Kingdom, Europe and Japan as well as selling to shops in the United Kingdom. Several pieces of their knitwear are in the permanent collection at the Victoria and Albert Museum, London.

They are the authors of the bestselling *Best in Show: Knit Your Own Dog*, *Best in Show: 25 More Dogs to Knit,* and *Best in Show: Knit Your Own Cat.*

Acknowledgments

Once again we have had the most wonderful group of people working on this book; thank you to Katie Cowan and Amy Christian for their endless support and enthusiasm, Laura Russell for her creative design, Marilyn Wilson for her incisive pattern-checking skills, and Kate Haxell for understanding everything there is to know about knitting. Equally, a huge thank you to Holly Jolliffe for her amazing photographs (it even snowed when needed), and to Caroline Dawnay and Olivia Hunt for their encouragement and hard work on our behalf.

Rowan Yarns have, yet again, generously supported this book; their yarn range is superb.

Also thank you to our families who cooked us many a supper, and to the makers of *Breaking Bad*, which entertained us during long evenings of knitting.

Join our online community at
www.bestinshowbooks.com